Jeff Carlson

The Photographer's Guide to Luminar 4

The Photographer's Guide to Luminar 4
Jeff Carlson
www.rockynook.com/the-photographers-guide-to-luminar/

Editor: Maggie Yates
Project manager: Lisa Brazieal
Marketing coordinator: Mercedes Murray
Layout and type: Jeff Carlson
Cover design: Aren Straiger
Proofreader: Julie Simpson

ISBN: 978-1-68198-404-9
1st Edition (1st printing, May 2020)
© 2020 Jeff Carlson
All images © Jeff Carlson unless otherwise noted

Rocky Nook Inc.
1010 B Street, Suite 350
San Rafael, CA 94901
USA

www.rockynook.com

Distributed in the U.S. by Ingram Publisher Services
Distributed in the UK and Europe by Publishers Group UK

Library of Congress Control Number: 2018932976

Printed in Korea

For my father, Larry Carlson.

About the Author

Author and photographer Jeff Carlson writes for publications such as *DPReview* and *Macworld,* and is a contributing editor at *TidBITS.* He is the author of the books *Take Control of Your Digital Photos* and *Take Control of Your Digital Storage,* among many other titles. He co-hosts the podcast *PhotoActive* and leads photo workshops in the Pacific Northwest. He believes there's never enough coffee, and does his best to test that theory.

Web: jeffcarlson.com
Instagram: @jeffcarlson
Twitter: @jeffcarlson

Table of Contents

Introduction

This doesn't seem like something one would say in polite company, but let's get the truth out of the way: a lot of people came to Luminar from Lightroom or Photoshop as a result of Adobe switching to a subscription pricing model. Perhaps they didn't think the ongoing cost was worth the switch, or maybe they object to subscriptions in general. Heaven knows we all have more than enough subscriptions now, from music streaming to video services to cloud storage.

But moving to a different photo application, and paying for it outright, isn't something one just casually does.

As you've no doubt discovered, Luminar isn't some backwater alternate to Adobe's tools. It's a comprehensive image editor and library manager, but it also has *ambition*. Skylum saw a future where it could deliver the tools and quality that photographers of all stripes demand—on the company's own terms.

I've worked with people from both Adobe and Skylum, and they're all focused on making great tools for photographers, resolving the pain points that disrupt workflows, and doing what they can to help you enjoy your images.

There are a few essential ingredients wrapped up in that statement. Skylum has invested heavily in building AI (artificial intelligence) tools that understand the content of a photo to best apply edits to specific areas. The application also includes the Luminar Libraries feature, a long–wished-for component that adds library management to the application. I can't stress enough how convenient it is to have editing and organizing under the same roof. You end up spending more time and focus on enjoying and working with your images, instead of managing files on disk and between applications. If you already use something like Lightroom or Apple Photos to organize your photo collection, Luminar also works as a full-featured plug-in that lets you make round-trip edits without disrupting your current organization scheme.

Whether you're here as a result of Adobe's subscription model, or you were drawn to Luminar's many photographer-focused features, this book will help you coax (or sometimes prod) the best versions of your photos to appear.

How to Read This Book

Editing photos is rarely a linear process. Some images demand tonal corrections before you can think about adjusting color, while others need the opposite approach. Adding a vignette could prompt you to boost saturation a bit or bring up the shadows to compensate for the darker edges of the frame. There's not a single editing path to follow.

Luminar's many tools and controls are also non-linear. That's a creative advantage! However, it also leads to situations where features overlap, an especially annoying trait when someone like me is putting it all in a linear medium such as a book.

Don't be surprised to find yourself skipping around between sections, depending on what you're trying to accomplish. For example, in Chapter 5 I cover Luminar's many editing controls. As you work, however, you may want to edit on adjustment layers, which are covered in Chapter 8, and apply masks, which are covered in Chapter 9. In fact, you may prefer to start with Chapters 8 and 9, and then refer back to Chapter 5 to learn how to use specific tools. (If you're thinking you've stepped into a time-bending Christopher Nolan movie, stick with me here.)

I do retain some linearity in terms of complexity. To wit:

- In Chapter 1, I share what I think are the most important controls and features that demand your attention right away.

- Chapter 2 details the variety of ways to get photos into Luminar, from importing them directly to using Luminar as a plug-in for other applications such as Lightroom Classic or Apple Photos.

- Chapters 3 and 4 walk you through editing a landscape and two portrait photos to give you an overview of a typical Luminar workflow.

- Chapters 5 and 6 build a foundation to understand how the editing and canvas tools work.

- Chapter 7 jumps into applying the presets that the software calls Luminar Looks. Technically, Looks are much easier to understand than individual tools, but knowing how a Look manipulates the tools' controls gives you more power over adjusting those settings.

- After all that, you'll be in a better position to understand the sometimes unique ways Luminar uses layers in Chapter 8.

- And then, in Chapter 9, I cover masks, blend modes, and other advanced editing topics.

- Chapter 10 is devoted to the Luminar Library, detailing how to organize photos, create albums, and work with files on disk.

- Chapter 11 is probably the most logically placed section, because when you're done editing, it's natural that you'd want to learn how to share your awesome creations.

So, what I'm saying is that you don't need—and I'm not expecting you—to read the book front-to-back, but there is some progression to be found as you encounter the topics. Besides, I fully expect you to read a little, edit some photos in Luminar, refer back to the book for details, and edit some more. The whole point of this book, and Luminar in general, is to help you develop your images into the photos you want them to be.

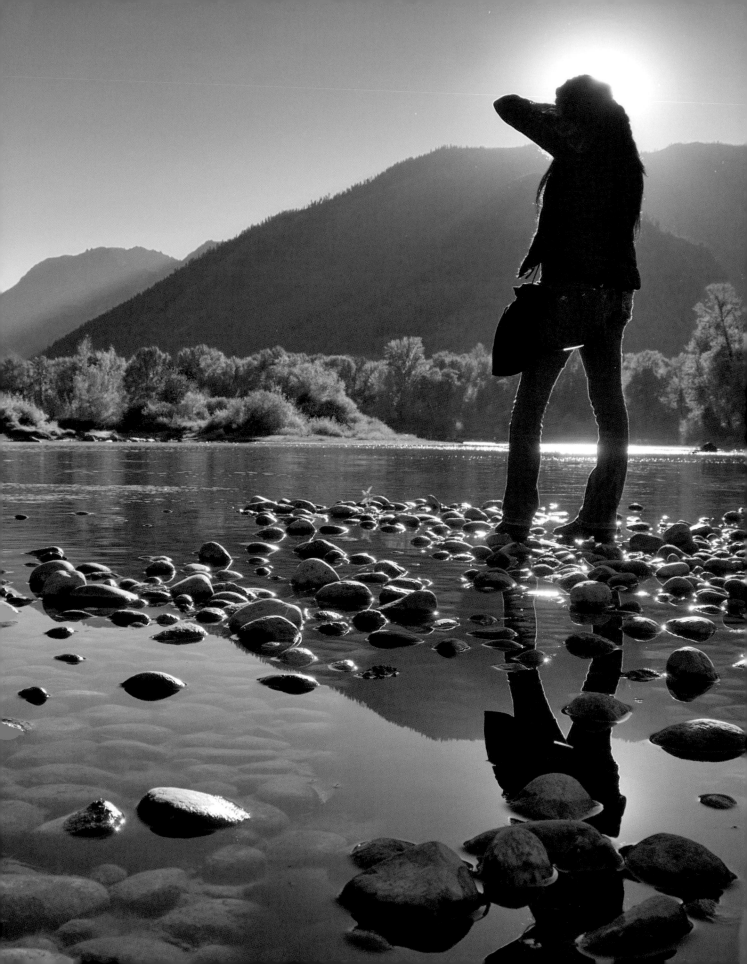

The Luminar Studio

1

In a lot of books, this is the chapter you're likely to skim over, or outright skip, so you can jump right to editing. I'm not judging! I've done the same thing. Touring an application's interface sometimes feels like getting stuck behind a slow driver on an expressway.

That said, think of Luminar as a photo *studio* (or your photo bag when you're in the field): when you know where everything is, you can easily grab the lens or filter you need and get the shot you want. If you're fumbling around trying to locate the right piece of equipment, you can get frustrated and lose focus on the image you're capturing or editing.

As you'll soon discover, Luminar has a lot of working parts, such as the Library, which organizes your photo collection, and tools for making edits. Many of those parts aren't visible at times.

Instead, let's take a slightly different approach. I'm going to point out the *essential* tools and areas that will soon become second nature to you, in what I believe to be their order of importance.

If you've used Lightroom, Photoshop, or most other image-editing applications in the past, you should feel immediately comfortable with Luminar. When viewing or editing, the image is nice and large in the frame, with editing tools in a sidebar to the right, and a toolbar up top. The Looks panel runs along the bottom, offering pre-made, one-click looks.

The Sidebar

"Sidebar" seems like a bland moniker for the portion of Luminar that will get most of your focus, but I appreciate that Skylum didn't try to jazz it up for crazy marketing reasons. In addition to the Library panel, the sidebar includes the Edit panel, with all the tools for adjusting a photo, the Layers controls, and the all-important Histogram **(Figure 1-1)**. The sidebar also includes the Info View.

If you want to eke out some more screen space, you can hide the sidebar by choosing View > Sidebar > Hide. That hides all the tools you need, though, so it's not something I recommend doing. A better way to get a less cluttered view of a photo is to choose View > Hide/Show Filmstrip to remove the images at the left side of the window. Or, for quick checks, press the tab key (or choose Hide/Show All Panels).

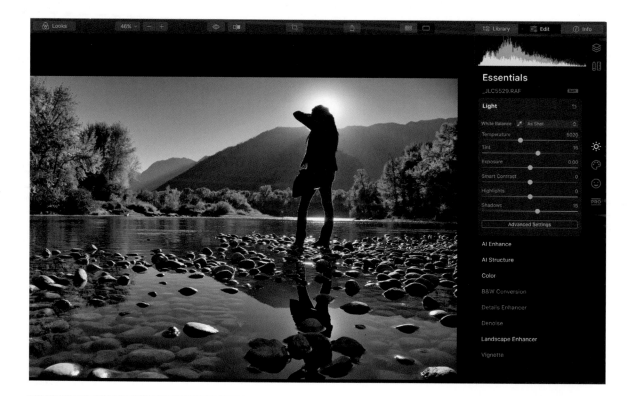

FIGURE 1-1: Nearly all of the editing tools are tucked away in the sidebar, leaving plenty of room for you to work on your image.

Edit Tools

I cover editing tools in much more depth in Chapter 5, so here I want to introduce the mechanics of how they work.

When you activate the Edit panel, a few tools are already visible, such as the Essentials group, which includes tools such as Light (for adjusting exposure and white balance) and AI Enhance (which does wonders with just two sliders) **(Figure 1-2)**.

Just below the group name is the current layer, which in most cases is the image's file name. As you'll learn in Chapter 8, each layer can have its own combination of adjustments, so this tiny detail helps orient you as you work.

Click a tool's heading to hide or show the sliders for applying that tool's edits. Only one tool's controls are available at a time **(Figure 1-3)**.

With so many tools available, it would be madness to include them all in a long sidebar list; you'd fall asleep while scrolling. Instead, they're organized into five main groups: Essentials, Creative, Portrait, Pro, and Deprecated. The last one appears only when you open an image that was edited using tools from earlier versions of Luminar that are no longer current; they still work, but aren't normally visible.

No More Work for Workspaces

Luminar 3 and earlier used a clever method of working with tools—referred to then as *filters*—called *workspaces*. Instead of grouping tools into several main categories, as in Luminar 4, filters could be mixed, matched, swapped, and swiped between workspaces. It was wonderfully configurable—and quite complicated. Several of the filters duplicated tools from other filters as the software evolved.

Skylum streamlined tools significantly in version 4 to remove all that complexity and to be friendlier to folks who just want to get in, edit their photos, and move on to the next thing.

The Histogram

For a long time I ignored histograms—I can see a photo with my own two eyes, after all! But was I *really* seeing it? After consistently underexposing my photos, both in camera and during editing, I realized that the histogram is more than a fancy colorful representation of the data in the image. Now, I keep the histogram visible at all times. If it's not already visible, click the

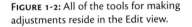

FIGURE 1-2: All of the tools for making adjustments reside in the Edit view.

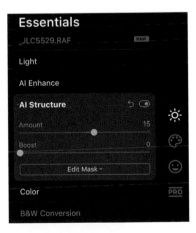

FIGURE 1-3: To streamline the editing interface, only the active tool will be visible.

FIGURE 1-4: Learn to love the histogram, because it can get you out of some bad editing situations.

More button at the bottom of the sidebar (⬤⬤⬤) and then choose Show Histogram, or choose View > Hide/Show Histogram **(Figure 1-4)**.

In addition to showing how color and tone are distributed in a photo, the histogram can reveal clipped areas that are blown out to white or darkened to complete black. Click the triangles that appear when you move the pointer over the histogram to view those areas. (For more, see Chapter 5.)

Compare and Quick Preview

Like the options for hiding toolbars and viewing the photo full-screen, these two options get used a lot. I'm listing the keyboard shortcuts first because I find it's so much easier to use them than to click the toolbar buttons with your cursor.

- **Compare:** Press the semicolon (;) key or click the Compare button (▢▪) in the toolbar to view a split-screen display of the photo **(Figure 1-5)**. Drag the middle divider to expose the Before and After versions of the image.

- **Quick Preview:** Press the backslash (\) key or click the Quick Preview button (👁) in the toolbar to reveal the unedited version of your photo for comparison's sake. (It's oddly named, since what you're doing is viewing the old version, not previewing the edited version, but you get the idea.)

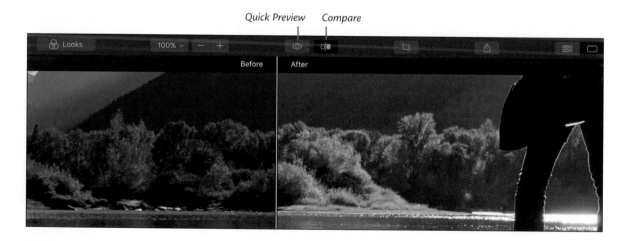

FIGURE 1-5: View a quick before-and-after comparison of your photo.

Hide/Show All Panels and Full Screen Preview

These commands are really just different ways to view your photo, but you'll find yourself using them all the time as you edit—which is why I'm including them so high in the list of importance.

- **Hide/Show All Panels (macOS):** Press the Tab key to make all the interface elements except the toolbar go away, leaving just your image **(Figure 1-6)**. The zoom level doesn't change if you're viewing the image at anything other than Fit to Screen, but you'll see more of the photo. You can also choose View > Hide/Show All Panels/Toolbars.

FIGURE 1-6: Hide all the panels when you want to get a better view of your photo.

- **Show All Toolbars (Windows):** Under the Windows version, pressing the Tab key makes all interface elements appear if they aren't visibile already. For example, if the Filmstrip was hidden, pressing Tab makes it appear. With all the elements onscreen, pressing Tab hides all of them except the toolbar and the image. You can also choose View > Show All Toolbars, which reads Hide All Toolbars when everything is visible.

- **Full Screen Preview (macOS):** Press the F key to hide all of Luminar's tools and view the image at its largest size on your display, zoomed to fit. You can also choose View > Enter Full Screen Preview. This also activates Full Screen mode, which puts Luminar into its own screen space, hiding the menu bar and any other running applications. Press F again, or choose View > Exit Full Screen Preview, to go back to editing.

- **Full Screen (macOS):** Separately, you'll also find the option to Enter Full Screen (choose View > Enter Full Screen, or press Command-Control-F), which does the same thing as Full Screen Preview, but retains the program's interface items such as the sidebar. Move the mouse pointer to the top of the screen to reveal the menu bar. To get out of Full Screen mode, choose View > Exit Full Screen, or press Command-Control-F again.

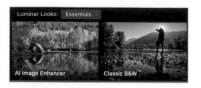

FIGURE 1-7: If you don't use looks often, keep the Looks panel closed so Luminar doesn't populate each look with a preview each time you select an image.

The Looks Panel

The easiest way into Luminar editing is via the Looks panel, which offers several pre-made edits that can be applied with a single click. Those presets range from styles that make color pop or increase clarity, to ones that use cross processing for creative, artistic effects.

Click the Looks panel button in the toolbar, or choose View > Hide/Show Looks Panel to display the row at the bottom of the screen **(Figure 1-7)**. They're organized by category; click the Luminar Looks pop-up menu to reveal them all **(Figure 1-8)**.

In addition to the built-in looks, you can create your own or import ones made by other people. At Skylum's website (skylum.com), once you have an account, you can discover free and paid preset packs to add.

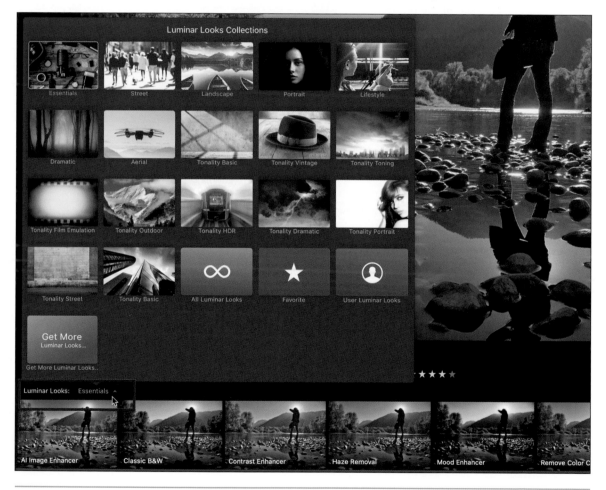

FIGURE 1-8: Choose from several categories of looks, or define your own and save them for later.

Zoom

Zoom is another feature that may seem inconsequential compared to the edit or canvas tools, yet you can easily use it hundreds of times while working on an image.

- **Fit to Screen:** Press Command/Ctrl-0 or choose View > Fit to Screen to view the entire image in the working area.

- **Original Size:** Press Command/Ctrl-1 or choose View > Original Size to zoom to 100% view, where the pixels on your screen correspond to the pixels in the image. This view is essential when retouching areas, creating masks, or even checking focus.

- **Zoom In:** Press Command/Ctrl-+ (the plus sign) or choose View > Zoom In to enlarge the view incrementally: 25%, 50%, 100%, 200%, 300%, 600%, 1200%, 2400%, and even 3000% (which basically makes everything look like algae).

- **Zoom Out:** Similarly, press Command/Ctrl-– (the minus sign) or choose View > Zoom Out to reduce the view in the same increments above.

- **Toolbar Zoom buttons:** Another option is to click the Zoom In or Zoom Out buttons, or choose a zoom level from the Zoom pop-up menu **(Figure 1-9)**.

FIGURE 1-9: You should always check your photo at 100% several times as you're editing. Although this menu tops out at 1200%, you can zoom in as close as 3000% using the – and + buttons!

When you're zoomed in, notice that the pointer becomes a hand icon. To move to another part of the image without zooming out, click and drag in any direction; or, if you're using a trackpad, swipe with two fingers.

To move around the image without dropping the tool, hold the spacebar as you drag the image.

The Canvas Panel

One of the ways Luminar differs from other photo-editing applications is the absence of a long toolbar taking up a portion of the screen. The tools that affect the shape of the image and that fix specific areas are stored in the Canvas panel **(Figure 1-10)**. (I cover the Canvas tools in more detail in Chapter 6.)

FIGURE 1-10: Instead of a lengthy tools palette, as found in other applications, Luminar concentrates its tools into a single panel.

Click the Canvas button in the sidebar to access its tools:

- **Crop & Rotate:** Use the Crop & Rotate tool to change the image's composition, specify other aspect ratios, and straighten the shot. On the Mac, you can also flip the image horizontally or vertically or rotate it in 90-degree increments. Crop also applies to the entire image and all its layers. Press the C key to quickly activate the Crop tool.

- **Erase:** The Erase tool removes areas of the image and replaces them using algorithms that calculate the result. It's great for erasing objects like stray power lines. In situations like that, the software can handle the task so you don't have to do it manually with the Clone & Stamp tool. Press Command/Ctrl-E to switch to the Erase tool.

- **Clone & Stamp:** A common method of making touch-ups is to use the Clone & Stamp tool. Let's say you need to remove some dust marks or fill in a patch of grass that stands out; you can define a nearby area as a source and then stamp (copy) the pixels to fix the spot. Press Command/Ctrl-J to switch to the Clone & Stamp tool.

- **Lens & Geometry:** This collection of tools can fix distortion, chromatic aberration, fringe issues, and vignetting caused by some lenses, as well as changing the overall shape of the image.

History

Editing a photo is never a linear process for me. I make some edits, change my mind, go back to an earlier version, try something different—you get the idea. In some applications, you can undo a set number of times, and if you close the document, that history is gone the next time you work on it.

Not so in Luminar **(Figure 1-11)**. It keeps track of all your edits, from the moment you open the file the first time. To step back through your last edits, choose Edit > Undo, or press Command/Ctrl-Z. To go to any previous edit, click the History menu in the toolbar and scroll to that point. Any subsequent edits are no longer applied. As soon as you make another edit, the ignored actions are deleted.

FIGURE 1-11: Return to earlier actions by selecting them from the History list.

The Library

There are a few ways of getting photos into Luminar for editing, as I detail in Chapter 2, but my favorite is the Library for one simple reason: convenience. If Luminar is your main tool for interacting with your photos, it helps enormously to have them all in one interface.

Unlike some applications that want to consolidate all images into one central location, Luminar can peek into whichever folder you choose to store your photos and make them appear in a gallery interface that lets you quickly identify them visually **(Figure 1-12)**.

Select a photo and double-click it, or press the spacebar to switch to single image mode. The Library panel in the sidebar reveals source folders you've added, any albums you create, and shortcuts to favorites and edited images. To return to the gallery view, click the Gallery Images mode (⊞) button, or press the G key.

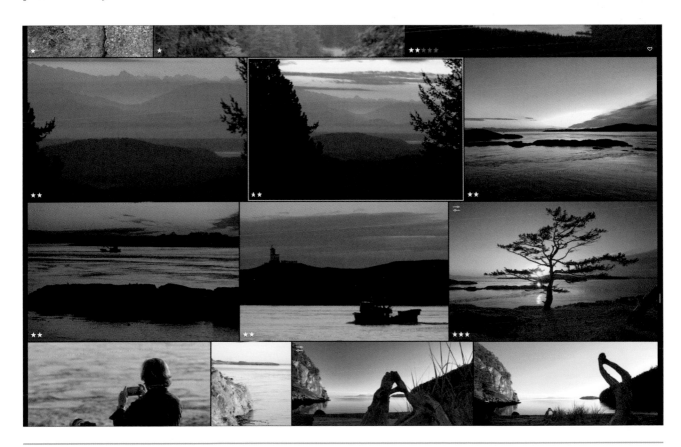

FIGURE 1-12: Using the Library lets you browse your entire photo collection without leaving Luminar.

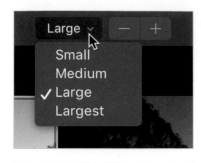

FIGURE 1-13: Change the size of the thumbnails in the grid view.

The Luminar Library isn't a full DAM (digital asset manager). You can assign star ratings and color labels, flag or reject images, and sort based on those criteria, but that's it. Support for IPTC metadata and text search are planned for the future.

Even so, I've wanted a library in Luminar for quite some time, and even this bare-bones version makes it easy for me to sort and cull photos in preparation for editing the ones that stand out. See Chapter 10 for more details on how to use the Library.

View Photos in the Library

With the beginnings of a library in place, let's look at how to navigate your photos in Luminar.

The library appears as a grid that you can scroll to peruse your photos. Change the size of the image thumbnails by choosing a view from the menu at the center of the toolbar: Small, Medium, Large, or Largest **(Figure 1-13)**. You can also click the – and + buttons next to it to switch between them, or choose View > Zoom In or View > Zoom Out.

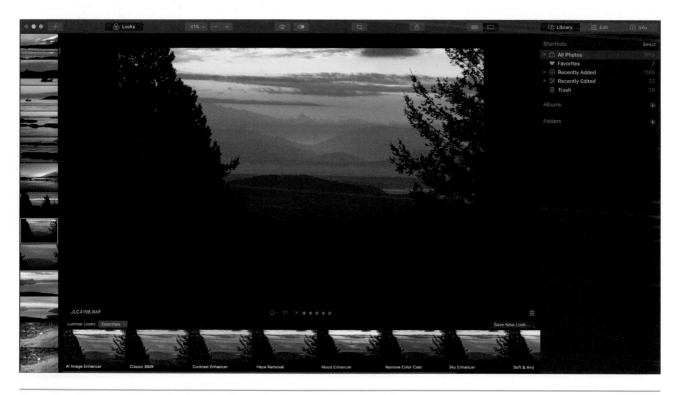

FIGURE 1-14: View a single image, but keep the library close by in the Filmstrip at left.

To view a photo larger, select it and double-click it, or press the spacebar. That presents a view where the image takes up most of the window with the sidebar at right, the Filmstrip at left, and the Looks panel at the bottom **(Figure 1-14)**. (In the Windows version, switching to this view automatically selects the Edit panel.)

Any of those elements can be hidden using the toolbar. Click the Hide/Show Looks button to toggle the Luminar Looks. Go to the View menu to set visibility for the sidebar, Filmstrip, and the Current Photo Actions strip at the bottom of the window.

FIGURE 1-15: The illustrious and illuminating Info panel. Yep, that's all there is.

The Info Panel

Press the I key or click the Info button at the top of the sidebar to reveal information about the image you're viewing: capture date and time, size in dimensions and storage, the camera and lens used, white balance mode, metering method, ISO, aperture, shutter speed, exposure compensation, and focal length **(Figure 1-15)**. You can also choose View > Sidebar > Info to switch to the Info view.

In future versions of Luminar, according to Skylum, the Info panel will host more information, such as IPTC metadata and keywords.

Change the Background Color

This doesn't quite count as an essential feature you'll turn to again and again, but it sure is helpful to get it nailed down early. As you're editing, the space behind the photo is often visible on the sides, especially when you're in the Fit to Screen view. Normally that area is black, but you can change it to something more comfortable for your eyes; a black background can be especially stark when working on bright images, for instance.

Choose View > Background and choose between Black, Dark Gray, Gray, Light Gray, and White. You can also right-click (or Control-click, on a Mac) the background area and choose one of those options from the pop-up menu that appears **(Figure 1-16)**.

FIGURE 1-16: Choose a more comfortable background color.

The Paths to Luminar

Luminar is hungry for your photos. To start editing, you need to feed it. Everyone has their own preference for how that happens. Perhaps you have one or two shots that need improvement, or maybe you're using another photo-management app and want to apply some Luminar polish or use features that aren't present in your other tool. Maybe Luminar is the center of your photo universe and you want to store all your photos in one convenient library.

While some programs railroad you into one way of working, Luminar understands you might use several methods, depending on circumstance. With the following paths to get photos into the software, you can focus on your images and not get sidetracked by the mechanics of how to get to them:

- **Open and edit a single image**, for when you don't need the overhead of library management.

- **Edit a photo from another application.** Luminar includes plug-ins for several popular apps that load the entire Luminar editing studio and keep the edited version in the original application.

- **Add photos to the Luminar Library.** This option involves specifying source folders on your hard drives or network volumes, as well as importing new photos from a camera or memory card.

Edit a Single Image

FIGURE 2-1: Open an image file without adding a folder to the library.

At times you may want to edit a photo without going through the steps of adding it as a permanent part of your library—maybe you're editing a friend's shot, or you need to adjust something that you have no interest in saving long term.

To edit a single image from within Luminar, do the following:

1. Click the Open Button Menu and choose Edit Single Image, or choose File > Edit Single Image, or press Command/Ctrl-O **(Figure 2-1)**.

2. Navigate to the image file you want, and click Open. The photo appears in the Filmstrip side panel with the Edit panel active.

Time to split a few hairs. Although I'm making it sound like the single-image approach is separate from the library, the photo actually does show up there. When you switch to the Library panel, you'll see a new Single Image Edits entry under Shortcuts, and when editing one of the images, all of the single images appear in the Filmstrip **(Figure 2-2)**. Luminar handles the image just like any other in the library, including letting you apply ratings and flags.

There are two key differences, though:

FIGURE 2-2: Single image edits have their own shortcut (top) and appear in the Filmstrip (bottom).

- Luminar leaves the image file where it was originally located. The image file won't appear in any of the source folders.

- The original file isn't affected when you make edits. Luminar holds onto that editing information since it takes up very little storage to record it in the catalog. At any point you can choose Image > Show in Finder/Explorer to reveal the file on disk.

The benefit to this organization scheme is that if you want to return to editing a photo, you can easily find it in the All Photos, Recently Added, Recently Edited, and Single Image Edits shortcuts.

When you're finished editing the photo, use the Export or Share features to save a new version of the image.

That also means, however, there's no capability to export the original with its associated edits; many apps store that information in a separate sidecar text file. See Chapter 11 for more on sharing and exporting photos.

Remove a Single Image Edit from Luminar

To remove the image from your library, select it in the Filmstrip side panel and choose Image > Remove from Single Image Edits (or press the Delete

button on a Mac). The image is removed from Luminar, but the file remains on disk where it always was.

However, the edits you made are also removed. If you open the original file again, it arrives in its original, unedited state.

Add a Single Image Edit to Your Library

If, on the other hand, you want to make the image a permanent member of your library, that's easy, too.

Open the Library panel, and drag the image's thumbnail from the Filmstrip to one of your folders (**Figure 2-3**). Keep in mind that doing so *moves* the file on disk from its previous location to the folder you specified.

Opening Luminar Files from Older Versions

Luminar 2 and earlier versions saved edited images as .lmnr files, which included the original image and all the information about how it had been edited. Luminar 4 can still read those older formats by opening them as single images, though it no longer uses the .lmnr file format.

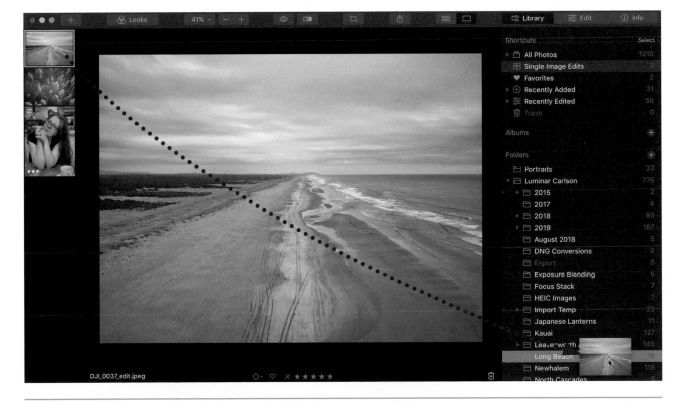

FIGURE 2-3: Add a single image edit to the library proper by dragging it to a source folder.

Edit a Photo from Another Application

Most photographers are not wedded to a single editing tool. Some of your photos may be stored in folders, while your mobile photos might be in Lightroom or Apple's Photos app. Or perhaps Luminar has a feature that Photoshop or another program doesn't, such as AI Structure or AI Sky Replacement.

In those cases, it's okay to use all the tools at your disposal. Luminar can install plug-ins for many popular applications that enable you to pop into Luminar's editing environment, make the adjustments you want, and then return to the first app.

Prior to Luminar 4, this ability was handled in Luminar 3 and also Luminar Flex, which was a separate product for people who had no interest in incorporating the Luminar Library. Now, it's all been rolled into Luminar 4.

Supported applications include Lightroom Classic (but not the newer, cloud-focused Lightroom), Photoshop, Photoshop Elements, and Photos for macOS. (There's also a plug-in for Aperture, but Aperture no longer runs as of macOS 10.15 Catalina.)

Install Luminar plug-ins

During the installation process, Luminar may have installed plug-ins for other software on your computer. To make sure they're set up, or to install new ones, make sure the other apps are not running and do the following:

1. Choose Luminar 4 > Install Plugins (macOS) or File > Install Plugins (Windows).

2. Click the Install buttons for apps in the list that are on your computer **(Figure 2-4)**.

3. Click Done.

FIGURE 2-4: Install the Luminar plug-in in available applications.

The plug-in for Photos for macOS is activated in a different way:

1. Choose > System Preferences.

2. Click the Extensions preference pane.

3. Select Photos Editing in the column at left **(Figure 2-5)**.

4. Click the checkbox next to Luminar 4 to enable the plug-in.

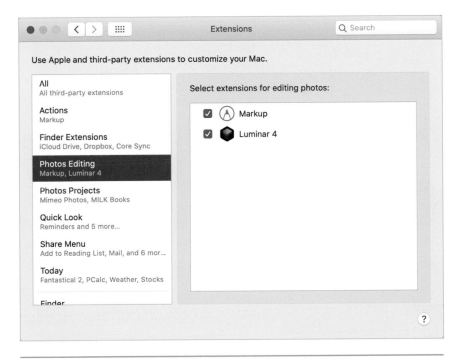

FIGURE 2-5: Enable Luminar as a Photos extension in the macOS System Preferences.

Edit a Photo from Lightroom Classic

Before you send a photo from Lightroom Classic, choose one of two options for doing so. If it's an unedited raw file, the fastest, easiest route is to *transfer* it to Luminar. If it's a JPEG or other format, or you've already applied edits in Lightroom, then you'll want to *edit in* Luminar.

The difference between the two involves just what is passed between the two applications. With the transfer option, the original file is simply picked up by Luminar for editing; when you're done, Luminar hands back an edited TIFF file (which is in the photo's original color space, a topic I'll get to shortly).

In the case of the second option, a copy of the image in TIFF format is sent, and Luminar performs edits on that. It seems like a small difference, but in some situations one method works better than the other.

Transfer to Luminar 4

Select a photo in the Library module, or open it in the Develop module, and then choose File > Plug-in Extras > Transfer to Luminar 4.

Luminar opens in a special mode where you're working on just that image; the Library is disabled, and the toolbar gains an Apply button and a Cancel button (**Figure 2-6**).

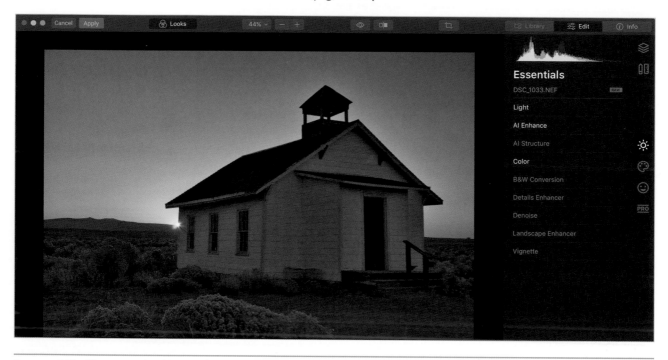

FIGURE 2-6: The file name under the controls group name indicates you're working on the original raw file.

FIGURE 2-7: In Lightroom Classic, the version edited using the Luminar plug-in (right) appears next to the original (left).

All of Luminar's editing controls are available. When you're done making adjustments, click the Apply button to send the edited version back to Lightroom as a TIFF file, where it appears in the library next to the original (**Figure 2-7**). You can also click Cancel to exit Luminar and discard any edits you made.

Edit in Luminar 4

The other approach gives you more options, but also more variables to pay attention to. If you've already done some editing in Lightroom, this is the route that keeps the results of those edits:

1. Choose Photo > Edit In > Luminar 4. You can also choose the same item from the contextual menu when you right-click the image.

 (On macOS as I write this, choosing Photo > Edit In > Edit In Luminar 4 opens the file in Luminar as a single-image edit, without an Apply button. That prevents the edits from being returned to Lightroom. The same option in Luminar for Windows works as expected. So, if you're using the Mac version, be sure to select the "Luminar 4" option, not the "Edit in Luminar 4" option that Lightroom adds near the top of the menu.)

2. Choose the type of file that gets sent to Luminar **(Figure 2-8)**. If you've already applied edits in Lightroom, choose the first option, Edit a Copy with Lightroom Adjustments. This is also the only choice if you're working with a raw or DNG image.

 If it's a JPEG image, you can also opt for Edit a Copy, which passes along an unedited copy of the original file. This option is good when you want to perform similar edits in Lightroom Classic and Luminar and see which you prefer. I don't recommend the third option, Edit Original, because it adjusts the image file itself without making a copy.

 For now, ignore the Copy File Options at the bottom of the screen. They require a bit more explanation, which we'll get to on the next page.

3. Click the Edit button to continue. Lightroom creates a separate file and opens it in Luminar in its plug-in mode, and Apply and Cancel buttons appear in the toolbar.

4. Make your edits, and then click Apply. The new version is saved and added to Lightroom's library, grouped with the original as a stack.

FIGURE 2-8: Choose from the Edit In options.

Copy File Options

When you choose Edit a Copy with Lightroom Adjustments, you can choose which file format is used for the copy that gets edited. For the most part, the default settings will work fine, but it's good to know what's happening in transit between the two applications. Click the Copy File Options exposure triangle to reveal the following settings:

- **File Format:** The default format is TIFF, which retains the same image quality as the version you're sending. TIFF is a lossless format, which means no data is thrown away to reduce the size of the file (though you can impose compression further down). Although you can choose JPEG as an option, I don't recommend it because you're discarding valuable image data before you've even started editing. PSD (Photoshop native format) is also available.

- **Color Space:** In digital imaging, color space refers to the total number of colors that can be stored and displayed. Color spaces have changed over the years as cameras and monitors have improved. This sounds like an ever-advancing leap into the future, but it can also trip up older systems that can't show all the colors in the file. As with shooting in raw or capturing more megapixels with a newer camera, it's good to work with more data than less. Lightroom's native color space is ProPhoto RGB, so that's what I recommend using. The dialog often defaults to Adobe RGB (1998), so it's worth checking the Copy File Options and switching to ProPhoto RGB before clicking the Edit button.

 It's worth noting that photo editing is best done using color-calibrated equipment. Both macOS (in the Displays preference panel) and Windows (in the Display Color Calibration control panel) include tools for calibrating your screen to show accurate color. Other companies sell more advanced calibration gear.

- **Bit Depth:** Leave this option set to 16 bits/component to ensure the most color information is included in the file for editing.

- **Resolution:** I suggest leaving this field set to the default; increasing or reducing the resolution is better done when exporting the image for use elsewhere. Our main concern is maintaining fidelity with the original when editing in Luminar.

- **Compression:** Keep this option set to None. Choosing ZIP requires your computer to work harder to decompress the file. If you're tight on disk space, I recommend buying a larger hard drive.

One important thing to keep in mind is that editing a Lightroom Classic image using Luminar's plug-in mode is a one-way trip. After you've clicked Apply and sent the adjusted image back to Lightroom, the edits are burned into that version; you can't go back to Luminar and change any of the settings you made. Even if you specify the original file to be edited when sending the edited TIFF back to Luminar, all the editing controls are reset back to their defaults. You can build on top of what you've already done, but you can't, say, change the Shadows amount from +50 to +25.

Edit from Photoshop or Photoshop Elements

The mechanism by which Photoshop and Photoshop Elements work with Luminar is similar, which is why I'm grouping them together here. However, Photoshop, the elder statesman of the two, also includes a clever way to re-edit images that have already gone through a Luminar adjustment pass.

In Photoshop or the Photoshop Elements Editor application, open a photo and choose Filter > Skylum Software > Luminar 4. You'll see the same tools and editing controls as usual in Luminar, with the addition of the Apply and Cancel buttons on the toolbar.

When you're finished editing, click Apply. The image in Photoshop or Photoshop Elements is updated to reflect the changes.

In fact, the Luminar edits replace the image on the current layer, which is the sole Background layer if you've just opened the file in Photoshop or Elements. To get back to the original version of the image, use the History panel to select an earlier edit. Or, consider duplicating the image layer before sending the photo to Luminar, which gives you more editing latitude **(Figure 2-9)**.

Photoshop (not Elements) features a way to return to your Luminar edits in case you need to adjust any of them. Here's how:

1. Open an image file and select the Background layer in the Layers panel.

2. Choose Layer > Smart Objects > Convert to Smart Object, or right-click the layer and choose Convert to Smart Object **(Figure 2-10)**.

3. Select the layer and choose Filters > Skylum Software > Luminar 4.

4. Make your edits in Luminar and then click the Apply button. The edits exist as a Smart Filter, which is a subset of the Smart Object layer. Toggle the visibility button on that layer to show and hide the edited version you made in Luminar.

5. To return to Luminar for further adjustments, double-click the Luminar 4 Smart Filter. Luminar opens the image again, with all of your earlier edits applied and editable.

6. Save the file as a Photoshop-format PSD file. You can close it and reopen it at any point to pick up where you left off in Luminar.

FIGURE 2-9: Duplicate the Background layer in Photoshop before you use Luminar's plug-in.

FIGURE 2-10: Convert the layer to a Smart Object to retain more editing capability.

FIGURE 2-11: Use the Luminar editing extension in Photos for macOS.

Edit from Photos for macOS

The Photos for macOS app has its own mechanism that supports editing a photo in a separate application, while keeping the result within the Photos library. Select an image and do the following:

1. Click the Edit button or press the Return key to enter the editing environment.

2. Click the More (⊙) button and choose Luminar 4 **(Figure 2-11)**. The Luminar interface loads within Photos.

3. Make your adjustments using Luminar's tools. That includes working with layers, a feature Photos doesn't offer.

4. Click the Save Changes button when you're finished editing.

5. Photos is still in its own Edit mode, so if you have no more edits to apply, click the Done button.

Photos also includes an Edit With feature, accessible by right-clicking a photo and choosing Edit With > Luminar 4. However, *do not* use that approach because it hands off a copy of the image to Luminar instead of using the Luminar plug-in.

The way Photos handles third-party edits is to keep an unedited original in reserve, and to present the edited version. Unfortunately, you can't return to the active controls from your previous foray into Luminar by choosing to edit the image again. If you want to do more work on the photo, you can make edits on top of the edited version, or return to the original.

To restore the original, click the Edit button and then click the Revert to Original button.

Edit a Photo in the Luminar Library

Some applications that manage a photo library store image files in specific locations. Lightroom (the newer, cloud-focused version, not Lightroom Classic) and Apple Photos default to putting the files into their own directories, which aren't in user-accessible locations. Luminar, by contrast, can use any folder on your computer.

Initially, Luminar starts building your library by setting the Pictures folder as the default source, since that's likely where your existing photos are stored. You'll see those photos show up in the Library module as Luminar scans the folder and any subfolders it contains.

If that's where all your images reside, you don't need to do anything else. All new photos added to that directory automatically appear in your library.

> ## A Case for Not Using the Pictures Folder
>
> Your computer's Pictures folder is the natural location for photos, so it makes sense to start there when building a library from scratch. However, if your Pictures folder is like mine, there's a lot of detritus you may not want in your Luminar library.
>
> Pictures is the default image dumping ground for most applications, meaning you may scoop up a lot of unrelated photos, thumbnails, and miscellany. Instead, I suggest storing your photo library in a different directory. It can be a folder within Pictures, or elsewhere on disk. To accomplish this, remove the Pictures folder as a source folder in Luminar, and then add your dedicated library folder as a new source folder.

FIGURE 2-9: Duplicate the Background layer in Photoshop before you use Luminar's plug-in.

Add Source Folders

You can also direct Luminar to read other folders as sources by doing the following:

1. Click the Library tab to view the Library panel if it's not already open.

2. Next to Folders, press the + button. You can also choose Library > Add Folder or press the Open Button Menu and choose Add Folder with Images **(Figure 2-12)**.

3. In the dialog that appears, navigate to the folder on your computer you want to set as a source.

4. Click the Add Folder button. Luminar scans that directory and adds photos contained there to the library, including images in subfolders.

FIGURE 2-12: Choose a source folder that Luminar will keep track of.

The link between what appears in the library and what exists in folders is live: if you add new photos or move image files in the Finder or Windows Explorer, those changes are reflected in the Luminar library. (However, I've occasionally seen Luminar not update when removing a file from a folder outside the application. Restarting the app refreshes the view correctly.)

Add Subfolders

It's also possible within Luminar to create subfolders within folders. With a folder selected in the Library panel, choose Library > New Subfolder and name the new folder; it's created in the folder hierarchy on disk, not just within Luminar. Any image you drag into it within Luminar is relocated on disk, too.

The hierarchy of folders and subfolders is inclusive. Selecting just a subfolder in the Library panel reveals only its photos. Selecting the subfolder's enclosing folder displays all the images stored there, plus the ones in the subfolder.

Remove a Source Folder

Just as you can add source folders, you can remove them from the library, too. But what happens to the image files and edits depends on which folder you choose, so read this part carefully:

FIGURE 2-13: Remove a source folder.

- Select a top-level source folder and choose Library > Remove from Catalog, or right-click and choose Remove from Catalog **(Figure 2-13)**. In the dialog that appears, click Remove Folder (macOS) or Yes (Windows). The source folder *and any edits you made to its photos* are removed from the library, but the original image files stay in place on disk.

- When you select a subfolder, the removal option disappears, leaving something that sounds more alarming: Library > Delete Forever. Choosing that option pops up a dialog confirming that the folder will be deleted, without the possibility of undo. Click Delete (macOS) or Yes (Windows) if that's your choice. Sure enough, that folder and any images within it are sent to the Trash or Recycle Bin.

To be honest, I don't know why Luminar treats subfolders differently. My guess is that everything within a source folder is read by the library because it's looking through the hierarchy of any folders within the source folder, and it's less efficient to create exceptions for subfolders that you wouldn't want to be included. (This is another reminder that I'm not a programmer.) Still, deleting the images and their edits in a subfolder seems like an extreme step. Perhaps Skylum will address this in a future update.

Handle Offline Volumes

The advantage of choosing source folders from anywhere is that they don't have to be physically stored on your computer. It's common to store large photo libraries on external drives or network-attached storage (NAS) devices.

When those locations aren't available, such as when you take your laptop on a trip and the storage stays in your home or office, Luminar shows a warning badge on the inaccessible files and displays the names in gray **(Figure 2-14)**.

FIGURE 2-14: Offline volumes are gone, but not forgotten.

In this situation, you can still view the image thumbnails and a low-resolution version when you switch to the detail view. Ratings, flags, and color

labels can also be applied, but you're not able to edit the photo until the source volume is reattached to the computer.

Locate Missing Edited Files

One downside to Luminar not organizing photos with a heavy hand is that sometimes files move without it being able to track them. Here's an example, entirely hypothetical and certainly nothing I've personally done on accident (except that one time I did):

You connect a removable drive, make edits to some photos stored there, then quit Luminar and disconnect the drive. Later, you realize you need that drive for something else, and copy those images to a new location.

What does Luminar do the next time you launch it? The images appear in a new Lost Edits shortcut **(Figure 2-15)**. The originals aren't available, so you can't perform any other edits. That leaves you with two options:

- Point Luminar to a new location by selecting one photo and choosing Image > Locate Image. Navigate to the folder in which the file resides and click Choose Folder. If any other lost images are there, they'll all be updated.

- Delete one or more lost images from the Library by selecting them and choosing Image > Delete. The image *and all of its edits* are removed from the Library. If you're viewing the lost edits in the Gallery mode, you can also click the Delete Lost Edits button.

FIGURE 2-15: The Lost Edits shortcut reveals images that have been edited but are no longer available.

Luminar File Management and Cloud Services

I don't want to get too far into the weeds about file management—after all, the whole point of a library is that the software is handling it for you—but it's helpful to know how Luminar structures files on disk.

The app creates a central catalog in the Pictures folder (in a directory called Luminar Catalog), which keeps track of where image files are located on disk and which edits have been applied to them. The files themselves don't move from their original locations, and aren't touched even during editing: all adjustments are stored in the catalog. When you export a photo, the edits are incorporated into the version that's created (such as a JPEG). Unlike some applications, Luminar doesn't create sidecar files (.XMP).

Why is this important? It means you can specify any folder as a source, including those created by cloud services such as Dropbox or Google Drive. Many photographers use those services to easily share photos among machines or to access images from mobile devices. While companies like Adobe and Apple charge extra for additional cloud storage, you can use disk space that you're likely already paying for. (I've had a Dropbox account for years.)

Because photo adjustments are stored in the catalog, not applied to the image files, you won't run the risk of edits getting out of sync as the cloud folders are updated.

That said, don't put the Luminar Catalog folder into a cloud drive or an external volume. It's best to keep it in the Pictures folder where Luminar expects to find it.

Work with Raw+JPEG Pairs

When your camera is set to record every shot as Raw+JPEG, it creates two separate files: an unprocessed raw file and a processed JPEG file.

Sometimes photographers do this for redundancy, or if they need the speed of turning around JPEGs, but with the flexibility of editing the raw file later. I like to shoot in Raw+JPEG mode because I can transfer the JPEGs from my camera to my mobile phone for quick review or to share on social media.

Luminar gives you a few options for how the image pairs appear. Choose View > Raw + JPEG Pairs and pick one: Show Raw Only, Show JPEG Only, or Show Separately.

This choice impacts editing because even though a pair is shown as just one image when viewing only the raw or JPEG version, you're still working with two separate files. Check the filename at the top of the Edit panel, or at the bottom-left corner in the Single Image mode. Whichever version is visibile is the one that's edited; those edits do not apply to the other member of the pair **(Figure 2-16)**.

To apply the same edits to both files, make adjustments to one and then choose View > Raw + JPEG Pairs > Show Separately, select both versions, and then choose Image > Adjustments > Sync Adjustments.

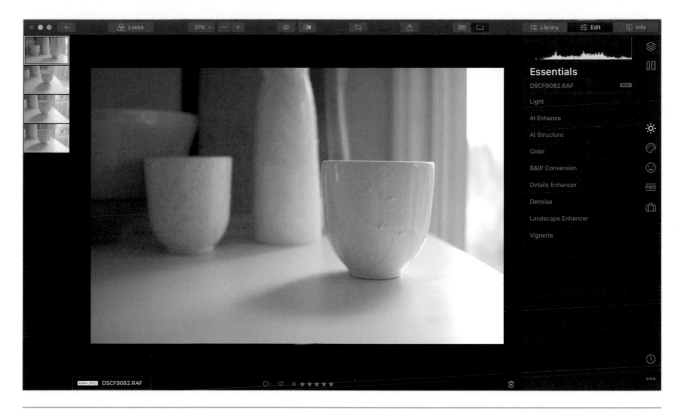

FIGURE 2-16: When working with Raw+JPEG pairs, look to these two locations to see which image file you're editing.

Add New Photos to the Library

Now that you know how to add existing photos on your hard disk to your Luminar library, it's time to move forward. You're back from a photo shoot and you want to unload the camera's memory card into Luminar. Copy images from a memory card or connected camera using the following steps:

1. With the memory card inserted or your camera connected to the computer, choose File > Import Images to a Folder. Or, you can select a folder in the Folders list of the Library panel, right-click it, and choose Import Images to this Folder.

2. Select the card as the source. In Windows, click the Browse button and specify the card's drive; on macOS, navigate to the card using the Locations sidebar item.

3. From the Import To pop-up menu, pick the folder on your disk where the images will reside **(Figure 2-17)**.

4. Under Action, choose Copy Images. The alternative is to choose Move Images, which deletes the files from the card, but it's better to format the card in the camera later. Move Images is a good option if you're importing photos from another folder or drive and want to consolidate them into one of your source folders.

5. From the Organize pop-up menu, decide which folder structure to store the imported images in. Although Luminar breaks out capture dates (see "Use Library Shortcuts" in Chapter 10), I find it's helpful to have a folder structure in place on disk in case I need to access the images outside of Luminar. Choose from the following options:

 • Into One Folder, which drops all the images into a single folder.

 • Keep Existing Folder Structure, which mimics what's on the card. This option is fine when importing from an existing folder, but not as ideal with memory cards, which often have a cumbersome naming structure (such as, using one of my cards as an example, *Untitled/DCIM/158_FUJI/*).

FIGURE 2-17: Import new photos from a memory card in Luminar for Windows (left) and macOS (right).

- Year/Month/Day, which separates the images into separate nested subfolders based on the date, such as */Pictures/2020/01/12/* for photos captured on January 12, 2020.

- Year/Month, which groups photos into nested folders based on the month they were captured in, such as */Pictures/2020/01/* for photos captured in January 2020.

6. Select the Include Subfolders checkbox to read nested folders on the card. If this option is not selected, Luminar sees only images in the folder you specified in step 2.

7. Click the Import (Windows) or Import to Folder (macOS) button to add the images to your library.

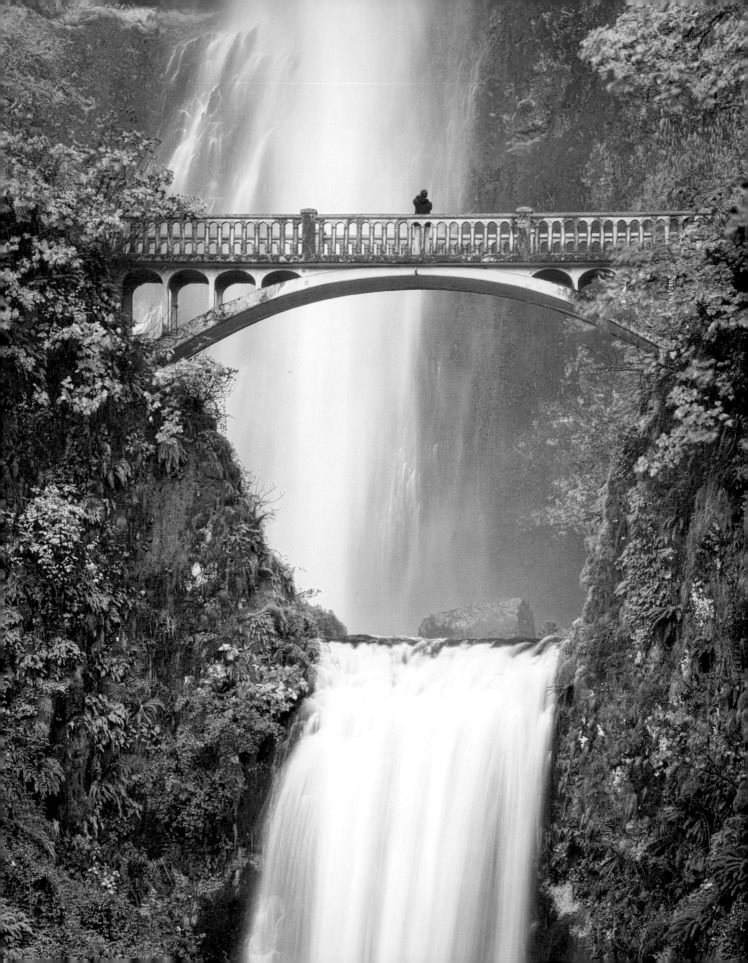

Landscape Walkthrough

Most of this book covers how to use Luminar's tools to improve your photos. Before we get into the specifcs, though, I want to walk through a few images to help you get a sense of how to edit from start to finish. That involves making a realistic appraisal of what a photo needs and choosing which tools to use. Sometimes it can be just a few slider adjustments, while other situations call for adjustment layers, masks, and creative choices.

If you're new to Luminar or photo editing in general, some of what I discuss may be unfamiliar. Don't worry: everything is discussed in more detail throughout the rest of the book. If you're an experienced editor, this chapter may reveal more about Luminar's workflows.

I've chosen a landscape photo for this section because editing landscapes includes a lot of the techniques that are useful for editing any type of photo: working with tone, color, composition, and occasional effects.

Keep in mind that these steps are how I approached the editing process. With a couple of exceptions, you can work on different aspects of the image in any order (such as color before tone), depending on what the photo needs.

Evaluate the Photo

The first step, after the image is in Luminar, is to figure out what needs improvement. The photo may have obvious shortcomings, such as being underexposed or having an uneven horizon. Or, you may have a vision of the end result and need to work your way to that result. Identifying these issues leads you on the editing path.

In the case of this photo **(Figure 3-1)**, several things need work:

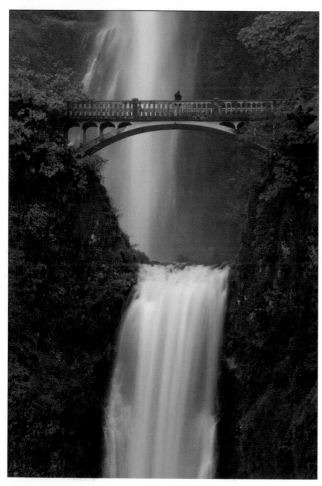

- The image is underexposed. Not only does it appear dark overall, I can see the tones in the histogram are weighted toward the left edge. What little there is at the right side doesn't reach the far edge, indicating that none of the tones are close to full brightness.

- The photo has a blue color cast due to the rainy, overcast day during which it was shot. This is actually a little surprising because I set my camera's White Balance setting to cloudy (revealed in the Info panel), which is designed to warm up cool scenes. However, I'd also attached a neutral-density filter to the lens to darken the overall scene and let me take a long exposure that makes the waterfall look smooth; the filter has made the image more blue.

- I shot the image in September, and although it was too early for the explosion of fall color, you can see that some of the leaves have begun to change from green to orange. I want to bring more attention to the foliage.

- Compositionally, I like how the image is framed, but the cliff rocks at the bottom of the photo pull my eyes away from the bridge. Cropping them out removes some of the lovely water, so I'll minimize those areas in other ways.

- To me, the person standing on the bridge makes this photo more interesting. It conveys the sense of scale of the waterfalls and draws the viewer's eye. However, I can also picture a version with no person, so we'll try to erase them from the scene.

FIGURE 3-1: The original, unedited raw image.

That sounds like a lot! Let's see how to tackle these steps.

Get Luminar's Opinion

Nearly every photo I bring into Luminar starts with a generous helping of the AI Accent slider in the AI Enhance tool. Sometimes the results are exactly what I want and I'm done with that image. More often it gives me an idea of how to proceed.

Although the AI Enhance controls affect things like exposure and color, those controls (in the Light and Color tools) are not affected. I'll sometimes use AI Accent at around 50 to start, and then make further adjustments to the image in other tools.

In this case, AI Accent has improved the overall exposure, but the color is still off and the orange leaves are still drab (**Figure 3-2**). Therefore, I'll click the tool's Reset button (🔄) to undo the edit.

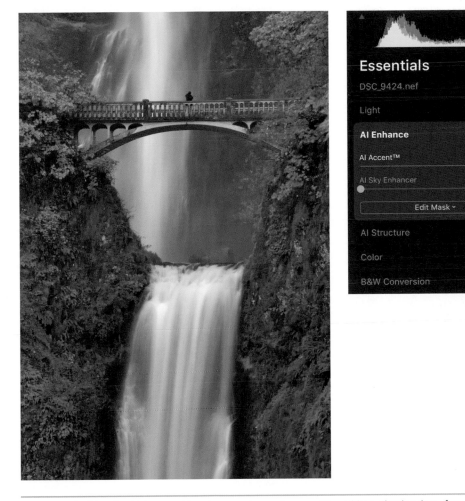

FIGURE 3-2: Pushing the AI Accent slider almost to its maximum setting addressed only a few of my issues.

Adjust Exposure

To overcome the darkness, run to the Light. I want to increase the exposure overall, but simply blasting the image with the Exposure control can often be heavy-handed. There's also a danger in blowing out the white highlights in the waterfalls, so I'll take a more measured approach that yields better results.

First, in the histogram, I click the top-right triangle that appears when I move my pointer over it to turn on the white clipping indicator; that will tell me when areas are overexposed.

Next, I'll push the Exposure slider to bring up the overall exposure. Some of the whites get clipped (marked in red), but that's OK for now **(Figure 3-3)**.

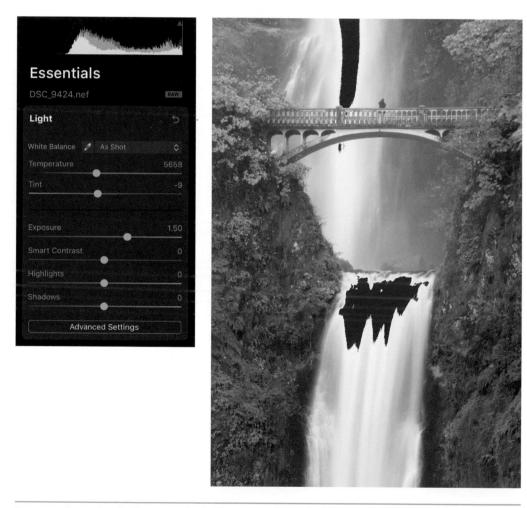

FIGURE 3-3: Increasing the Exposure value brightens everything, which is often too much.

The image is brighter, but it's also washed out. As you can see from the histogram, the left side is completely bare, revealing a lack of truly dark pixels. I've brightened all the midtones, but now there's a lack of contrast.

I could increase the Smart Contrast slider, but it affects the current range of tones, not the overall distribution; I'd see more contrast, yes, but that gap at the left edge of the histogram is still there. Instead, I'll click the Advanced Settings button and then drop the Blacks value until the histogram tones stretch almost all the way to the left **(Figure 3-4)**.

The histogram is now nicely stretched across the full range of tones, though I'd like to see more brightness in the midtones. For that, I prefer to increase the Whites slider and nudge the Shadows slider, although that pushes the exposure too far to the right. To compensate, I'll back off on Exposure.

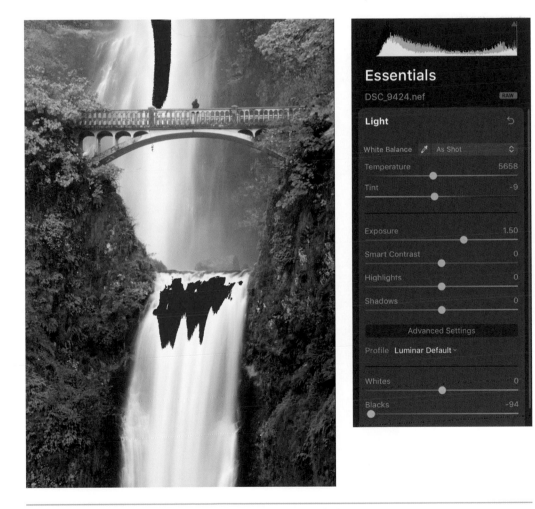

FIGURE 3-4: Decreasing the Blacks value significantly balances out the histogram.

As you can see, working with these controls is always a balancing act. I like to illuminate a scene with Whites versus Exposure because the adjustments are more targeted; Exposure is really a big light cannon.

At this point, I can't ignore the giant streaks of red indicating blown out pixels, so it's time to drag the Highlights slider to the left until the clipping indications disappear **(Figure 3-5)**.

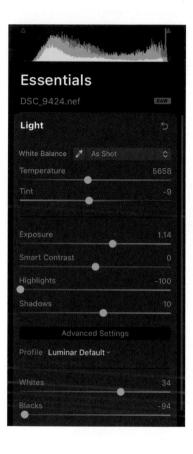

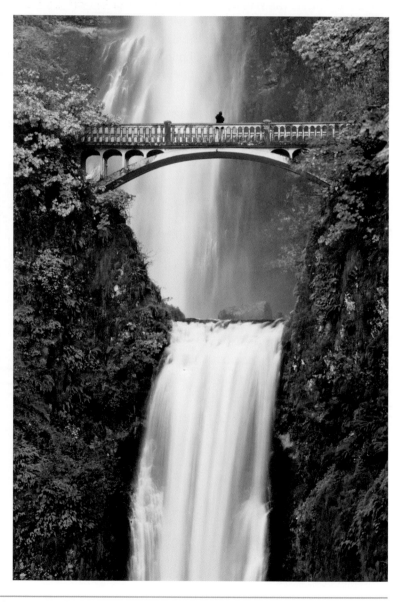

FIGURE 3-5: Reduce Highlights to prevent clipping at the high end.

Adjust White Balance

It's time to fix the white balance and warm up this image. Luminar has a few different tools that could work, such as the Remove Color Cast slider in the Color tool, but the White Balance controls in the Light tool will do just fine.

White balance is especially important in a photo like this where water is a central feature, because off-color water streams are a fast indication that the color temperature of the image is wrong. To make the adjustment, I'll select the White Balance eyedropper and then click a neutral gray—in this case, a spot on the bridge **(Figure 3-6)**. I can make the same adjustment by moving the Temperature slider a bit, but the eyedropper gets me close to a more appealing color temperature.

Since I'm looking for a warm, colorful appearance for this photo, I'll increase the Temperature value a bit higher (8844) than what the eyedropper picked (7732). That introduces a slight color cast on the water, but I'll deal with that later.

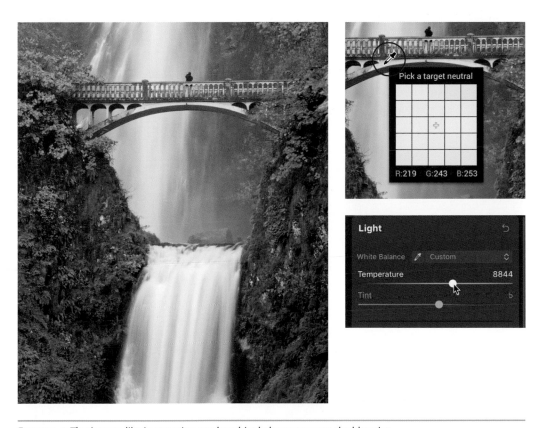

FIGURE 3-6: That's more like it: warming up the white balance removes the blue tint.

Punch Up the Foliage

With the exposure and white balance adjusted, it's time to get creative. To make those almost-orange leaves more dynamic, I'll open the Color tool. It may be tempting to increase the Saturation and Vibrance sliders—MORE COLOR!—but the greens are already pretty prominent. So, let's take a more tactical approach by clicking the Advanced Settings button to reveal the individual color controls.

When I select the orange button and increase the Saturation slider, and also decrease the Hue slider slightly, the drab, pale-orange leaves become more like what I have in my mind. I'll also tweak the yellow channel, increasing Luminance and Saturation to draw out more color from amidst the green **(Figure 3-7)**. As a finishing touch, I'll switch to the Landscape Enhancer tool and boost the Foliage Enhancer slider, which pops the darker shades of green.

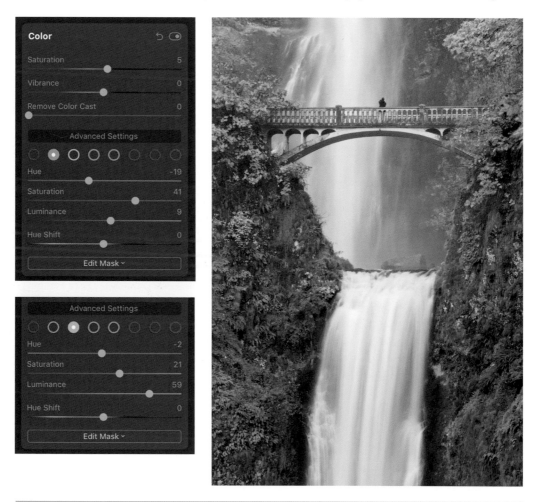

FIGURE 3-7: I use the color channels controls so often that I wish they weren't hidden behind Advanced Settings.

Be Careful Editing Late at Night

If you stay up late editing photos, as I find myself doing frequently, your computer may be giving you the wrong impression when it comes to white balance.

Features designed to help your eyes actually work against photographers. On the Mac, Night Shift automatically warms the entire screen at a predetermined time to cut down the blue light that some people believe contributes to eye fatigue and difficulty sleeping. Under Windows, this feature is called Night Light.

These features can be great for your eyes, but terrible for editing photos! How many times have I adjusted the white balance of a photo and then realized that it was actually way out of whack due to Night Shift? Too many to count.

So, either turn off the features entirely or check to make sure they're not active when you're editing photos. (Or stop editing late at night, but I can tell you that won't happen in my case.)

Draw Attention Away from the Rocks

I like how this is turning out, but take a moment and pay attention to where your eye travels through the image. You probably start at the figure on the bridge (because we're good at spotting other humans, particularly when it's the only person in the photo) and to the orange leaves (because we're drawn to color). Then the waterfalls pull our attention down (because they're bright and evoke movement), right to…that patch of rock at the left.

A few options present themselves. I could see if the Erase tool or Clone & Stamp tool could replicate the foliage and fill in that spot. I could crop it out, but then I'm losing a chunk of that beautiful waterfall. Or, my preference, I could darken the areas so they aren't as prominent.

To do that, I'll use the Dodge & Burn tool in the Professional group. And because I'm done with my basic tone and color edits, I'll do it on a separate adjustment layer, like so:

1. I'll switch to the Layers panel, click the Create Layer (⊕) button, and choose Add New Adjustment Layer (**Figure 3-8**). Now, any further edits are stored on that layer. Since it's an adjustment layer, it doesn't contain any pixels—its edits apply to the layers below it, in this case the base image layer.

2. With that in place, I'll click the Pro button and then expand the Dodge & Burn tool (**Figure 3-9**).

FIGURE 3-8: Subsequent edits will appear on a new adjustment layer.

FIGURE 3-9: The Dodge & Burn tool seems to be lacking controls…or is it?

3. Unlike tools such as Light that affect the entire image, this tool is designed to paint areas to make them lighter (dodge) or darker (burn). Clicking the Start Painting button enters the tool's interface, which includes a toolbar above the image for controlling the brush settings. I'll click the Darken button and then set the Strength to a low value like 20%, because I want a subtle effect. I'll also increase the size of the brush.

4. With a few strokes in the lower-left corner of the image, I can minimize the visibility of the rocks **(Figure 3-10)**. I'll also do the same in the lower-right corner for balance.

5. When it looks good, I'll click Done in the toolbar to exit the Dodge & Burn editing mode.

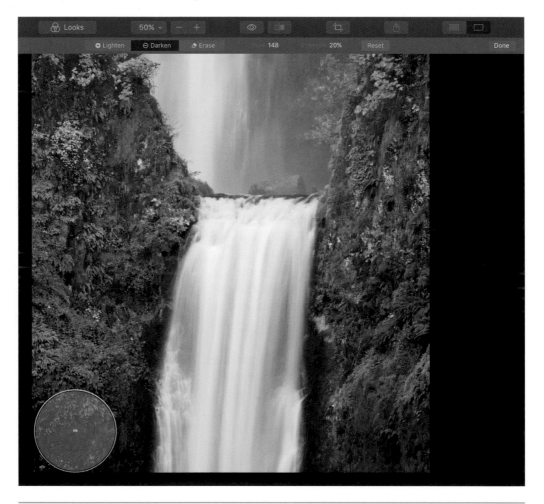

FIGURE 3-10: Painting with the Dodge & Burn tool allows me to darken the rocks.

Adjust the Waterfalls

Now we're nitpicking, but I'd like to brighten the waterfalls and subtly cool their temperature. When I adjusted the tone at the beginning of this process, the brightness of the waterfalls required a lot of back-and-forth adjustments between Exposure, Whites, Highlights, and Shadows to make sure I wasn't overexposing the image. I don't want to get into all that again, and with a luminosity mask I don't have to.

In the Layers panel I'll create another new adjustment layer. Before switching to the editing tools, however, I'll click the Edit Mask button and choose Luminosity **(Figure 3-11)**. That creates a mask over the entire image that's based on the brightness of the entire image. Lighter areas, such as the waterfalls, will receive most of any edits I apply, while darker areas are largely unaffected.

To adjust the waterfalls, I'll go back to the Light tool. Since this is on a separate adjustment layer, all the Light controls are reset to zero. I'll increase the Whites value significantly **(Figure 3-12)**. Notice that the water gets brighter, but the rest of the image doesn't; that's especially noticeable in the histogram, where the tones at the right side increase, but don't go past the edge.

I'll also take this opportunity to drop the Temperature slider slightly to counteract my white balance edits earlier in the water.

FIGURE 3-11: Any edits on this layer will show through only the masked areas.

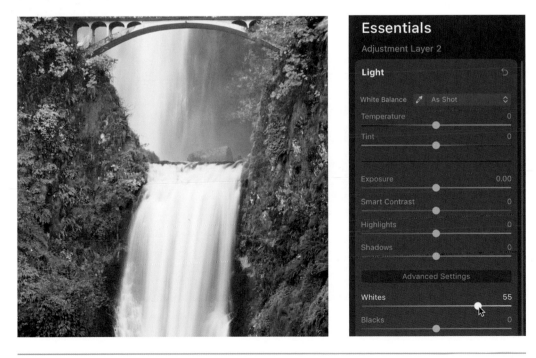

FIGURE 3-12: Pushing the Whites value this much would normally brighten everything, but the luminosity mask restricts the edit to just the lightest areas.

Add Effects and Final Touches

We're almost done, but a few things still catch my eye. When I boosted the orange tones, it oversaturated a few spots: a clump of leaves at right, and some rust spots on the bridge. I'm also curious to see what a couple of small effects might have on the final image.

I'll create another new adjustment layer, rename it "Fix Orange and Effects" (because it's helpful to start naming layers once you get beyond two or three), and then go to the Color tool in the Essentials group. I'll reduce the Saturation slider until those hot spots are muted. That has the effect of killing the saturation throughout the image, so the next step is to create a tool-specific mask for just the Color tool: click Edit Mask and choose Brush.

I'll paint on the oversaturated spots to create the mask. Only the areas I paint are desaturated **(Figure 3-13)**. When finished, I'll click Done. I can always edit the mask later by choosing Brush from the Edit Mask submenu within the tool.

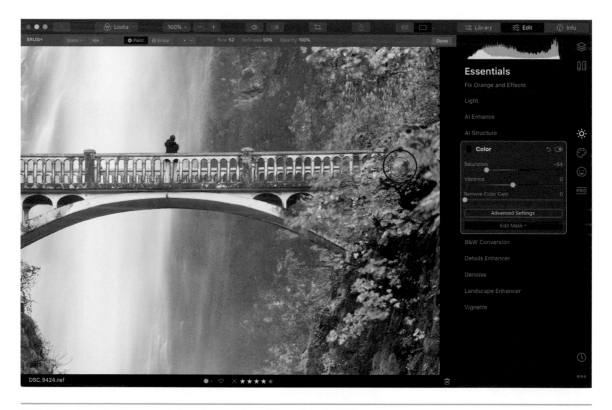

FIGURE 3-13: I can desaturate spots by using a tool-specific mask in the Color tool.

While we're on this layer, I want to throw in a subtle vignette. Although I darkened the bottom corners to draw attention away from the rocks, the top corners seem a little bright still. Also, I find that a small amount of vignette helps to draw attention to the middle of the photo and to add some saturation without specifically adding Saturation.

In the Vignette tool, I'll set the Amount slider to a negative value, and, under the Advanced Settings, increase the Feather control **(Figure 3-14)**.

Since the mask I created was only for the Color tool, the Vignette tool's effects apply to the entire image.

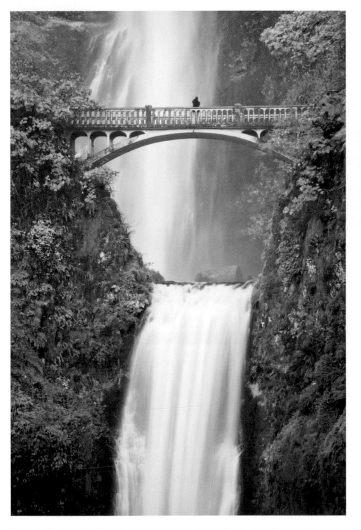

FIGURE 3-14: Adding a subtle vignette balances the tones of the top corners with the bottom ones.

Enhance Details

The last thing I'll do to this photo is enhance the details. I'll create a new adjustment layer, rename it to Sharpening, and open the Enhance Details tool.

For this image, increasing the Small Details slider does what I want: give some definition among all the leaves and small details, so they don't appear as soft smudges **(Figure 3-15)**. It's not a big change, but not every edit needs to be.

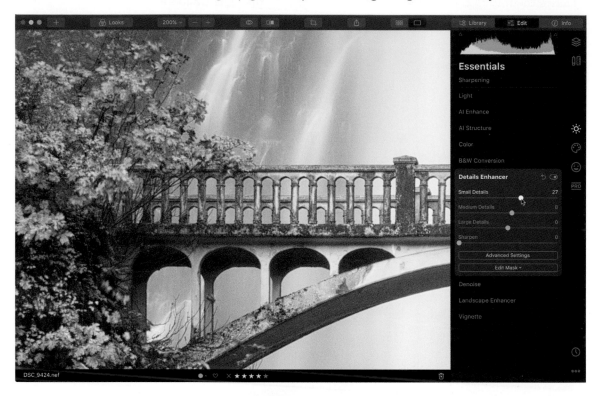

FIGURE 3-15: The most important thing about adjusting details is to use a light touch.

Remove the Person

For the sake of argument, let's say we decide that the person on the bridge is too distracting. Or perhaps you have a photo in which some item is drawing the viewer's attention, such as a piece of garbage on the ground or power lines in the air.

The Erase tool intelligently repairs areas. However, as you'll hear me mention a few times throughout the book, notice that I've saved this step for last. That's because Luminar creates a new image layer—a pixelated copy of your image on a layer—to apply the fixes. (I describe this in more detail in Chapter 6.)

In the set of Canvas tools, I'll select the Erase tool, which opens the Erase interface. With the mode set to Add (meaning, I'm adding new areas to be erased, which is a little confusing), I choose a brush size and then paint over the person **(Figure 3-16)**. You can paint multiple areas before making the edit, such as when you're removing dust spots from an image. I then click the Erase button to apply the erasure.

To be honest, I'm surprised at how well the Erase tool did its job. Earlier versions of the tool in Luminar were lacking, but it gained a significant improvement in version 4.1.

Before and After

If I was a stickler for getting every shot correct in-camera, I would have skipped right past this image. However, knowing what Luminar can do, I've taken a dark, blue original and turned it into a bright, autumnal photo that makes me remember what I saw and felt on the day I captured it.

Clicking the Quick Preview (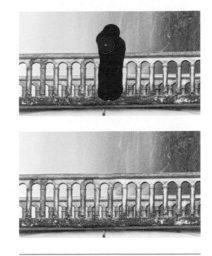) button or the Compare () button in the toolbar reveals the before and after versions **(Figure 3-17)**.

FIGURE 3-16: A single pass of the Erase tool does a pretty good job of removing the person on the bridge.

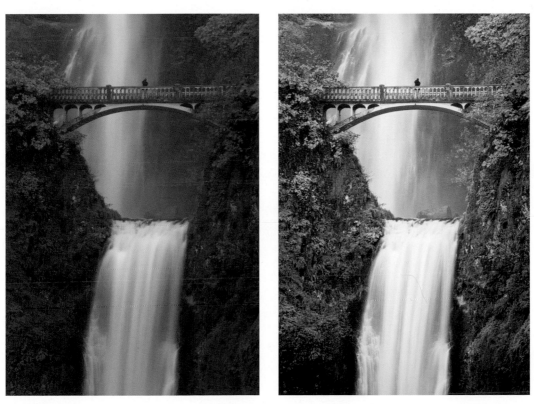

FIGURE 3-17: By manipulating data that was always there, the edited image at right is more natural and vibrant.

Portrait Walkthrough

The first thing to remember about portraits is that they're still regular photos that need basic adjustments to tone and color. They just happen to contain one or more people as the main subjects. And for that, Luminar offers some extra tools.

You may also find yourself doing more correction using the Erase or Clone & Stamp tools to remove skin blemishes, dust or hair on clothing (which I swear always appears, no matter how much you brush before taking the photo), and to make other small fixes.

In this chapter, I'll walk through two portraits: one that needs only a few edits and one that I've deliberately chosen precisely because it requires more work.

Evaluate the First Photo

As you can see, I was going for a dark, mysterious look for this photo, which is evident in the histogram weighted so far to the left **(Figure 4-1)**. Subsequent shots were more brightly lit, but I liked the man's expression the best in this exposure. Specifically, I can see a few other issues I need to address:

- His right eye is almost entirely hidden in the shadows on that side of his face, which makes his gaze less interesting, especially since he's looking straight at the camera.

- His eyes, being so shadowed, need more life to them. If you look closely, a catchlight is reflected there, but I want to draw more attention to them.

- That spot on the background over his shoulder at the right will haunt me until I erase it, but I need to wait until the end of the editing process to deal with it. A few other spots and threads need to be erased, too.

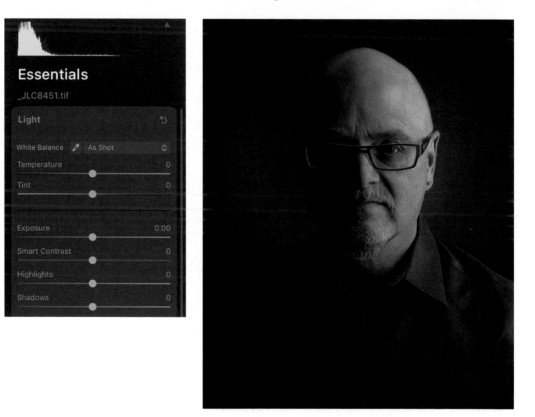

FIGURE 4-1: The original, unedited image.

Edit Tone and Color

A dark photo like this is a great example of a shot you wouldn't want to flood with a high Exposure setting, because it would push everything to gray.

Instead, I'll push Exposure up slightly and use the Shadows and Whites controls more liberally to open up the tones **(Figure 4-2)**.

Those adjustments can overexpose the bright side of his head, so I made sure to turn on the white clipping indicator and then lowered the Highlights slider to compensate.

Lastly, I warmed the photo slightly by increasing the Temperature slider. The skin tones are no longer as cool, but the value isn't high enough that it introduces yellow into his shirt or the background.

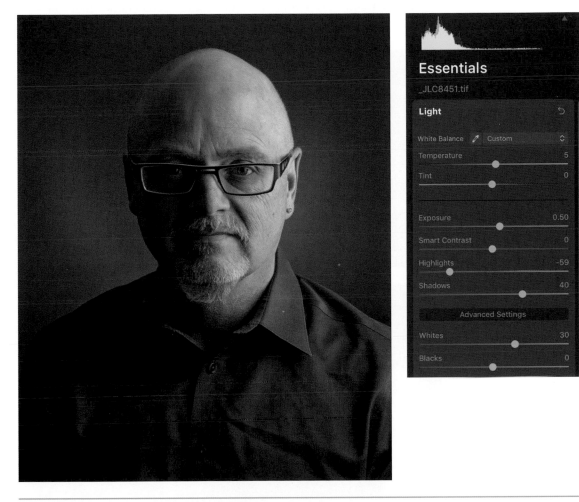

FIGURE 4-2: I've hit the basic tone and color adjustments using the Light tool to get started.

Enhance the Skin

With any portrait of someone, I want the image to be flattering, which in many cases includes smoothing the person's skin. That's not the same as removing wrinkles; the amount of retouching depends on the circumstances.

I prefer to work on facial edits on their own layer, so I'll create a new adjustment layer in the Layers panel and then switch to the Portrait group. After zooming in to 100% view to get a better idea of what the tool is doing, I'll open the AI Skin Enhancer tool and drag the Amount slider about midway **(Figure 4-3)**.

Setting the value to 100 usually looks plastic to me, so I'll settle on 75. Looking closely, you can see that the skin looks more flattering, but it still has the wrinkles and texture that make it interesting. Also notice that the hairs in his mustache and goateé are still crisp.

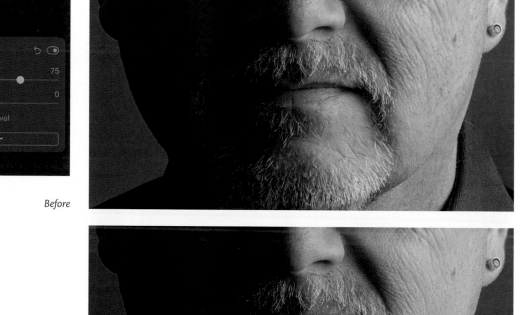

Before

After

FIGURE 4-3: The AI Skin Enhancer smoothes skin, but leaves important texture in place.

Enhance the Face

The "AI" in the name of the AI Skin Enhancer refers to artificial intelligence that can determine which area of the photo contains a face. The same technology is used for the Portrait Enhancer tools; if Luminar can recognize a face, after all, it can figure out which areas are eyes, a mouth, and other features.

I mostly want to improve the eyes, so I'll increase the Eye Enhancer, Eye Whitening, and Dark Circles Removal controls (**Figure 4-4**). The amounts are highly subjective, and depend on the photo, but I find that I don't need to be shy about using them. A high Eye Enhancer value, in particular, adds the pop I'm looking for.

I often use the Face Light slider to cast a little illumination on the entire face. I'll also increase the Eyebrow Improve slider to darken them slightly.

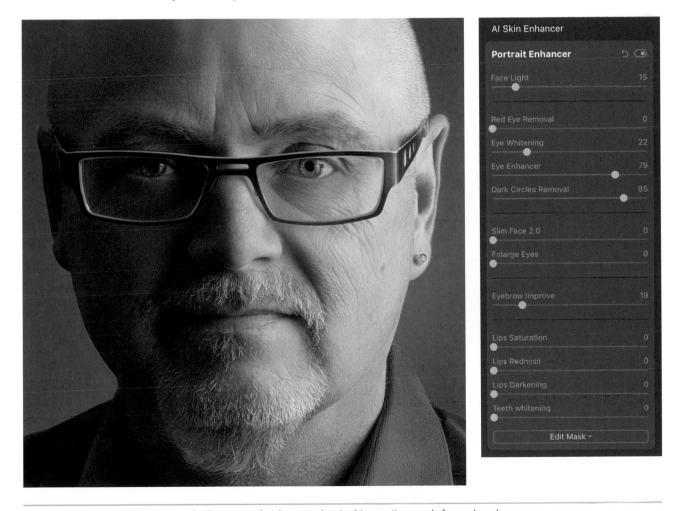

FIGURE 4-4: The Portrait Enhancer tool affects many facial aspects, but in this case I'm mostly focused on the eyes.

Apply Spot Touch-Ups

Now I can finally eradicate that spot in the background. In the Canvas tools, I'll click the Erase tool to open the Eraser interface. I've saved this step for last because Luminar creates a new image layer containing all the existing edits when you use the Erase or Clone & Stamp tool.

Working at 200% view, I'll use the bracket keys ([and]) to resize the eraser and click or paint over the spots that need to be removed. Beyond the background blotch, I noticed a stray hair on his collar, a blown pixel on his forehead, and a few bits of dust on his shirt **(Figure 4-5)**. When they're all selected, I'll click the Erase tool, and then check each one to make sure the results are acceptable. If they're not, I'll choose Edit > Undo and refine the selections.

If I wanted to go after wrinkles, I could also do that with this tool, though the Clone & Stamp tool is often a better option for that task. As long as the Eraser tool is still active, I can continue to find and remove spots until I click the Done button. If I found a spot I missed, using the Erase tool again would create a brand new image layer; it's not possible to tweak the erasures you already made.

FIGURE 4-5: The touch-up areas are erased only when you click the Erase or Done button in the toolbar.

First Photo Before and After

This portrait was dark and lifeless to begin with, but honestly it didn't require much work **(Figure 4-6)**. I still have the dark, mysterious photo I'd intended, but the exposure is better, the eyes are much improved, and that darn spot is finally gone. (Obsessed? Me?)

One advantage to the edits I made is that I could switch to the gallery mode, select all the shots around this one, and sync these edits to those other photos by choosing Image > Adjustments > Sync Adjustments and save myself a lot of time.

Or, if I'd made all the edits on the base image layer, I could create a new Luminar Look that would let me apply this same result to any future photo with a click. Since the portrait edits are AI-based, it wouldn't matter if my subject moved or was larger or smaller in the frame, because Luminar finds the face and applies the edits to those areas.

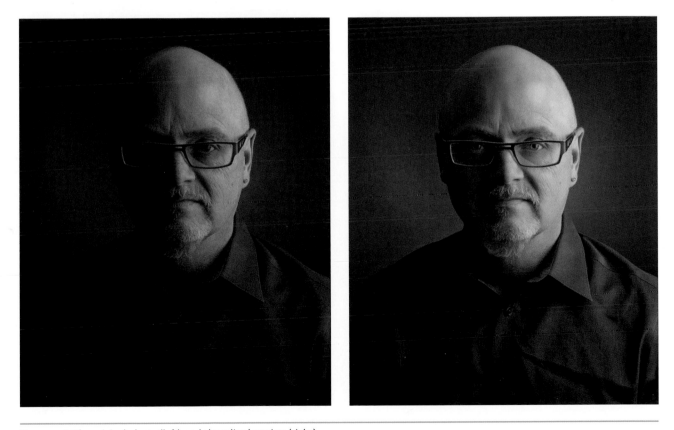

FIGURE 4-6: The original photo (left) and the edited version (right).

Evaluate the Second Photo

Ideally, for this photo I would have brought a flash or even a reflector to illuminate the subject **(Figure 4-7)**. Instead, this shot came about when we drove past a sunflower field just before sunset and decided to stop and take some quick photos. I exposed for the sky to keep it from blowing out to white with the hope that I'd be able to coax the colors out of the shadows. This image is by no means ideal, which makes it a great example for what you can do in Luminar. Looking at the histogram, there are peaks at both the dark end (left) and bright end (right). Let's jump in and discover what needs to be done.

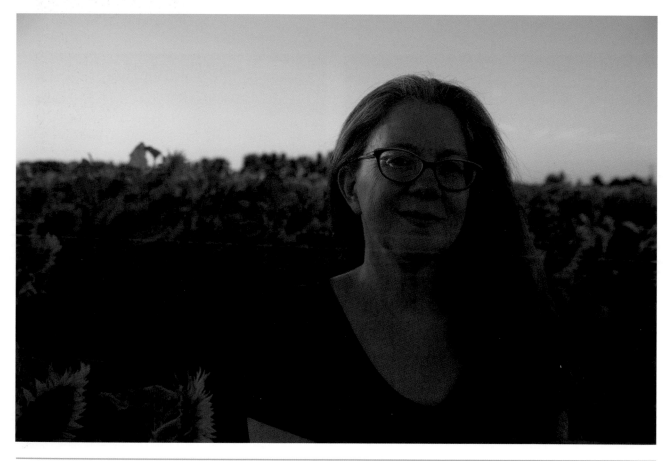

FIGURE 4-7: Oh, this is going to be fun.

Let Luminar Do (Much of) the Work

For the previous portrait, I chose to manipulate the Light controls to have more control over the shadows and highlights. This time, I'll throw AI Accent at the photo, using nearly the maximum value **(Figure 4-8)**.

The rest of the editing will be on the woman herself, so while I'm here in the Essentials group, I'll perk up the yellow leaves on the sunflowers using the Color tool: clicking Advanced Settings and increasing the Luminance and Saturation sliders for the yellows.

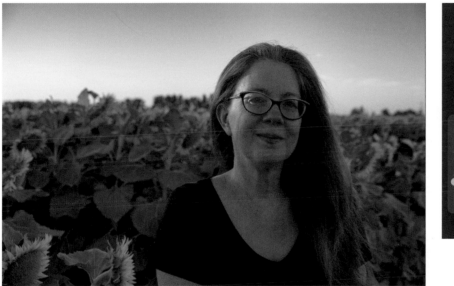

FIGURE 4-8: If she weren't still deep in shadow, this photo edit would be almost complete using one slider.

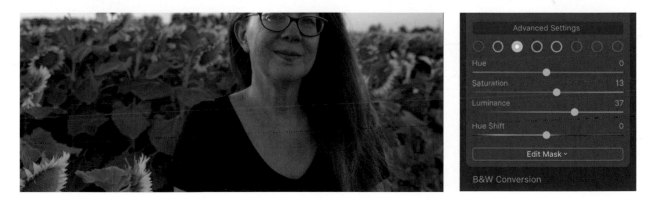

FIGURE 4-9: Sunflowers don't deserve to be as muted as they were above, so I've increased their luminance before moving on.

Enhance the Skin and Face

For the Portrait tools, I'll create a new adjustment layer and rename it to keep my layers orderly (which means I'm less likely to spend two minutes clicking around trying to figure out which layers have which edits). Next, I'll zoom in on her face, open the AI Skin Enhancer tool, and set the Amount slider to 50, which looks pretty good to me.

As always, it's the eyes that draw our attention, so in the Portrait Enhancer tool I'll increase the values for the "Ocular Trinity": Eye Whitening, Eye Enhancer, and Dark Circles Removal **(Figure 4-10)**. (I know, the Red Eye Removal tool is in the same category, but it's needed so rarely that I don't pay attention to it.)

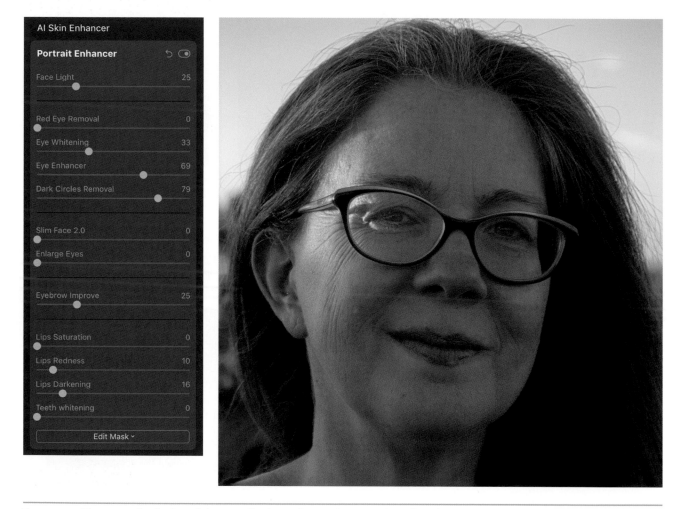

FIGURE 4-10: These portrait edits haven't been as effective as the ones in our previous photo because she's still dark, but trust in the process.

Her face is still dark, obviously, and although I turn often to the Face Light control, I'm going to use it sparingly this time. Why? The AI looks only for a face, and in this photo her neck and upper chest are prominent; turning up the Face Light could make her look like she's wearing clown makeup.

Brighten the Subject

Already this photo is much improved, but the subject is still too dark. Granted, she's in shadow, but she's also the sole focus of the image, and we want to see her more prominently.

There are a few ways I could go about this, such as increasing the exposure and using a mask to protect the background. However, I'm going to take a less conventional approach that (a) delivers a better result in my testing and (b) reveals more of Luminar's capabilities.

FIGURE 4-11: We need a stamped layer to pull off this next edit.

1. In the Layers panel, I'll click the Create Layer (⊕) button and choose Create New Stamped Layer **(Figure 4-11)**. A new image layer appears, which incorporates all of the edits in the layers below it. Visually, the photo is unchanged.

2. From the Blend pop-up menu in the stamped layer, I'll choose Screen **(Figure 4-12)**. The blend mode dictates how pixels on the current layer interact with those below it. In this case it brightens everything, washing out the sky in the process **(Figure 4-13)**.

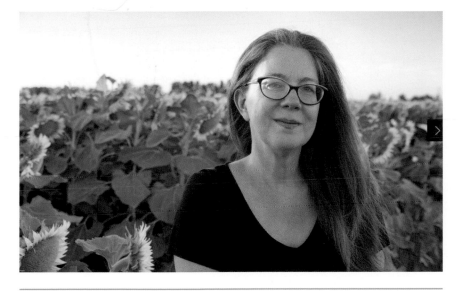

FIGURE 4-13: Changing the blend mode increased the exposure in a natural-looking way.

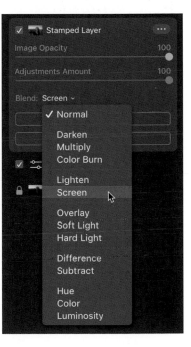

FIGURE 4-12: The Screen blend mode quickly lightens the entire photo.

FIGURE 4-14: Enable Show Mask to see your brush strokes if needed.

3. While still in the Layers panel, I'll click the Edit Mask button and choose Brush to create a mask for the entire layer.

4. It can be helpful to click the Show Mask (👁) button in the toolbar to better see which part of the layer is visible, marked in red as I paint over the woman **(Figure 4-14)**. Click Done.

5. Since the screened version is obviously lighter, I'll paint the rest of her without the mask visible **(Figure 4-15)**.

6. The effect looks a little too bright to me, so I'll lower the Image Opacity slider in the Layers panel to 80 and reveal some of the darker version underneath.

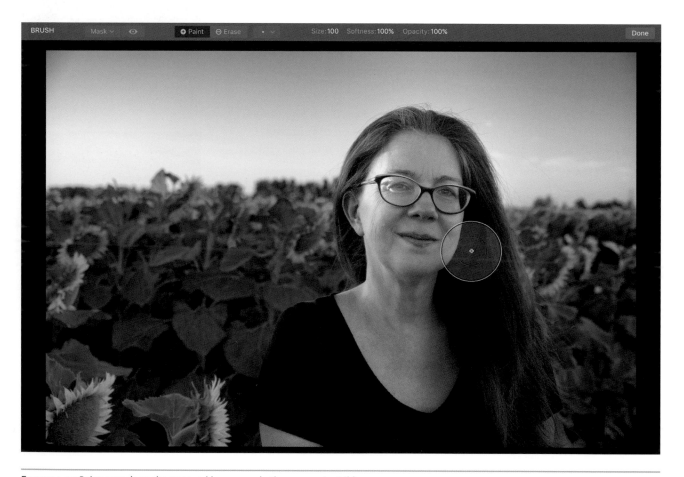

FIGURE 4-15: Paint a mask on the stamped layer so only the woman is visible.

Correct Skin Tones

She's still a little pale, and the skin on her upper chest is flushed, which is distracting. To warm up her overall color, I'll switch to the Light tool and bump the Temperature up to 10.

To minimize the flushed skin, I'll need a new adjustment layer. But first, I need to copy the layer mask that's on the stamped layer by clicking the Options (●●●) button and choosing Mask > Copy. Next I'll create the new adjustment layer, click the same Options (●●●) button, and choose Mask > Paste. A small mask thumbnail appears next to the layer name **(Figure 4-16)**.

I'll open the Color tool, choose Brush from the Edit Mask button, and paint over the exposed skin area **(Figure 4-17)**. I'll click Done to exit the mask interface.

With the area masked within the tool, I'll return to the Color advanced settings, select the Magenta color at the far right, and increase Luminance and decrease Saturation **(Figure 4-18)**. I'll do the same with the Red color to reduce the coloring and blend it with the rest of the skin.

FIGURE 4-16: The copied mask is exactly the same on both layers.

FIGURE 4-17: This mask applies only to the Color tool.

FIGURE 4-18: Adjusting the Saturation and Luminance values of the Magenta and Red colors has reduced the coloring.

Fix the Eye Reflection and Apply Touch-ups

FIGURE 4-19: The reflection draws attention away from her eye.

Now it's time to correct the tiny details. Something odd is happening with the eye on the left: zooming in reveals it's the reflection of the arm of her glasses **(Figure 4-19)**. Although that's a legitimate reflection, and not an issue with the lens or sensor, it's still distracting. For that and a few other spot edits, I'm going to choose the Clone & Stamp tool from the Canvas group.

Unlike the Erase tool, where you paint over a spot and the software figures out how to fix it, the Clone & Stamp tool lets you define a source area and copy those pixels to a new location.

In this case, the best source is her other eye. In the Clone & Stamp interface, I'll first click the center of her eye on the right, and then resize the brush to a small diameter. Using a few single clicks within the eye on the left, I'll copy the pixels from the other eye **(Figure 4-20)**.

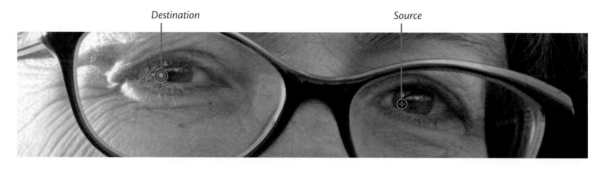

FIGURE 4-20: Here I've set the eye on the right as the source and am clicking the eye on the left to copy its pixels.

While I'm in this mode, I'll also patch some spots with irregular pigmentation. However, as you'll notice when moving the brush, the source and destination always keep the same relative distance from each other. So, to redefine a new source (clone), I'll Option/Alt click near one of the spots that shares the tone and color I want for the replacement. Then I'll click on the spot itself to paste (stamp) those pixels **(Figure 4-21)**. When you're working with this tool, it's common to redefine the source often.

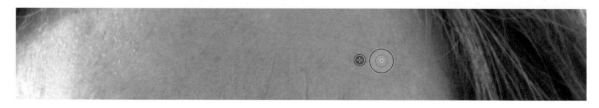

FIGURE 4-22: Option/Alt-click to define a new source area, and then click to stamp those pixels on the area you're fixing.

Second Photo Before and After

When I first chose this image as an example, I didn't know if it would work at all, but I really like how it turned out **(Figure 4-22)**. Yes, you should always strive to capture great exposures in-camera, but sometimes you shoot what you can knowing that Luminar will bring the best attributes out of the data.

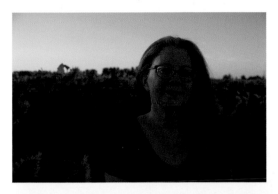

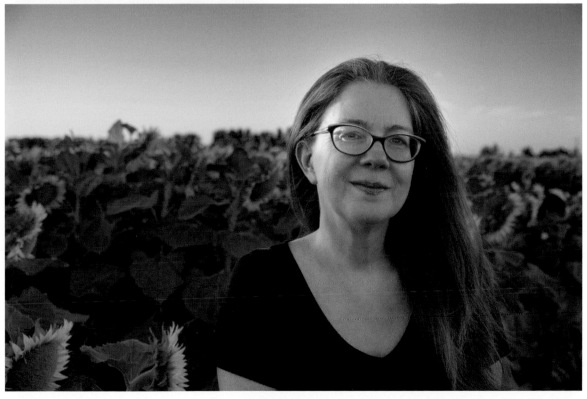

FIGURE 4-22: I'm detecting a subtle difference between the original shot (top) and the edited version (bottom).

Editing Tools

Here we go. The editing tools are the essence of getting great-looking photos in Luminar, so the Edit panel is where you'll spend most of your time. The number of available tools can be intimidating, but here's why I like Luminar's approach: would you rather have all the options available in one place, or scattered and hidden behind several menus and dialogs that have accrued over the years? (Not that any specific application comes to mind, *cough cough*.)

Being the curious reader I imagine you to be, you've probably already explored the Luminar interface. And if you've been reading this book from the beginning, you've seen the tools in action in the editing walkthroughs. Now it's time to dig into all the controls and how they affect your photos.

However, let's quickly cover some fundamentals, and take an essential detour through one of the most important tools you'll use while editing: the Histogram.

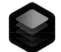

FIGURE 5-1: Access the five groups of tools at the right of the Edit panel.

FIGURE 5-2: You love sliders? Great! Luminar has sliders for everything.

Editing Tool Fundamentals

The power of the editing tools is the ability to experiment with settings until you reach the look you want. Remember, the tools are non-destructive, so you can't hurt the original image.

All of the editing tools reside in the Edit panel: click the Edit heading in the sidebar or press the D key. (Why "D?" Because if you've used Lightroom Classic in the past, it's the shortcut key to open the Develop panel, and muscle memory is a powerful thing. The first time I opened Luminar, in fact, I hit the D key out of habit, and it just worked.)

The main editing tools are split among five groupings, accessible by clicking the icons to the right of the Edit panel: Essentials, Creative, Portrait, and Pro **(Figure 5-1)**. You may also see the Deprecated group, which contains tools that still work in Luminar 4 but are no longer in the four main groups due to the reorganization between versions 3 and 4. Hover the pointer over an icon to reveal the name until you get accustomed to the icons.

In addition, you access the Canvas tools in the Edit panel, which include tools for cropping and rotating, erasing blemishes, cloning and stamping to fix problematic areas, and the lens and geometry tools. The Canvas tools are covered in Chapter 6.

Tool Controls

Most controls in each tool are sliders: move the slider right to increase an effect or left to decrease it **(Figure 5-2)**. As you do, the image adjusts in real time based on your action. You can also manipulate the setting in several other ways:

- Click the number to the right of the slider and type a value if you know exactly which setting you want.

- Instead of typing, which moves your hands off the mouse or trackpad, click the number and drag left or right to change the amount in small increments.

- Double-click the slider or the slider's name to reset the value to its original amount.

- On some tools that offer them, click the Advanced Settings button to reveal more related controls.

- To set all the controls in a tool to their original values, click the Reset button () that appears to the right of the tool name.

- As you edit, you may want to see what the image looks like without a tool applied. Position your pointer over the tool's title bar and click the Visibility button (■) to temporarily disable the effect without deleting it. Click the button again to activate the tool.

Edit Tools, Layers, and Blend Modes

Even though edits are easy to apply, it's important to understand a few conceptual twists regarding layers and blend modes.

First up: layers. I cover this in more detail in Chapter 8, but here's the gist. When you're working with two or more layers, each one contains its own tools—potentially *all* of the tools. That construction seems confusing the first time you add an adjustment layer and discover that your settings in the sidebar seem to have disappeared! They're not gone, just hidden; you can return to editing them by selecting the layer on which they appear.

For example, on the base image layer you may adjust the AI Enhance tool (in the Essentials group) and also apply the Glow tool (in the Creative group). If you then create a new adjustment layer, the AI Enhance and Glow tools are reset to zero, but only because you've started with the new layer. All of the tools are available for that layer, and you can apply several tools to a layer.

Think of tools and layers as a combination of how Lightroom and Photoshop apply edits. In Lightroom, adjustments apply to the entire image, but operate independently. In Photoshop, you can make separate adjustment layers for each type of edit.

To further muddle things, a few tools, such as Erase, put their results on new image layers automatically, as you'll see in Chapter 6. Such is the burden of having a lot of editing power in one application.

If that's not enough, each tool can also have its own mask, so the tool's effect applies to only a portion of the image. Masking is covered in Chapter 9.

This will all become clear as we dig into it, I promise.

Editing Tool Differences between Luminar 4 and Luminar 3

Skylum did away with the workspaces architecture in the move from Luminar 3 to Luminar 4, but it wasn't the only casualty. In version 3 and earlier, every filter could have its own blend mode, in addition to its own mask. You could also duplicate filters to stack their effects.

In Luminar 4, those tasks have been pushed to the layer controls. It's still possible to apply blend modes and duplicate edit tools, but the mechanism now is to create new adjustment layers for them.

Also moved to layers is the ability to set the opacity of the tools' effects. Luminar 3 had a master slider at the bottom of the workspace that could affect the overall impact of the current layer's filters. In Luminar 4, again, you create an adjustment layer, apply edits to it, and then change the opacity of that layer.

Understand the Histogram

The histogram seems as far removed from an image as you can get, but I encourage you to work it into every aspect of your photography—especially when shooting. In Luminar, it reveals the intensity and frequency of tones and colors in the open image, and sometimes alerts you to problems that aren't obvious when you're viewing the image itself. For instance, there's a difference between a very dark area of an image and one where the pixels are completely pushed to black. In the former instance, you may be able to recover some much needed detail or texture by increasing the exposure or shadows values; in the latter, you're stuck with a swathe of black that can't be rescued.

If it's not already visible, choose View > Show Histogram, or click the More button () at the bottom-right corner of the sidebar and choose Show Histogram.

How to Read the Histogram

The left edge of the histogram represents the darkest pixels in the image, pure black. The right edge is the bright opposite, representing pure white. Everything in the middle is a gradation between the two extremes. Each vertical bar in the histogram refers to the relative number of pixels of those intervening values **(Figure 5-3)**.

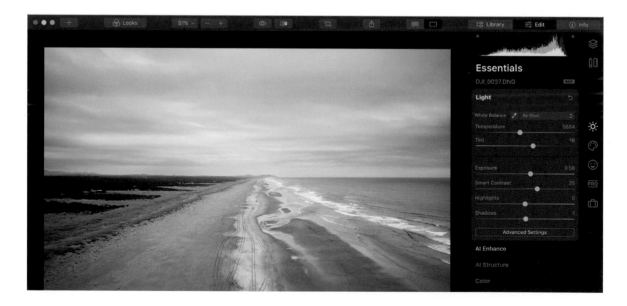

FIGURE 5-3: The histogram reveals the intensity of tones and colors in your image.

The histogram also shows the occurrence of red, green, and blue pixels (RGB), the foundation of how screens display color. Click the middle of the histogram to cycle through each color channel **(Figure 5-4)**.

In practice, when looking at the histogram, keep your eyes sharp for three things:

- **Clipped dark areas.** When a series of pixels are pure black, you'll see levels pushed against the left side of the graph. The term *clipped* refers to making an adjustment that takes non-black pixels and makes them completely black, such as lowering the image's overall exposure value; the pixels could have also been underexposed when the shot was made. Click the triangle at the top-left corner of the histogram to reveal those areas in your image, displayed in blue **(Figure 5-5)**.

- **Clipped highlights.** Similarly, areas that are pure white show up pressed against the right side of the graph. Click the triangle at the top-right corner to reveal clipped highlights in red.

- **Distribution of tones.** *In general*, the histogram for a well-exposed photo looks like a bell: low on the dark and light edges, high in the middle. That often translates to having good shadow detail and no extremes at the dark or light ends. I'm hedging my description here, because every photo is different—sometimes you want a moody shot to be underexposed at the edges in order to spotlight a well-lit subject, for instance.

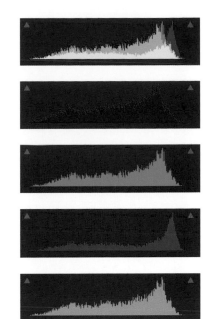

FIGURE 5-4: Click the histogram to cycle through the distribution of colors (from top): combined, red, green, blue, and brightness (which is not a color, but you get the idea).

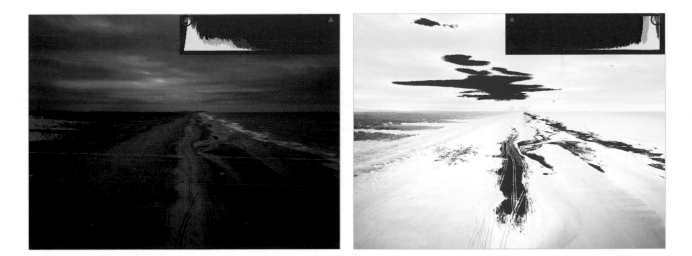

FIGURE 5-5: Click the triangles in the histogram to reveal clipped blacks in blue (left) and whites in red (right).

As you make adjustments to a photo, the histogram changes to reflect them. Notice how the photo appears compared to the histogram. If the image looks fine on a bright, backlit LCD screen, but the histogram reveals that there's more data on the left (dark) edge than on the right (light) edge, the image is likely underexposed and will appear too dark when published online or printed.

Essentials Tools

This is the panel you'll turn to first and most often for making adjustments. In fact, you could probably use only these tools on your photos and get great results.

It's important to note that, unlike Luminar 3 and earlier, there aren't separate controls for raw and JPEG or HEIC images, as was the case with the Develop filters in particular. When you're working on a raw image, some tools reveal extra raw-specific controls.

Raw, JPEG, and HEIC Differences

A raw file, as the name suggests, contains the unprocessed data captured by the camera's sensor. An application like Luminar needs to first read that data and create—or *develop*, harking back to film terminology—a version of the image with colored pixels reflecting what was recorded. That data is malleable, and aspects of it can be adjusted during the development process, such as compensating for characteristics unique to the lens used to capture the photo, like distortion or chromatic aberration.

Some applications handle raw development as a separate step that must be completed before you can move on to other edits. Luminar doesn't split the tasks that way; adjustments can be changed whenever you like.

A JPEG or HEIC (the format generated by the iPhone and a few newer cameras) image, by contrast, gets developed in the camera immediately after the image is captured. The camera's processor determines the tone and color, and then it compresses the image file so it occupies less space on the memory card. Unfortunately, that compression is *lossy*, meaning the camera is discarding image information that could otherwise be used during later editing.

That's not to say JPEG or HEIC images are bad—far from it. There's still a lot of data for Luminar to work with. Raw files just give you more editing latitude. If you capture in RAW+JPEG format, you get a copy of each: the raw file for the most editing flexibility, and a JPEG that can be shared easily from the camera in some cases, or that applies film or effect simulations, such as in-camera black-and-white processing.

Adjustment Layers

Allow me to make an early pitch for using adjustment layers. My editing in Luminar has evolved from when I first jumped into earlier versions of the app. I like that I can use all the tools I need with just the image layer selected in the Layers panel. For many photos, that's all I need to do.

However, that leads to a situation where all of my editing eggs are in one basket.

If I know I'll be using multiple layers at the outset, I'm more inclined to apply edits by creating adjustment layers.

So, for example, I may do my exposure work on the original image layer, and then do any portrait editing on a separate adjustment layer. Or, let's say my shot includes some dust spots in the sky that I want to eradicate. The Erase tool takes care of those, but with a significant qualification: Luminar creates a new *image layer* based on the state at which I started using the tool, burning all the filter settings into that layer. If I want to change a setting I've already applied, I have to return to the original image layer, make the change, discard the new image layer created by the Erase tool, and fix the spots again with the Erase tool.

I don't make a new adjustment layer for every filter I want to apply—although you can certainly do that—but I do tend to group filters into a few adjustment layers to give myself the most flexibility. And I try to leave any erasing and cloning until the end of the edit process.

Light

In general, the Light panel's controls affect the brightness and contrast of an image. However, this is also where you'll find two controls that affect color: White Balance, presumably because it's a more convenient location than tucked into its own separate tool, and Curves, which can be used to modify colors as well as tones.

White Balance

When we refer to white balance, we're really talking about how warm or cool a photo is, represented as *temperature*. The term comes from how that warmth is measured: If you have something in your picture that's pure white, such as a piece of paper, the image's warmth can be adjusted based on what the software understands to be "white."

This control is necessary, because white balance can get thrown off by all sorts of things. Cloudy days tend to be more cool; most indoor lighting isn't actually white; the angle of the sun affects color temperature; and so on. You may have set Auto White Balance on your camera, in which case the camera attempts to come up with the correct temperature for every shot, or you may have specified a setting for the conditions, such as Cloudy.

When you bring your photo into Luminar, you have four ways to correct white balance in the Develop filters:

- **White Balance pop-up menu:** The default option here is As Shot, keeping the value set by the camera during capture. If the image is a raw file, the camera's white balance information is included in the file, and a set of camera-specific presets shows up in the pop-up menu. If it's not a raw image, As Shot is the only option.

- **Eyedropper:** Select the Eyedropper tool () and click an area of your image that should be white or a neutral gray **(Figure 5-6)**. Luminar calculates the proper temperature based on that reading.

- **Temperature:** To adjust the warmth manually, drag the Temperature slider to the warmer (yellow) or cooler (blue) ends. For raw files, the value represents temperature in degrees Kelvin (K), from 2,000 to 25,000. For JPEG images, the default As Shot value is 0 and is represented as either a positive (warm) or negative (cool) amount. Even if you first use the Eyedropper tool to sample a value, you may find yourself adjusting the Temperature control to fine-tune the look. Sometimes, you may want to make a photo warmer or cooler depending on the look or mood you're going for.

- **Tint:** In addition to warmth or coolness, a photo's temperature can have a green or magenta color cast. Nudge the Tint slider in one direction or the other to compensate.

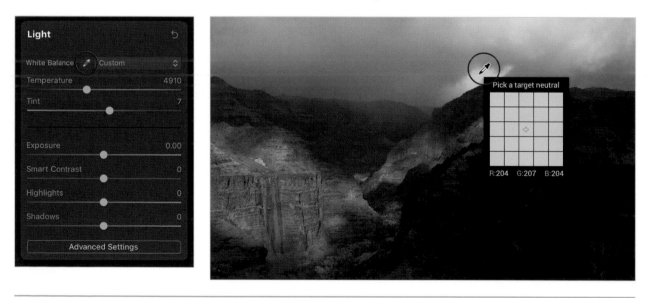

FIGURE 5-6: Use the eyedropper tool or the sliders in the White Balance portion of the Light tool.

Exposure

The Exposure control affects the overall lightness or darkness of an image, just as you expose more or less light to a camera sensor when you press the shutter button. It's a blunt tool that is often all you need to bring up the tones in an underexposed shot **(Figure 5-7)**, or to dial things down if the photo is too bright.

I find that unless an image is dramatically dark or light, adjusting Exposure in small increments works best. (Before you start cranking Exposure, though, see "Strategies for Adjusting Tone" a few pages ahead.)

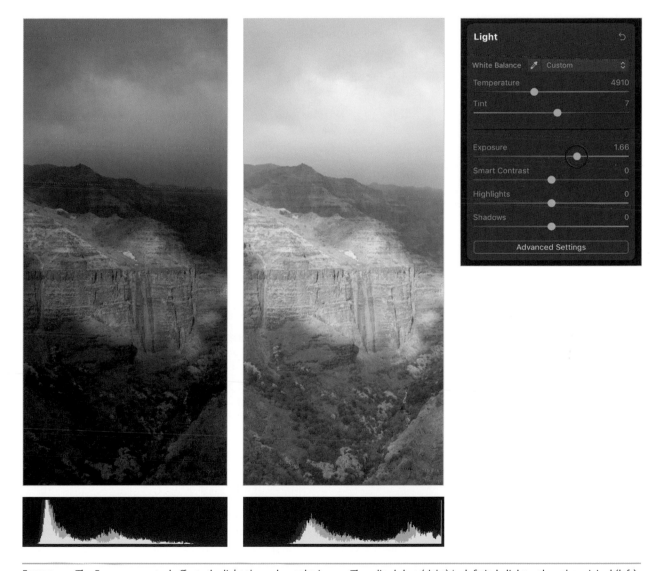

FIGURE 5-7: The Exposure control affects the light throughout the image. The edited shot (right) is definitely lighter than the original (left), but it's also washed out.

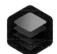

Smart Contrast

Contrast accentuates the difference between dark and light areas, particularly in midtones. Luminar's Smart Contrast control does so with more finesse than most implementations, which can often darken the image more than you'd like. When you increase the Smart Contrast value, look at the histogram: it stretches the values across the graph, making light areas lighter and dark areas darker **(Figure 5-8)**. Moving the slider to the left pushes the values, and the histogram, closer together, resulting in a faded, more uniform appearance.

FIGURE 5-8: Smart Contrast pushes tones to their extremes, though the "smart" in the name keeps the adjustment reasonable.

Highlights

The Highlights control is most often used to tamp down the brightest areas in an image; it's great for pulling detail out of clouds, for example **(Figure 5-9)**. If you've increased the exposure to the point where a few areas are blown out (turn on the clipping indicator in the histogram), adjusting the Highlights value usually fixes those hot spots. You can also use it to push bright areas up when they seem muddled.

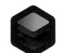

FIGURE 5-9: The brightest sections of the clouds are overexposed, as indicated by the red clipping indicator, but Highlights fixes them.

Shadows

The counterpart to the Highlights control is Shadows, which lightens the midtones without overexposing bright areas **(Figure 5-10)**. Increasing the Shadows control is often all you need to reveal detail in dark areas, especially with raw images where there's more data to work with. You can also usually push the Shadows slider quite high without overcooking the image.

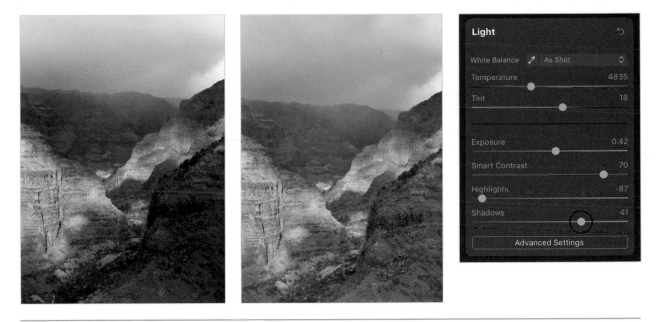

FIGURE 5-10: The Shadows control pulls detail out of dark areas.

Whites (Advanced Settings)

Click the Advanced Settings button to reveal the Whites control. Whites affects pure white and near-white pixels in the image, increasing or decreasing their intensity **(Figure 5-11)**. Whites can lighten a photo without affecting all of its pixels the way the Exposure control does. In fact, this is my preferred method of bringing tones up in many cases (see "Strategies for Adjusting Tone," on the opposite page).

Blacks (Advanced Settings)

When you adjust the Blacks control (also located under the Advanced Settings portion of the Light tool), the black and near-black pixels shift in the direction you move the slider. It's a great option for subtly darkening the image without, again, getting the heavy-handed Exposure control involved.

Although I mentioned earlier that you generally don't want to clip black pixels, I often nudge the Blacks value. Making a subtle adjustment (such as –5 or –10) ensures the eye registers that pure black tone, which contrasts well with the rest of the tones. When an image has zero pure black pixels, the whole thing tends to look slightly washed out.

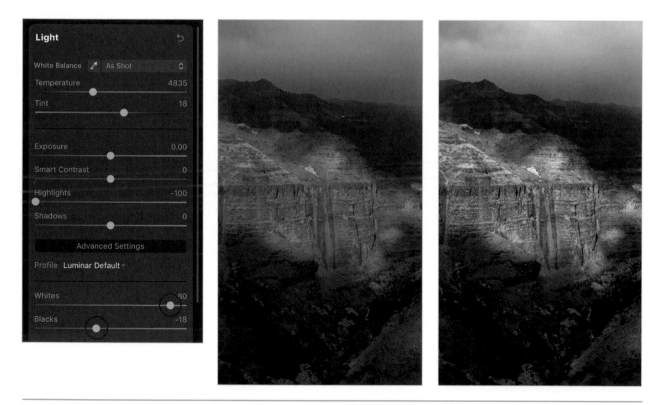

FIGURE 5-11: Compared to the original unedited version (left), increasing the Whites and decreasing the Blacks values adds contrast and brightens light areas (right) without the need to push up the Exposure setting or the Smart Contrast control.

Strategies for Adjusting Tone

When you edit a photo that's over- or underexposed, your first inclination may be to open the Light tool and reach for the Exposure control. But hold on—you don't want to always grab the biggest hammer in the toolbox.

Instead, click the Advanced Settings button and start with the Whites and Blacks sliders. Every image requires its own approach, of course, but here's a good general plan for adjusting tone:

1. In the histogram, click the triangles at the top corners to view the areas clipped to white or black. Don't worry if the highlight colors aren't immediately visible.

2. With an eye on the histogram as well as the image, use the Whites control to increase the brightest pixels in the image. Stop dragging when you see highlighted areas appear red, indicating clipping on the white end. See, I told you the histogram would be important!

3. Slide the Blacks control to the left to deepen the dark areas, pushing them against the left edge of the histogram, until you see dark areas highlighted in blue. Just this combination of adjusting Whites and Blacks increases contrast without having to touch the Smart Contrast slider.

4. Drag the Highlights slider to the left until the red highlights disappear to compensate for any overexposed areas, or to bring detail to the brightest sections.

5. Use the Shadows slider to open up midtones in the dark areas until the blue highlights are gone or minimized to your liking.

The advantage to this approach is that it doesn't overpower the image with exposure and contrast adjustments that touch every pixel (though, to be fair, Smart Contrast also helps in this regard, much better than standard contrast controls in other apps). You can always work with the exposure and contrast as needed, but using this method, you're starting with a more targeted effect.

Curves (Advanced Settings)

While most tools adjust their settings using sliders, the Curves control takes a different approach. It's a graph representing the tonal values in an image, manipulated by adding points to a line and changing their position, creating a curve. Some people find curves adjustments to be a more natural method, while others are more comfortable with working with levels. You can get similar results from each. Click the Advanced Settings button under Light to reveal the Curves control.

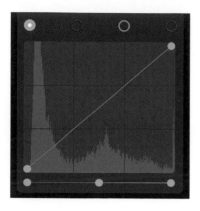

Figure 5-12: The Curves control with no edits applied.

To understand how Curves operates, let's break down what's going on **(Figure 5-12)**.

The working area includes a histogram in light gray that represents the same values found in the Histogram panel (but stretched vertically to match the space). Bisecting that is a diagonal line, starting at the bottom-left of the graph—pure black tones—and extending to the top-right corner—pure white tones. The color circles above the graph let you edit all colors (the white circle), or just the red, green, or blue tones. Lastly, at the bottom is a slider with points for (from left) the black point, midtones, and white point.

At the start, with no edits made, the line is straight. To make a change, click to place a point on the line in the range of tones you want to adjust, and then drag the point up to brighten those tones or down to darken them. That action creates the curve: the line warps to connect the points smoothly.

For example, when you click the center of the line to create a point and drag up, two things happen: the photo gets lighter and it loses contrast. Drag it down, and the image gets darker and contrast increases **(Figure 5-13)**. The photo and the histogram adjust in real time as you drag. To reset a point, double-click it.

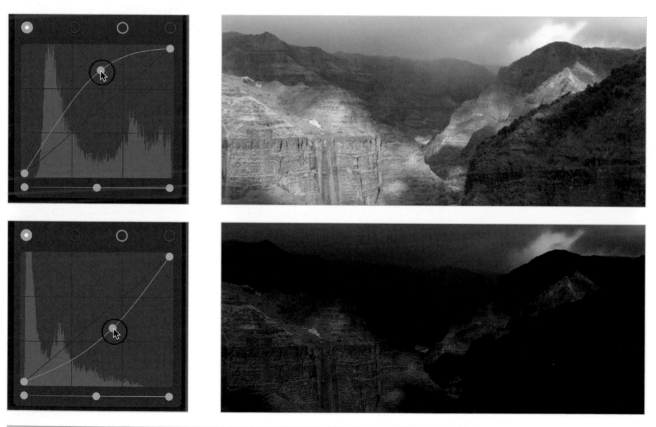

Figure 5-13: Adjusting curves is much more free-form than working with the other slider-based controls.

Adjusting the curve is, admittedly, a much more touchy-feely (that's a scientific term) approach, since you can move the points anywhere on the graph. Adding more points lets you target more tones. There's no rule determining how many points is the right amount; the Curves filter allows you a lot of latitude. In general, two or three is a good amount; you can work up or down from there.

When you move the points on the tone slider below the graph, the entire curve adjusts to compensate for the shift in whites, blacks, or midtones.

Click the color buttons to manipulate just those tones **(Figure 5-14)**. The adjustments are quite sensitive, so you may not need to move points too far from the baseline, depending on the image.

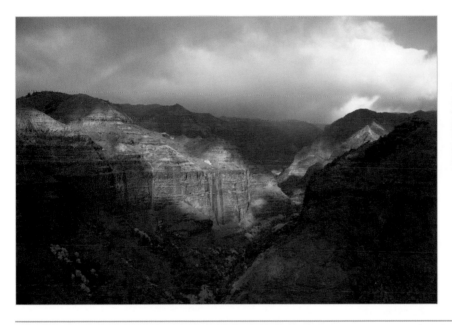

FIGURE 5-14: Here I've increased the exposure and decreased the dark areas (the gray curve), darkened the blue hues (the blue curve) and brightened the midtones (the middle slider on the bottom).

Profile (Advanced Settings)

When working with a raw image, the Profile control assigns raw profiles to the photo. Think of a profile as a recipe concocted by the camera manufacturer to define how to interpret raw image information. Remember, a raw image is just data—ones and zeros—until it's developed; the profile dictates how the data appears visually.

(Profiles are a lot like LUTs, or Look-Up Tables, which are becoming a more popular method of defining colors. See "Color Styles (LUT)," later in this chapter.)

FIGURE 5-15: If Luminar detects profiles stored within the raw file, it reveals them in the Profile pop-up menu.

Your camera may have a setting where you can specify a look that's tuned for landscapes or portraits. This information is often (but not always, depending on the manufacturer) included in every raw image file, even for profiles you weren't shooting with.

Luminar reads that information and includes it in the Profile pop-up menu. You may see options such as Camera Neutral, Camera Landscape, or Camera Portrait **(Figure 5-15)**. Choose one that matches the type of photo you shot, or leave the setting at Luminar Default.

What's important to know about profiles is that their settings have no effect on the other filters or adjustment controls; a landscape profile may increase the saturation of the photo's colors, but the Saturation slider itself doesn't change.

If an image doesn't include that information, or you want to use a profile from a different camera—let's say you like the way a Nikon D850 handles landscape colors—there's a way to extract and use that profile. First, convert the raw file into a DCP (DNG camera profile) format:

1. Download and install the free Adobe DNG Converter utility (helpx.adobe.com/photoshop/using/adobe-dng-converter.html).

2. In the Finder or Windows Explorer, create a new folder and copy the raw images you wish to convert and use as profiles. The utility is designed to convert scads of image files at once, so isolating one or a handful is a more direct approach for what we want to accomplish here.

3. Open the utility and click the Select Folder button; pick the folder you created in the previous step. You can ignore the next options (choosing a destination, renaming the files, and setting conversion preferences).

4. Click Convert.

Next, with a DNG file in hand, do the following in Luminar:

1. In the RAW Develop filter, click the Profile pop-up menu and choose Load DCP Profile from DNG.

2. Locate a DNG file you created above.

3. Click Open. The profile, which shares the name of the DNG file, is immediately applied to the image you're editing and selected in the Profile pop-up menu.

If you downloaded a DCP profile from somewhere else, bypass the Adobe DNG Converter and follow the second set of steps, choosing Load Custom DCP Profile from the Profile menu. Recent ones appear in that menu for later.

AI Enhance

I don't think it's an understatement to say that articical intelligence (AI) is becoming the most transformational change in photography since the shift to digital. We're mostly seeing this with smartphone cameras, as dedicated microprocessors enhance what the image sensor records, from auto-focus to features like Smart HDR and Deep Fusion in the iPhone.

AI uses machine learning algorithms to analyze a scene and make adjustments based on what it knows from datasets of hundreds of thousands to millions of photos. On the editing side, that means AI can help your photos look better simply by dragging a slider.

Seriously, you may make an AI Accent adjustment and call it good.

AI Accent

One feature Luminar doesn't have that you may have used in other applications is an Auto button when editing. I'm a firm believer in letting software do the work for you. It's helpful to see what the program's algorithms think is the best way to edit an image—and then be able to build on that, accepting or ignoring the recommendation.

Luminar's version of this feature is AI Accent, which is a single "make better" slider. Drag the AI Accent control to apply the effect **(Figure 5-16)**.

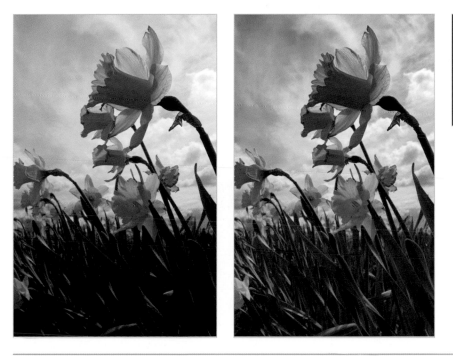
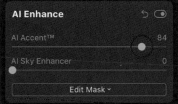

FIGURE 5-16: The AI Accent control has added more contrast to the sky, improved the color saturation, and brightened the dark areas among the flower stalks at the bottom of the image.

Unlike an Auto feature like the one found in Lightroom, AI Accent doesn't affect any controls in other tools. Think of it as a one-stop improvement that is perfect for someone who just wants the easiest route possible to enhance a photo. I tend to increase the slider moderately to see what happens, and then supplement it with other controls based on the look I'm aiming for.

AI Sky Enhancer

The ability to analyze an image automatically leads to a tool like AI Sky Enhancer. It makes skies look better because Luminar can identify a portion of a photo that is most likely a sky. All you need to do is increase the Amount slider. The filter automatically creates its own internal mask so the adjustment applies only to the sky **(Figure 5-17)**.

I say "internal mask," because it's not editable. You can create a new mask for the filter, but that's separate from what the AI is using (see Chapter 9 for more on working with masks). In my experience, it does a surprisingly good job. If the controls remain grayed out, the AI couldn't identify a sky.

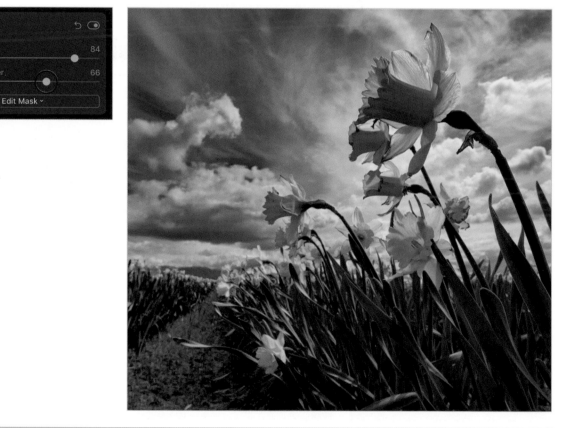

FIGURE 5-17: The AI Sky Enhancer added drama to the sky, but didn't affect the flowers that intersect it.

AI Structure

"Structure," to Luminar, is a combination of detail enhancement and edge contrast. Sometimes it conveys an HDR look, where details are often exaggerated for dramatic effect. When used sparingly, structure can add punch without knocking out the photo (or the viewer).

However, there's a downside: structure affects everything, so if a person is standing in front of a textured background, they end up with unflattering, hyper-detailed skin. The AI Structure tool automatically senses when a person is in the shot and excludes them from the effect, without you having to create a mask to accomplish the same task.

Drag the Amount slider right to increase detail and contrast **(Figure 5-18)**, or drag it to the left to soften the image. The AI feature applies only when increasing the effect, not when decreasing it, so when you apply negative values, everything uniformly gets soft.

The Boost slider accentuates the effect in either direction.

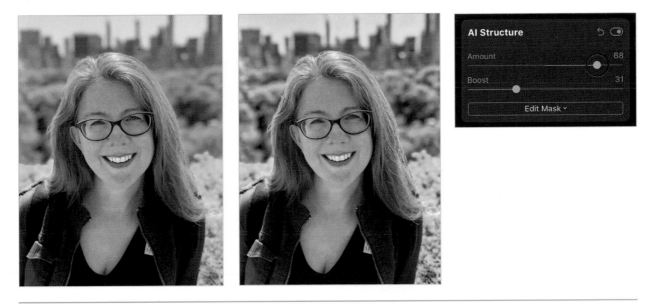

FIGURE 5-18: Using AI Structure, the background gains more definition (right), but Luminar has protected the subject from the effect.

Color

After I get a handle on a photo's tone, the saturation and vibrance are the next tools I select. The real power comes in the advanced settings, though, giving you control over individual color tones.

Saturation

Increasing the Saturation slider pushes the intensity of all colors in the image **(Figure 5-19)**. It's best used in small increments to avoid making the photo look garish (unless that's exactly what you're going for).

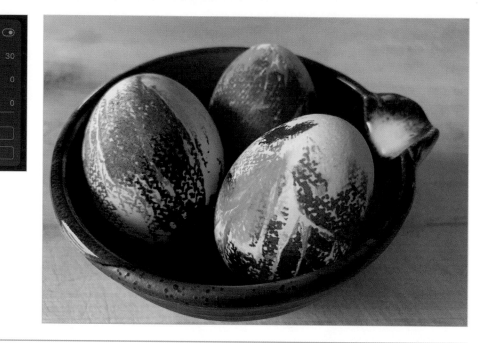

FIGURE 5-19: Increase Saturation to add punch to all the colors in the image.

Vibrance

Vibrance also affects the intensity of colors, but at a finer level. More important, vibrance does a good job of increasing saturation while preserving skin tones in images with people. If I'm working on a portrait, I might use only the Vibrance slider and not touch Saturation at all.

Remove Color Cast

Getting "accurate" color in an image is no easy task. Something in the environment, like a bright yellow bus, could confuse the camera's sensor. Some sensors just exhibit a slight color shift.

Color cast can often be remedied in other ways, such as by correcting white balance or adjusting specific colors in the Color Enhancer tool, but it's worth trying the Remove Color Cast control. This is one of those features that employs the time-tested method of "try it and see what happens." As you increase the value, Luminar guesses which color is dominant and counteracts it **(Figure 5-20)**. It often darkens the image, so you may need to go back and increase your Whites or Exposure values to compensate.

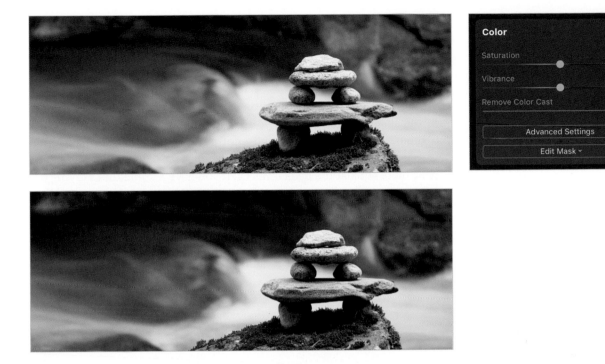

FIGURE 5-20: Luminar has picked up the green color cast in the image at top and compensated by making it more blue, at bottom.

Hue, Saturation, and Luminance (Advanced Settings)

Of all the Luminar controls, Hue, Saturation, and Luminance (HSL) in the Color tool's advanced settings are ones I turn to most frequently when editing color. They can turn a decent photo of fall foliage into a spectacle of color, or take the edge off a dominant color, such as when bright reds go supernova on the camera's sensor. I'm grouping them here because they all work together.

The eight color selection buttons above the sliders represent the main colors found in any image. Click the color you want to manipulate, and then adjust the following controls:

- **Hue:** This slider determines where on the spectrum the color appears. You may think yellow is yellow, for instance, but yellow can exhibit an orange or green tint, the colors to the left and right of yellow.

- **Saturation:** This control boosts or lessens the intensity of just the color you've selected.

- **Luminance:** Drag this slider to change how light or dark the color appears.

Let's say you want to boost yellow autumn leaves. You'd click the Yellow button and increase the Saturation and Luminance values. If you wanted to give the impression the leaves are further along than when you shot them, you could drag the Hue slider to the left to give them an orange tinge **(Figure 5-21)**.

As with so many aspects of editing color, you may need to play around with the sliders to get the look you want. Sometimes the color you think you should adjust doesn't respond—not because the software has somehow forgotten what "blue" is, for example, but because what you see as blue may be more aqua at the pixel level. Or, if you have a scene that's crying out for more green, the solution may be to adjust the Hue slider under Yellow instead of Green.

Hue Shift (Advanced Settings)

Push this control left or right to shift all hues in the image along the full color spectrum.

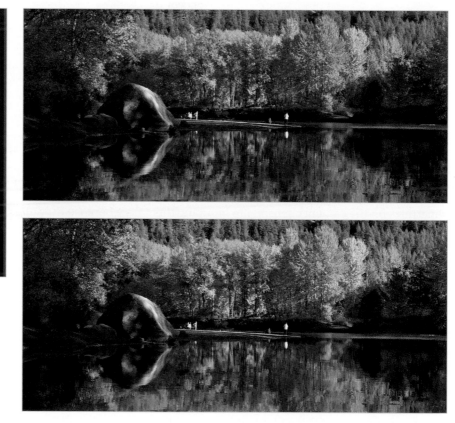

FIGURE 5-21: The leaves here weren't as vibrant as I'd hoped, but I didn't have the opportunity to return to this spot a couple weeks later when the colors would be peaking. Instead, adjusting the Hue, Saturation, and Luminance values gets the colors more to my liking.

B&W Conversion

If you wanted to take the easiest route to create a black and white photo, you could simply remove all saturation using the Saturation slider in the Color tool. Voilà, done!

But is that how Ansel Adams or Henri Cartier-Bresson would edit their photos if they had this technology? No way. In the B&W Conversion tool, each color's grayscale tones can be manipulated to give you control over the black-and-white appearance. The color information is still there even when it's grayscale, which means you can adust the luminance of each hue.

In the B&W Conversion tool, click the Convert to B&W to get started. Adjusting any of the sliders also converts the image to black and white.

Luminance

In the Luminance tab, each color slider represents different color filters: red, yellow, green, cyan, blue, and magenta. Think of them as colored pieces of glass you'd put in front of your lens. Drag a control to affect the brightness of just its hue; the Blue filter, for example, boosts or darkens the brightness of blue areas, like the sky **(Figure 5-22)**.

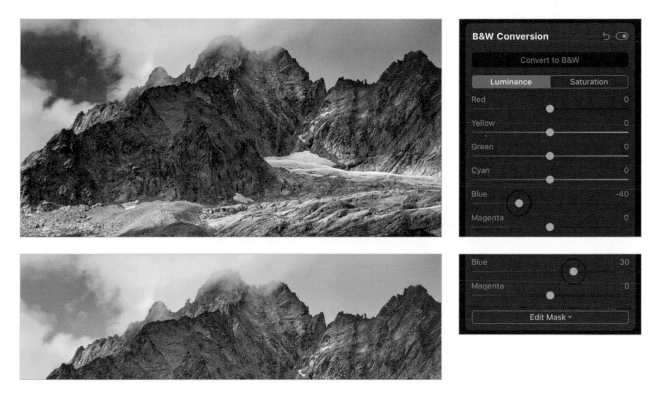

FIGURE 5-22: The Luminance sliders affect the brightness of each color channel, affecting the tones in a black-and-white photo. Decreasing the Blue setting (top) darkens the patch of open sky and the mountain peaks, while increasing it brightens those areas (bottom).

85

Saturation

The color sliders also appear in the Saturation tab, but instead of adjusting the luminance of each hue, they control how much of that actual color appears. Turning up the Yellow slider, for instance, would return color to a sunset while leaving the rest of the image (at least, the non-yellow areas) in black and white **(Figure 5-23)**.

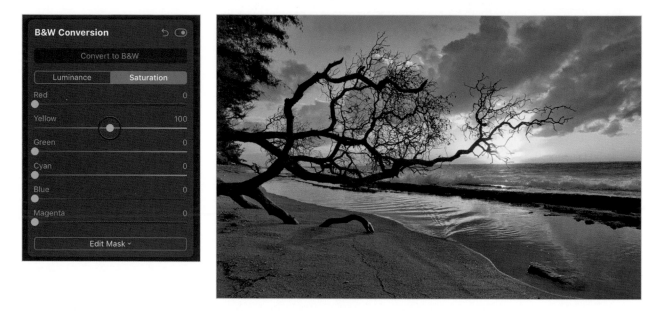

FIGURE 5-23: Increase Saturation to add punch to all the colors in the image.

Details Enhancer

If you remember nothing else about editing digital photos, remember this: software cannot make blurry images sharp. No tool in the world will help if your photo is soft due to the camera's focus, the type of lens, or the introduction of camera movement. (Some tools can get awfully close. Photoshop's Shake Reduction filter can do wonders in some circumstances, but the results depend a lot on the image.)

Where photo software excels is accentuating detail that's already present, adding crispness to already sharp or *just slightly soft* images. These controls can apply broad or fine detail enhancement, and in a couple of cases go in the opposite direction and correct for unwanted digital noise.

Details (Small, Medium, and Large)

As you can guess, the Small, Medium, and Large Details sliders apply sharpening in fine-grained increments. Small affects the sharpness of fine details

(think of the center portions of a flower), while Large works on broad areas (the outlines of the petals or leaves). Drag right to increase the effect; or, drag left of center to decrease the effect, which softens the image **(Figure 5-24)**.

These are often subtle changes, so expect to do a lot of eyeballing until it looks right. You may find it helpful to zoom in to 200% or closer, and turn on the Compare view to easily see the before and after—and be sure to occasionally zoom back out to see how the effect looks on the entire image.

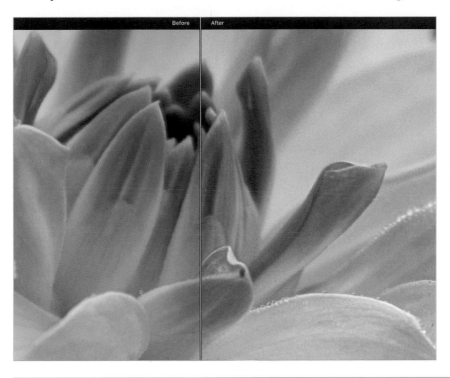

FIGURE 5-24: At 200% zoom, you can see that the Small Details slider is adding definition to the small beads of water, while the Medium Details and Large Details controls are accentuating the larger petals.

Details Protection (Advanced Settings)
If detail enhancement is creating unwanted highlights, click the Advanced Settings button and drag the Details Protection slider until they go away.

Details Masking (Advanced Settings)
Usually, not everything in an image needs to be sharpened. The Details Masking slider, also found in the advanced settings, dictates how precise the mask is. A low value applies sharpening to more details, while a high value applies sharpening only in areas where there is more contrast.

So, for example, setting a high Details Masking value is good for editing a photo of a person's face, because it will sharpen eyes and other prominent features, while leaving cheeks and forehead smoother **(Figure 5-25)**.

FIGURE 5-25: I've deliberately over-sharpened the image on the left to show how Details Masking works on the right. The eye is still crisp, as is the single hair arcing down her cheek, but the skin doesn't look as harsh.

Sharpen

When we talk about sharpening, we're really talking about contrast. The reason an image looks "soft" is because there isn't much contrast between light and dark areas at the pixel level. As you add contrast, the image appears "sharper"—but at a less blunt level than an overall contrast adjustment. Drag the Sharpen slider to set how much sharpening is applied.

The Details controls are another example of edits that require a lot of trial and error to see what looks best. I usually start with the Small Details and Medium Details sliders, and then move to Sharpen to gauge the results.

Sharpening Radius (Advanced Settings)

This value determines how large of an area to take into account when adjusting sharpness. A higher radius produces a stronger effect.

Sharpening Masking (Advanced Settings)

Also found in the advanced settings, the Sharpening Masking slider controls the scope of the areas that are affected by the Sharpen control.

Denoise

Today's free camera lesson is: always check your settings before you start shooting. On more occasions than I'd like to admit, I've shot some images the night before at a high ISO setting—to boost the light sensitivity of the camera's sensor—but forgot to switch back to a low ISO. When capturing photos the next day in bright daylight, the camera was already boosting the light sensitivity of the sensor, spattering the image with digital noise.

Sometimes you have no choice but to accept increased noise, such as in low-light situations when you have to raise the ISO just to get a well-exposed photo. Also, some cameras are just more noisy in dark areas than other cameras.

The Denoise tool applies some basic noise reduction, but keep in mind there's a tradeoff involved: as you reduce noise, you also soften the image, because Luminar is essentially blurring areas to banish those specks. You'll probably find yourself using this tool in small increments to find the best balance between noise and sludge.

Zoom in to 100% magnification or closer to get an accurate look at what's going on, and then use the following controls.

Luminosity Denoise

Increase the slider to reduce the noise varations in brightness, which tends to be monochromatic **(Figure 5-26)**.

FIGURE 5-26: Reducing luminosity noise smoothes the image, which is especially noticeable here in the lantern.

Color Denoise

More noticeable—and annoying—than luminance noise is color noise, which manifests as random colored spots. Increasing this slider compensates for the color variations.

Boost (Advanced Settings)

With one or both of the other sliders active, click the Advanced Settings and drag the Boost slider to increase the effect.

Landscape Enhancer

Just as Luminar includes tools dedicated to editing portraits, it collects a few controls into one group that are specific to landscape photography.

Dehaze

The Dehaze tool is designed to cut through atmospheric conditions caused by water or smoke in the air. Drag the Amount slider to reduce haze in an image. Even if there isn't visible haze, I usually give the slider a quick stab for landscape photos just to see if it helps the image.

The success of the effect depends on your image, of course, but overall it does a good job. Do note that Dehaze tends to introduce a slightly blue color cast, so you may need to offset that with an HSL adjustment that balances the blue and aqua channels.

Golden Hour

The "golden hour" is that time when the sun is low to the horizon, either at sunrise or sunset, so its rays are partially blocked by the curve of the Earth, strafing across the landscape with deeper hues than you find during midday.

Those hours are small slices of any given day, and your schedule may not allow you to get to your location in those windows. To punch up a lackluster real-life golden hour, or even fake the effect, increase the Golden Hour slider **(Figure 5-27)**.

In fact, sometimes I use Golden Hour instead of adjusting white balance. Although you can achieve a similar effect by increasing the Temperature slider in the Light tool, what's nice about Golden Hour is that it seems to retain white areas (like clouds) without making them completely yellow.

Foliage Enhancer

When you want to punch up the greenery in a scene, but not every other color around it, add the Foliage Enhancer tool.

The Amount slider increases saturation just in the green hues common to foliage **(Figure 5-28)**. It tends to benefit from a lighter touch than, say, modifying the green hues in the Color tool's HSL controls.

FIGURE 5-27: The Golden Hour control can warm up images, as seen here, or accentuate actual golden hour photos.

FIGURE 5-28: Foliage Enhancer can quickly turn into neon, but at small doses it can punch up the greens in a landscape.

Foliage Hue (Advanced Settings)

Did you catch just the end of summer when everything is starting to turn brown? Drag the Foliage Hue slider to the right to bring back some of the green. Alternately, if the real foliage color came through as too intense, but you don't want to desaturate everything else in the image, you can dial the Hue slider to tone down those greens. Note that Foliage Hue has no effect if the Foliage Enhancer control is set to zero.

Vignette

The Vignette tool is a funny thing. It's an effect that simulates what is usually considered an optical failing: with some lenses, the image gets darker around the edges of the frame. That perceived disadvantage can be put to good use, though. A subtle vignette often makes an image seem more saturated without adjusting Saturation or Vibrance settings. It also helps to draw attention to the subject matter in the middle of the frame and can minimize distractions at the edges.

A vignette is usually an oval centered within the image, but Luminar provides several controls for manipulating the shape and intensity of vignettes. Click the Advanced Settings button to reveal them all. Also, make sure you're viewing the entire image (choose View > Fit to Screen) as you apply the effect.

Amount

Drag to the left to darken the vignette area, or drag to the right to lighten the vignette (**Figure 5-29**). Be aware, pushing all the way to the right may bring back memories of mall-store portrait studios in the 1980s. However, if you're editing an image that already has an optical vignette, setting a positive Amount value can often negate the effect and balance the tone throughout the photo.

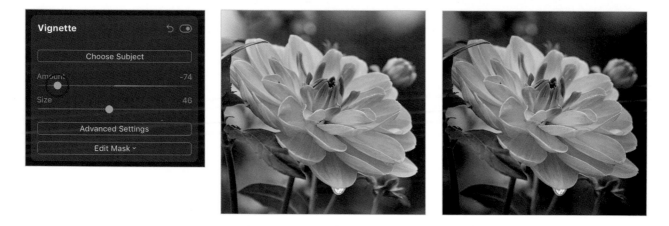

FIGURE 5-29: Adding a vignette to the original (left) reduces the distractions around the edges (right).

Size

The Size control affects the area in the middle that does not contain the effect. A lower Size value creates a vignette that reaches almost to the center, while a higher value pushes the vignette to the outermost edges.

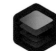

Choose Subject

A vignette is usually balanced in the frame, but you may want to move that framing—suppose you want to de-emphasize elements on the right side of the photo without cropping or painting on a new layer. Click the Choose Subject button and then click anywhere in the photo to establish that spot as the middle of the vignette **(Figure 5-30)**.

It's helpful to temporarily exaggerate the vignette by setting the Amount and Feather (under Advanced Settings) to −100 before clicking Choose Subject. Doing so gives you a more accurate representation of the affected area.

FIGURE 5-30: Shifting the center of the vignette puts more emphasis on the drop of water than the middle of the flower.

Mode (Advanced Settings)

Choose Post-Crop to ensure that the vignette occupies the entire frame, even if you crop the image. If you choose Pre-Crop, the vignette appears as it does when you add it; if you then crop the image, the vignette doesn't adapt to the new size.

Roundness (Advanced Settings)

A vignette is elliptical by nature (unless your photo is square). The Roundness slider changes the outside shape of it. To see the adjustment more clearly, set the Amount slider to −100, and then drag the Roundness control; at low values, the vignette appears more like a rounded rectangle than an ellipse.

Feather (Advanced Settings)

Adjust the Feather slider to affect the smoothness of the transition from outside to inside the vignette. At −100, the vignette looks more like a frame **(Figure 5-31)**; at +100, the vignette is much more subtle.

FIGURE 5-31: Setting the Feather control to −100 clearly shows where the vignette's edges are.

Inner Light (Advanced Settings)

When you're feeling down and uninspired about photography, increase the Inner Light slider to show the world that you *are* a good photographer, by gum!

Then, after you asked yourself how you possibly used the term "by gum," drag the control to increase or decrease the exposure in the middle of the image.

Kidding aside, I love the Inner Light control, because often one side effect of adding a vignette is reducing an image's overall exposure. Nudging Inner Light compensates for that without requiring that you adjust exposure elsewhere.

Creative Tools

I'm going to throw in my bias at this point and say that I'm drawn more to tools that correct aspects of a photo, such as exposure, detail, and color. I tend to want to enhance a scene based on how it really appeared, or bring out details that weren't as prominent when I captured the image.

Some of Luminar's tools stick to that approach, while others move in the other direction, applying dramatic looks or introducing elements that weren't there originally.

Neither approach is wrong—we're all just manipulating pixels, so there isn't a correct way to edit. If you want to get more creative, do it! Several tools in Luminar make that possible.

AI Sky Replacement

Let's go straight to one of the tools that push the boundaries of creativity. Replacing the sky in an image not only seems like cheating, it usually requires a lot of work—in other applications, that is. You have to mask out the sky and bring another image in as a separate layer, and then mess with the tones to make sure the colors of both images are complementary.

The AI Sky Replacement tool does all of that for you, automatically detecting which area is likely a sky in your image and swapping it with another image.

But...*why?*

It's handy for all those times you woke up early, arrived at a location in the dark with nothing more than your photo equipment and a weather report, and found yourself skunked by a layer of clouds that obscured the rising sun (or conversely, a completely clear sky that was beautiful but boring).

It's for real estate photographers who usually don't have the luxury of waiting for the perfect backdrop to appear behind a property to make it a more attractive sale. Since customers are looking at the house, not the sky, it doesn't matter whether the photo accurately reflects the conditions when the photo was shot.

I could go on—advertising images, environmental portraits—but you get the point.

What the tool cannot do is manufacture light that wasn't originally present, or change the direction of the sun. Keep an eye open for where light originates in your photo and match that with the background as much as possible, or else the effect won't be believable.

The AI Sky Replacement tool saves time and makes the process easier. It's also one of the more complex tools in Luminar's lineup.

A Few Quick AI Sky Replacement Notes

You'll find that AI Sky Replacement works really well, especially the way it can handle masking fine details, but it does have some limitations and quirks.

- It's not designed to work with night sky images. The technology that senses the sky area relies on there being enough contrast between land and sky to create the mask, and night images are usually too dark. However, you can certainly use a photo shot at blue hour and add a night sky image to it, as long as you adjust the tones in the foreground so it doesn't look like an obvious day image.

- When importing your own sky photos, AI Sky Replacement doesn't pay attention to their contents. You can just as easily choose a snapshot of your most recent favorite dessert and it will appear at the top of your photo like a benevolent pie-god arriving to bless the world with whipped cream (or cheese, if that's your thing).

- The dimensions of an imported sky image aren't important, because the tool will scale it as needed. That said, very low-resolution images may exhibit artifacts as they're scaled.

- If your photo includes a reflection of the sky, such as in a glassy lake, you'll end up with a mismatch, because the reflection will still show the original sky. However, you can work around that; I describe how in Chapter 9.

- If you want to apply AI Sky Replacement on a separate layer, it must be on an image layer, not an adjustment layer. (See Chapter 8 for more on the types of layers in Luminar.)

FIGURE 5-32: Choose from built-in skies or one of your own images.

Sky Selection

The first step is to find a replacement sky. Click the Sky Selection button to choose from several options that are built into Luminar **(Figure 5-32)**. If the button is inactive, the program doesn't think the photo contains a likely sky, and the tool won't work.

Luminar includes many built-in skies, and by all means, try several of them. However, unless you want your photo to look eerily like others created by fellow Luminar owners, it's better to use one of your own images. Choose Load Custom Sky Image at the bottom of the menu, and locate a JPEG image with the sky you want to use.

Luminar automatically detects the sky in the existing photo and adds the new sky image to it **(Figure 5-33)**. It also masks objects that extend into the sky area.

Next, use the rest of the controls to adjust the placement and appearance of the new sky.

Horizon Blending

Luminar attempts to align the bottom of the sky image with the perceived horizon in the your photo, which often won't be a stark line. Adjust the Horizon Blending control to smooth the gradient between the original photo's sky and the new sky.

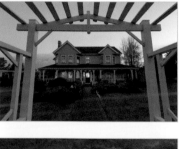

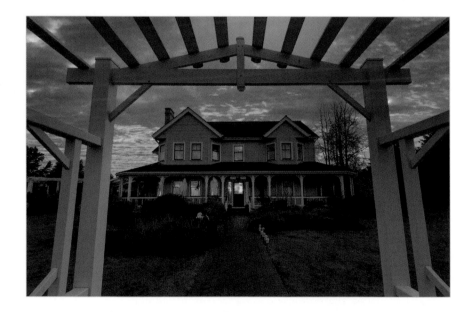

FIGURE 5-33: The original photo contains many impediments that break up the sky, but Luminar has done a good job of replacing the sky with the new image. In some applications, you'd need to spend a lot of time masking the beams and roof of the arbor, not to mention the house and trees (believe me, I've done that with this image before).

Horizon Position

Drag this control left to drop the horizon lower or right to raise it higher. Not only is this good for aligning the horizons, it's helpful to position the new sky so the most interesting aspects of it are visible, such as if the actual horizon is hidden by mountains, trees, or buildings.

The Horizon Position tool works only vertically; you can't slide a sky image left or right. Do note, though, that Luminar scales the image as needed to ensure that it stretches across the image when you drop or raise the horizon level dramatically.

Relight Scene

When you drop in a replacement sky, Luminar analyzes the colors and tones in the new image and adapts the rest of the image to reflect those settings. An orange sunset casts warm tones on everything, for instance, and without that detail, the sky looks artificial.

Increase the Relight Scene slider to apply more of the sky's tones and color to the photo **(Figure 5-34)**.

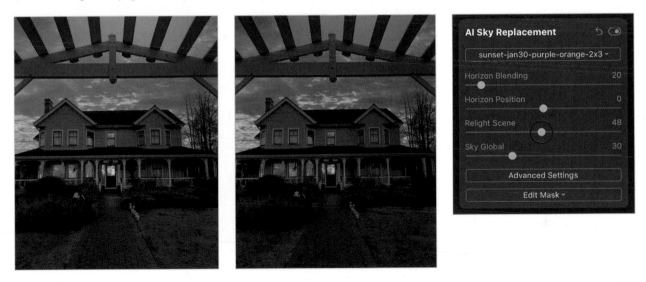

FIGURE 5-34: Luminar can adjust the color and tone in the scene based on the appearance of the imported sky image.

Sky Global

The Sky Global slider controls the intensity of how elements from the original photo appear in the sky. For instance, existing clouds or distant hills may appear in the new sky, potentially throwing off the illusion. Increase the Sky Global value to suppress the background imagery. In some cases, adjusting

Sky Global will cause Luminar to re-evaluate the image and fill in spots that weren't initially caught **(Figure 5-35)**.

Close Gaps (Advanced Settings)
The AI does a great job of finding and masking edges, but it's not always perfect. Use the Close Gaps control to attempt to improve trouble areas.

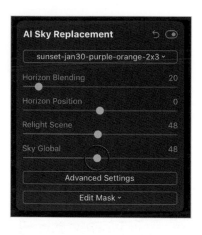

FIGURE 5-35: The tool didn't catch a few spaces in the boards at the top of the image (top), but increasing the Sky Global control fills them in (bottom). However, that caused the sky to bleed into the post at left.

FIGURE 5-36: Increasing the Close Gaps amount fixed the post. Since we're relying on the AI to determine what's sky and what isn't, it can sometimes be a game of coaxing the final result, and deciding what's good enough. In this case, it's barely noticeable.

Sky Local (Advanced Settings)

While the Sky Global control works on the intensity of the background compared to the overall sky, the Sky Local slider sticks to the areas where the imported image meets the original photo. Increase this value to help tame those edges.

Sky Defocus (Advanced Settings)

In a lot of landscape photography, you want to get as much of the image in focus as possible. That's not the case if you're shooting at wider apertures, which take advantage of shallow depth of field to create soft backgrounds.

When you need to match background blur, such as replacing the sky behind a portrait subject, increase the Sky Defocus control (**Figure 5-37**).

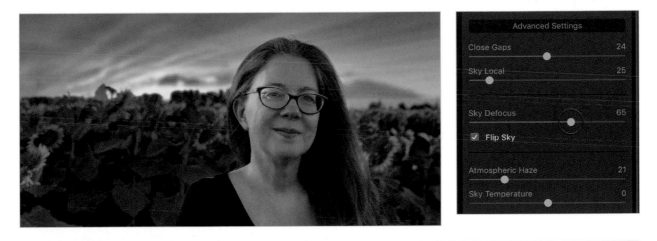

FIGURE 5-37: Use Sky Defocus when the original photo was shot with a shallow depth of field.

Flip Sky (Advanced Settings)

Perhaps the sun should be coming from the other direction, or you're looking for variety in your replacement sky. Click the Flip Sky button to flip the image horizontally.

Atmospheric Haze

The sky—the real sky—isn't just a projected firmament. A lot of air separates us and the clouds, and even on clear days the air can be hazy. Increase this value to match the conditions of the air in the base photo.

Sky Temperature and Sky Exposure (Advanced Settings)

These two controls adjust the white balance and exposure of the sky image, providing another way to match it with the original scene.

AI Augmented Sky

Building on the same technology as AI Sky Replacement, the AI Augmented Sky tool can add objects into an otherwise plain sky for creative results.

Object Selection

Click the Object Selection button and choose from the built-in items, or pick Load Custom Image to specify your own file. (For best results, your file should have defined transparent areas and saved in the PNG format. Luminar will also read solid black areas in a JPEG as transparent.) Use the Amount slider to control the opacity of the image.

Place Object

Unlike AI Sky Replacement, you have much more control over the size and placement of the imported image. Click the Place Object button and use the image handles to position the object **(Figure 5-38)**.

Warmth and Relight

Use these controls to affect the colors of the image and surrounding photo.

Mask Refinement (Advanced Settings)

Adjust this slider to blend the image into the sky background.

Defocus (Advanced Settings)

Optionally change the focus of the imported object to make it appear more realistic in the scene (if that's the effect you're going for).

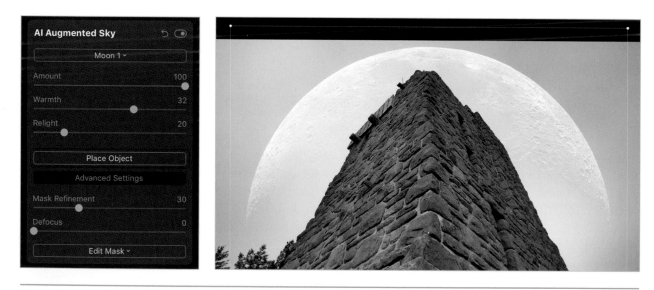

FIGURE 5-38: Luminar's AI automatically accounts for items that break up the sky, such as this tower, when adding objects to the scene.

Sunrays

Oh, I rolled my eyes pretty hard when this feature was announced. I'm not above heavily editing a photo to give it a certain look or to enhance the scene to be more dramatic than it appeared in real life, but...adding fake sun rays? No, no, no, no.

And yet...don't reflexively dismiss the Sunrays tool. Although you can definitely end up with a cheesy effect, the number of parameters available can make it a genuinely useful tool. For example, you can add a sun-kissed glow just outside the frame by setting the number of rays to 0 and position the centerpoint beyond the image boundary.

Use the Sunrays controls to adjust the appearance of the effect, from its intensity to the number of rays and how warm they appear. This step always involves experimentation to get the look you're happy with.

I suggest using the Sunrays tool on a separate adjustment layer, which allows you to also change the layer's opacity for better blending into the scene. (See Chapter 8 for more on working with layers.)

Place Sun Center

Position the sun by clicking the Place Sun Center button and dragging the circle at the middle of the rays; increase the Amount slider to make the rays themselves appear (Figure 5-39). Although you can put it anywhere in your image, make sure the direction of the light matches the shadows of the

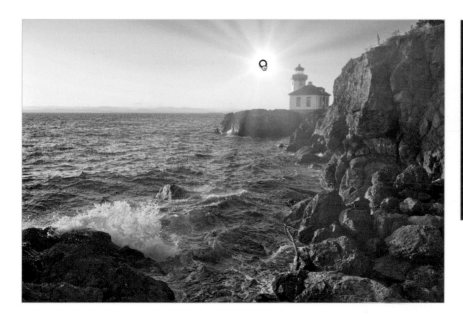

FIGURE 5-39: Drag the "sun" anywhere in the photo.

scene. (Or, if you're accentuating an existing light source, like a street lamp in the fog, place the "sun" where the light originates.)

Click the Done button that appears, or click the Place Sun Center button again when you're finished rearranging the heavens.

Amount

Increase the Amount value to set the intensity of the effect **(Figure 5-40)**. Notice that Luminar doesn't just blast light into the area where the artificial sun appears—the rest of the image's tones adjust based on what real sunrays might do to the image.

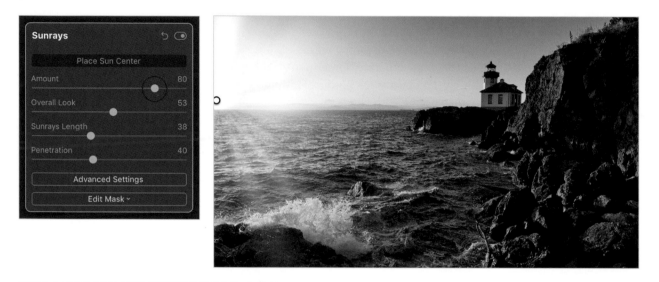

FIGURE 5-40: Moving the fake sun to where the real sun would be starts to make the image look more convincing.

Overall Look

This control acts similarly to the Relight Scene control in AI Sky Replacement, applying the amount and temperature of the artificial sun to the rest of the image.

Sunrays Length

Extend the rays to the edges of the image with a larger value, or limit them closer to the sun.

Penetration

To be honest, the Penetration control is what sold me on the potential of the Sunrays tool. It can detect where an object, such as a horizon line or mountain range, might be and incorporate that into the effect.

When the sun is placed on an object that seems like it could be a physical feature, Luminar adjusts the rays to adapt to it. The best way to see this in action is to click the Place Sun Center button and drag the spot around your image **(Figure 5-41)**.

A lower Penetration value gives the appearance of the sun behind those objects.

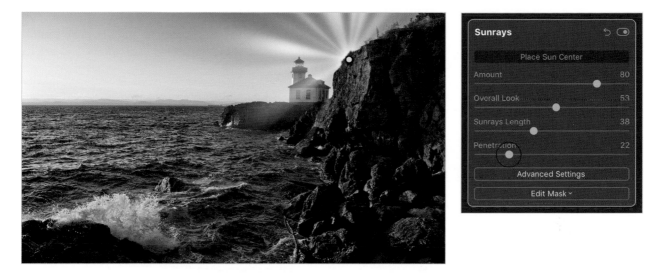

FIGURE 5-41: Ignore for a moment that the sunrays are coming from a completely wrong location, and focus on how they're being occluded by the rock. The lighting changes as a consequence, as well.

Number of Sunrays (Advanced Settings)

How defined do you want each ray to be? The Number of Sunrays control ranges from fewer broader rays (a low number) to more, narrower rays (a high number).

Sun Radius, Sun Glow Radius, Sun Glow Amount (Advanced Settings)

These three controls affect the size of the sun itself and how the glow appears. A larger Sun Glow Radius value creates a brighter, less defined sun, for example. Again, if I haven't said this often enough, play around with the sliders and see how they look.

Sun Warmth, Sunrays Warmth (Advanced Settings)

Just as the temperature of a scene can be warm or cold, so can the light emanating from the sunrays source. These two sliders make the sun and its rays warmer or cooler.

Randomize (Advanced Settings)

The problem with an artificial light source is that it can be too uniform. You are, after all, specifying how many sunrays appear and how long they should be. The Randomize slider throws some variety into the width of the rays you've set up.

So they look more…real. Okay, I couldn't avoid one more eyeroll.

Dramatic

The Dramatic tool is a quick way to increase contrast and decrease saturation in an image. Use the Amount slider to activate the effect and set its intensity **(Figure 5-42)**.

Local Contrast

Local Contrast specifically targets finer details.

Brightness and Saturation (Advanced Settings)

One consequence of increasing contrast is that overall exposure can be diminished. Use the Brightness control to open up the image, or drop it deeper into the dark depths.

The Saturation slider enhances the already desaturated look, although notice that it's working only on the saturation level imposed by the Dramatic tool; setting Saturation here to –100 doesn't remove all color in the image.

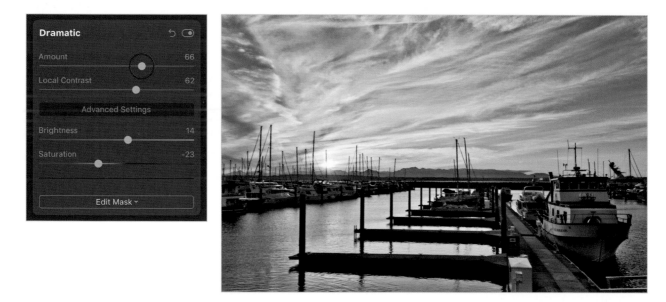

FIGURE 5-42: How dramatic is Dramatic? You can easily go overboard, or add just the right amount of contrast.

Matte Look

The Matte Look tool achieves a faded, contrasty appearance that is popular in photography right now for creating images with a specific mood.

Increase the Amount slider to apply the effect. As you do, you'll see the histogram pull away from the left side of the graph, as all the dark tones are brightened **(Figure 5-43)**.

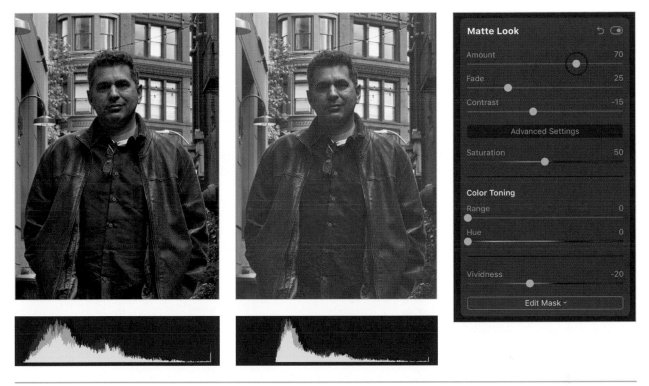

FIGURE 5-43: The Matte Look tool delivers a popular, lived-in look that can be a respite from the excesses of saturation.

Fade
To accentuate the washed out look, increase the Fade control. Strike a balance between the Amount and Fade sliders to prevent the image from becoming too gray.

Contrast
The Matte Look tool on its own increases contrast, but you can use the Contrast slider to enhance or pull back on the appearance.

Saturation (Advanced Settings)
Because of the increased contrast, the image's saturation is also bumped up. Use the Saturation slider under Advanced Settings to balance it (or push it

higher). Even at its maximum setting, it shouldn't oversaturate everything; that's what Vividness, under Advanced Settings, is for.

Color Toning (Advanced Settings)

The Color Toning option introduces a wash of color over the entire image; think of an old print slightly yellowed with age.

Use the Range slider to set the strength of the effect, and the Hue slider to define the color that's applied **(Figure 5-44)**.

Vividness (Advanced Settings)

The Vividness control affects overall saturation, and can either dramatically desaturate the photo or knock it into orbit.

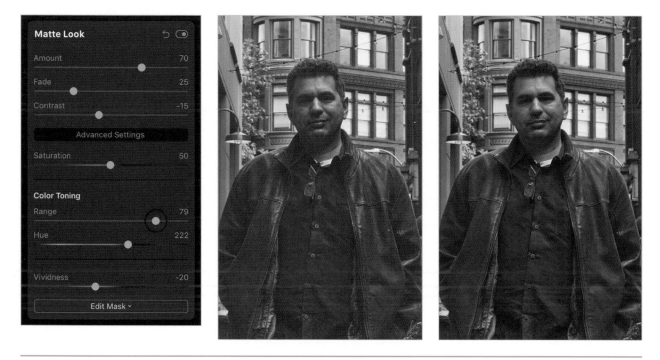

FIGURE 5-44: Adjusting the Color Toning controls adds a hue to the matte look.

Mystical

I'm not going to roll my eyes this time, I promise, even though the name of this tool makes me want to. Mystical is best described as adding a dreamy, soft look to photos.

What's nice is that it accomplishes this effect without simply making everything blurry. When you increase the Amount slider to activate the tool,

Luminar does add a soft glow to lighter areas, but not without sacrificing detail throughout **(Figure 5-45)**.

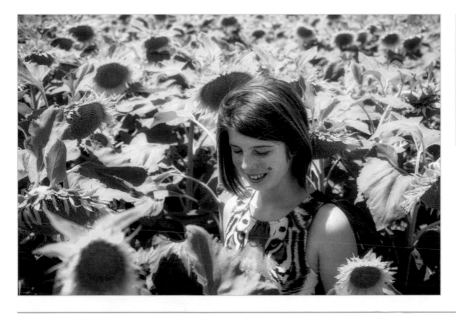

FIGURE 5-45: I'll grudgingly accept that Mystical, because it's not overdone, has its uses.

Shadows

The Shadows control lightens or darkens the midtones in the image, as you would guess, but it also enhances the dreamy appearance when you increase the value.

Smoothness (Advanced Settings)

The Smoothness value affects how blended the effect is with the original image. The smoother you set it, the more the look is distributed throughout the image. With a low Smoothness value, the photo keeps its dreamy quality while increasing contrast.

Saturation and Warmth (Advanced Settings)

When we think "mystical," it's easy to imagine a warm, colorful scene. These two controls let you manipulate saturation and color temperature.

Color Styles (LUT)

In the video editing world, LUTs, or lookup tables, are used to color grade footage to give it a specific look. That can range from punching up colors to making it look like the film was run through a bleach process. The same technology has carried over to editing still photos.

A LUT is like a Luminar Look in the sense that you can get a completely different appearance with just one or two clicks. However, whereas a Look applies several tools and their controls, a LUT doesn't touch any of them. Instead, a LUT tells Luminar how to interpret the color values in a photo. You can then apply tools on top of that.

To map a LUT to a photo, click the Choose LUT button in the tool and pick one from the pop-up menu that appears. Luminar previews each LUT effect as you move the mouse pointer over its name; click to select one **(Figure 5-46)**. Use the Amount slider to set the intensity of the LUT.

For quick access, sliders for Contrast and Saturation are also included in the tool.

One of the advantages of LUTs is that you can load others. From the pop-up menu, choose Download New LUT Files to be taken to a page at Skylum's website that includes some free and for-purchase LUT collections. As soon as you have LUT files downloaded, choose Load Custom LUT File from the pop-up menu and select it. That also applies the LUT to the image.

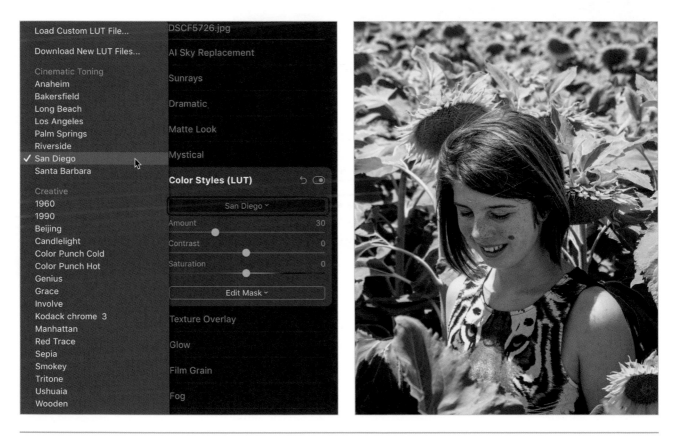

FIGURE 5-46: Apply cinematic or other looks without affecting other controls by loading LUTs.

Create Your Own LUTs

A LUT is a great way to apply a consistent look to the images you process or share—perhaps you favor a slightly faded wash for Instagram photos, or you apply a bright, crisp appearance to product photography. A custom Luminar Look is one way to do it, certainly, but a LUT adds that consistent appearance without messing with filters and sliders.

Instead, you can create your own LUT to load and use in Luminar. Unfortunately, you can't make it within Luminar, so you'll need to fire up Photoshop if you have a copy.

1. Open an image in Photoshop and edit it using adjustment layers.

2. Choose File > Export > Color Lookup Tables.

3. In the dialog that appears, give the LUT a name and make sure CUBE is selected in the list of formats.

4. Click OK.

5. Name the LUT file, choose a destination, and click Save.

If you do not also own Photoshop, another option is the shareware utility LUT Generator (generator.iwltbap.com).

Texture Overlay

The Texture Overlay tool is an interesting mechanism with more creative uses than you might expect. The idea is that you can add a texture to an image—imagine the photo looking like it's printed on raised paper, or maybe a grunge-inspired appearance leading toward the edges of the frame.

All you're doing is importing a JPEG file that is blended with your photo, so that image can be anything, from your kitchen tile to warm light cast on a neutral background to produce the simulation of a light leak.

If you're looking for textures, go to Help > Skylum Account > Quick Access and click the link for the Skylum Marketplace to download free or for-purchase textures.

Load Texture

Click the Load Texture button and locate the JPEG image you want to use as the texture. Note that there isn't a way to remove a texture once it's been loaded, aside from replacing it with another texture image or resetting the Texture Overlay tool settings.

By default, the Keep Aspect Ratio option is selected, which scales the image if needed to cover the entire photo **(Figure 5-47)**. With that option turned off, Luminar stretches the texture image as needed to fill the frame.

Optionally click the Flip (top-bottom) or Flop (left-right) buttons to flip or flop the image.

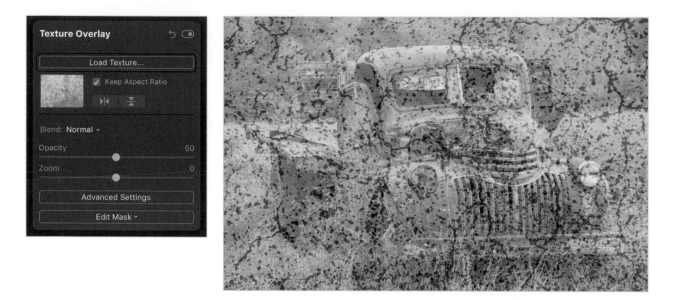

FIGURE 5-47: Load a texture from a separate image file.

Blend Mode

Normally, the texture sits on top of your photo at 50% opacity, which may be too distracting. The Blend pop-up menu controls how the image interacts with the underlying photo **(Figure 5-48)**. (See Chapter 8 for more on how blend modes work.)

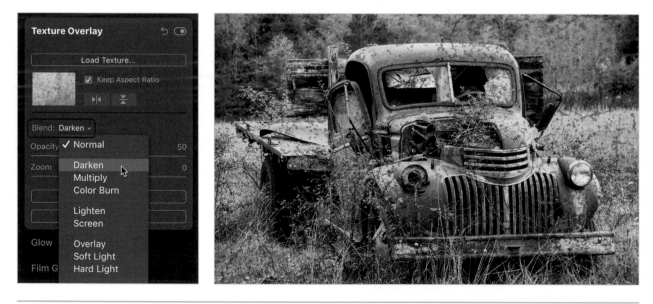

FIGURE 5-48: Change the blend mode to control how the texture's pixels appear over the base photo.

Opacity and Zoom

Adjust the Opacity slider to determine how much of the image appears. A higher value makes the texture more prominent; if you're still in the Normal blend mode, that's the only thing you see.

The Zoom slider changes the size of the texture image. Note that a negative setting reduces the size to be smaller than your photo.

Brightness, Contrast, Saturation, Hue (Advanced Settings)

These controls affect the appearance of the texture image, not the underlying photo. Using these you could, for example, change the hue of a color texture image so it looks as if the texture is purple or green.

Glow

The Glow tool seems to be in the same camp as the Mystical tool, as they both share similar effects. Why would you add artificial glow to an image?

Well, this look has some serious heritage. The next time you watch a movie from the 1940s or earlier, pay attention to the closeups of the leading lady. Filmmakers would dab petroleum jelly on the lens to soften the actresses' appearance, and the result would be smooth skin and a gauzy glow.

The Glow tool can give you that ethereal look today, and you don't need to muck up your camera lens.

As with many other tools, increase the Amount slider to apply the effect, and then use the following controls to refine it **(Figure 5-49)**.

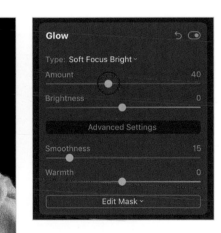

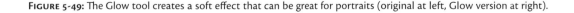

FIGURE 5-49: The Glow tool creates a soft effect that can be great for portraits (original at left, Glow version at right).

Type

From the Type menu, choose one of three glow effects **(Figure 5-50)**:

- **Soft Focus Bright:** The default choice applies the glow to the entire image and boosts the exposure. This is the most dreamy option.

- **Soft Focus:** When you want a gauzy image without the light boost, Soft Focus is a more reasonable choice.

- **Soft Glow:** The Soft Glow option applies the effect to the brightest areas of the image.

Brightness

Glow is an attribute of light, enhancing brighter areas. Use the Brightness slider to bring up the lightness of the entire image and, as a consequence, enhance the glow effect.

Smoothness (Advanced Settings)

Smoothness controls how dispersed the glow effect appears. At a low value, the image exhibits more contrast, while a high value exaggerates the glow throughout the photo.

Warmth (Advanced Settings)

Adjust the color temperature of the glow effect using this control.

Soft Focus Bright

Soft Focus

Glow

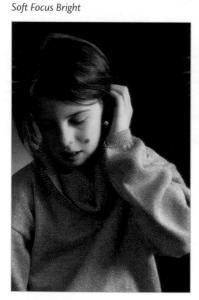
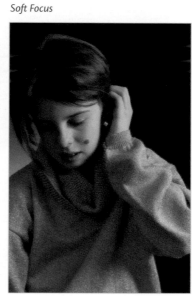
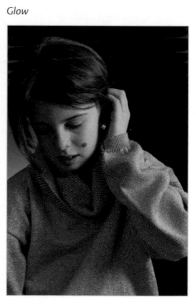

FIGURE 5-50: The three stages of Glow become more subtle as you move down the menu.

Film Grain

At one point, grain was a natural tradeoff in photography. When film was developed, tiny metallic particles became visible. Grain was more pronounced on some film stocks than others, and is still regarded as an appealing characteristic of some prints, especially black and white photos.

We have no metallic particles in the digital realm, but we do often end up with noise (see Denoise, earlier). Noise and grain are not the same thing, however; grain tends to have a more random pattern to it. Adding grain to a photo can often give it more of an analog feel.

Amount

This slider controls how visible the grain is; a higher value produces darker and more obvious grain, while a lower value is more subtle.

Size (Advanced Settings)

Although the Size slider would seem to affect the dimensions of the grain particles—which it does to a degree—I think of it more as a control that makes the grain more or less "splotchy" **(Figure 5-51)**.

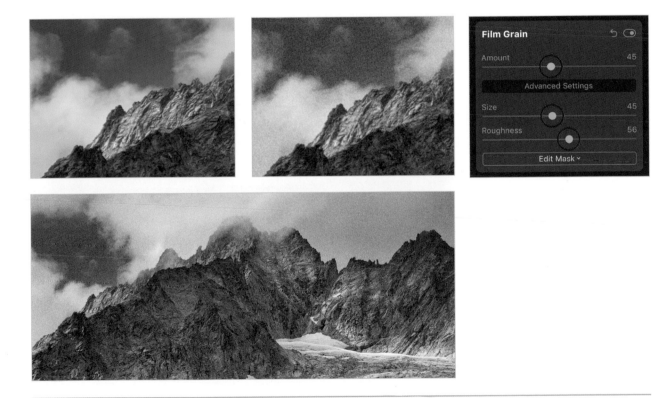

FIGURE 5-51: Adding film grain to an image (top right) evokes the texture of classic photographic film. In this case, the grain is large and rough. The zoomed-out photo below gives you a better sense of the effect.

Roughness (Advanced Settings)

This slider changes how the granules appear, mostly making them appear darker at high values.

Surprisingly, although the Grain tool is effectively "damaging" a photo by introducing pixels that were not originally present, it can sometimes make a photo appear more sharp. A fine grain can hide imperfections and trick the eye into thinking the image has more resolution than it does.

If you have a portrait of a person that's a little soft, and applying other sharpening tools isn't helping, try adding grain (preferably on an adjustment layer above the other tools, so you're not sharpening the grain, too).

Fog

Photography is often about atmosphere, and a foggy morning can imbue a bland scene with mystery.

The Fog tool, however, is more likely to make you want to stay in bed. Choose either Light Fog or Dark Fog from the Type pop-up menu, and drag the Amount slider—and watch your image lose contrast (**Figure 5-52**).

If you need a hint of fog, it may help to use this tool in small doses, or put it on an adjustment layer and use a blend mode or opacity to contol the effect. Otherwise, I don't find it useful.

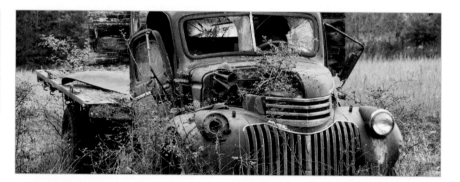

Light Fog *Dark Fog*

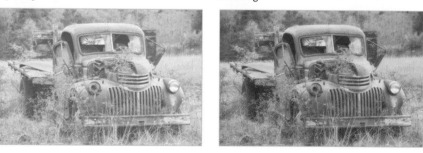

FIGURE 5-52: The Fog options offer what looks like a basic contrast removal, and don't seem particularly realistic.

Portrait Tools

Portraits get special attention, not just because they often include people we care about, but because we see human faces differently than their surroundings. We want edits to be flattering, and many of the tools used to enhance landscapes are anything but flattering to faces. That's why the AI Structure tool automatically excludes any faces it finds when increasing local contrast in an image.

So how do we work with portraits? Luminar includes two AI tools that go beyond simple tone or color adjustments, targeting face-specific features and edits that you typically make when editing people. The set of Portrait tools also includes two common effects used in portraits.

AI Skin Enhancer

I want to introduce this feature by telling you what you're *not* going to do. Traditionally, smoothing the appearance of a person's skin involves duplicating layers and blurring one for a soft texture, then painting on a layer mask to reveal those areas. Or, you'd go a step further and use frequency separation to work with tones and textures on separate layers. I'm not knocking those techniques, which are used by professional retouchers every day.

Instead, let's take a much easier approach. In the AI Skin Enhancer tool, drag the Amount slider **(Figure 5-53)**. That's it.

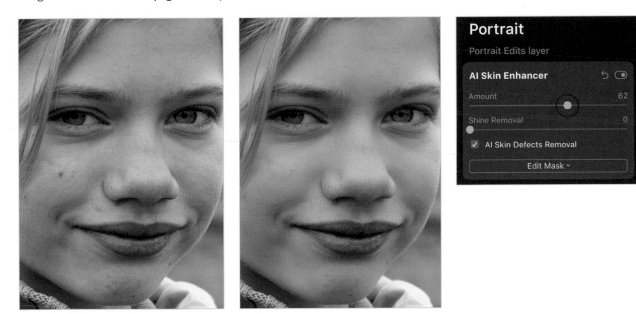

FIGURE 5-53: The AI Skin Enhancer tool determines which area is the subject's face and smoothes the skin. Notice that the skin still has texture, creating a realistic appearance. I also enabled AI Skin Defects Removal, which hid a few blemishes.

Luminar automatically determines which area is a face and smoothes the skin while retaining the texture that ensures the edit looks realistic. In fact, even when you push the tool to its maximum value of 100, faces still appear human, not like mannequins.

Two other thing to note: AI Skin Enhancer rightly doesn't mush together facial hair **(Figure 5-54)**. Also, the mask that Luminar creates to limit the effect to just faces is internal; you can't edit it. The Mask feature belonging to the tool is the same type of full-image mask used by every tool.

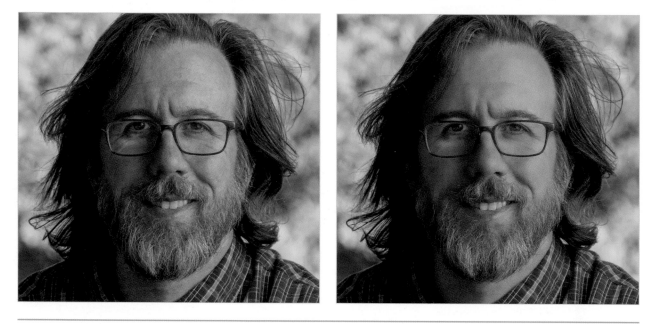

FIGURE 5-54: Even with AI Skin Enhancer set to 100, the facial hair on this chap is crisp and detailed, and the skin still looks realistic.

Shine Removal

Drag this slider to easily reduce glare from the sun or a nearby light that reflects off a person's skin.

AI Skin Defects Removal

Click the AI Skin Defects Removal checkbox to let the tool identify and remove spots or blotches. This feature is hit or miss in my experience, since facial details vary so much between people. But it's worth seeing what the AI comes up with; you can always deal with blemishes using the Erase or Clone Stamp tools if you don't like the results (see Chapter 6).

Portrait Enhancer

Luminar's knack for identifying faces extends to the ability to discern different facial features and manipulate them. No, that doesn't mean you can turn your family members into giant-eyed aliens. Rather, you can easily edit sections that you'd likely otherwise edit using more complicated means.

Open an image with people in it. If the controls in the Portrait Enhancer tool remain inactive, it means Luminar can't identify the face(s).

Face Light

This is an edit I end up making all the time, even in small degrees, formerly using gradient masks. Drag this slider to increase the exposure just on the person's face (**Figure 5-55**).

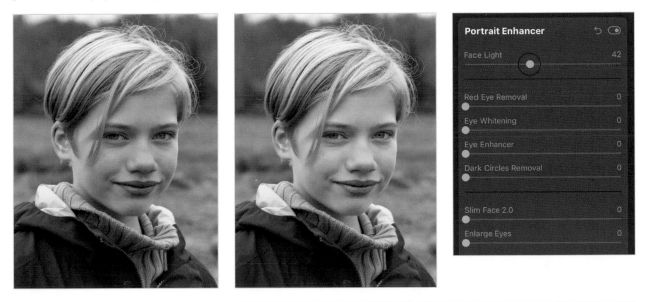

FIGURE 5-55: If you didn't augment the light on a person's face during the photo shoot (using a reflector or flash), the Face Light control can do the job for you in Luminar. Experiment with the amount to ensure the effect looks natural.

Red Eye Removal, Eye Whitening, Eye Enhancer, Dark Circles Removal

We're naturally drawn to people's eyes, and this collection of controls works on this important area.

Increase the sliders to apply the effects, which are pretty self-explanatory. I'm partial to the Eye Enhancer, which adds a little light and contrast to the eyeballs, and Dark Circles Removal, which addresses discoloration that everyone shares in some fashion (**Figure 5-56**).

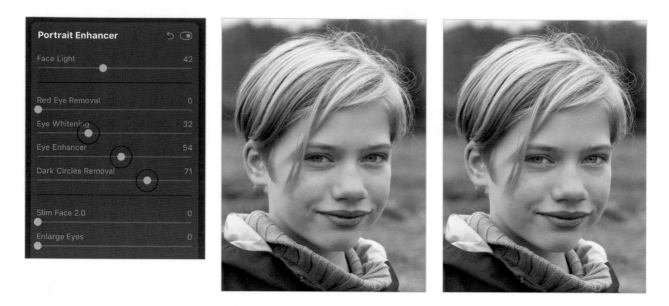

FIGURE 5-56: The eye areas always get some attention when editing portraits, since that's where our gaze naturally travels. Here, I've whitened the eyes, adding light and contrast to the eyeballs, and minimized dark shadows.

Slim Face

This control narrows the head, paritcularly the cheek, jaw, and portions of the neck, to introduce a slimming appearance and correct for lens distortion **(Figure 5-57)**. Again (returning to a theme), the edit is subtle and realistic in most situations.

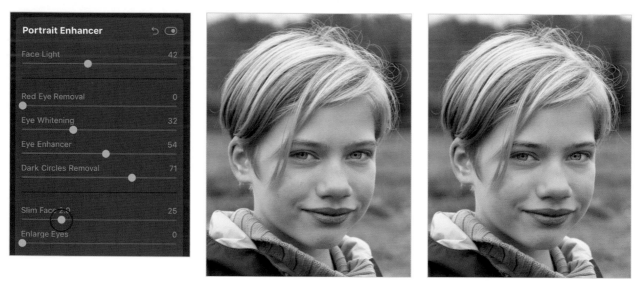

FIGURE 5-57: I tend to shy away from edits that manipulate body shape, but if the photo can benefit from them, the controls are there.

Enlarge Eyes

Increasing the Enlarge Eyes slider won't make a sleepy person look more awake, but it can slightly improve narrow eyes **(Figure 5-58)**.

Eyebrow Improve

This control identifies eyebrows and makes them darker, filling in areas where the brows may be sparse **(Figure 5-59)**.

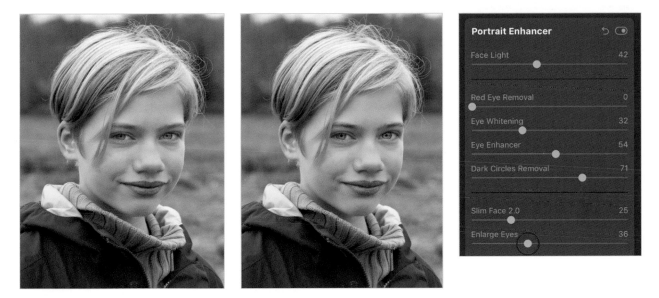

FIGURE 5-58: Although this photo doesn't really benefit from slimming the subject's face or enlarging her eyes, I've applied both so you can see what the effects look like.

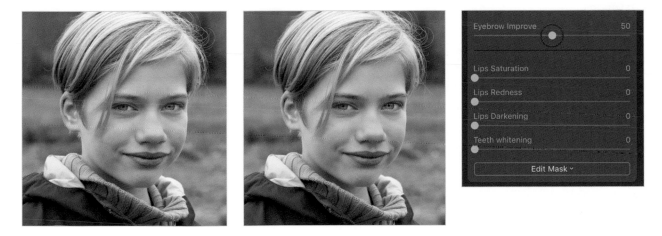

FIGURE 5-59: The Eyebrow Improve control adds just a bit more definition, which can be good for subjects with pale or whispy eyebrows.

119

Lips Saturation, Lips Redness, Lips Darkening

When a person's lips appear pale and undefined, this trio of controls adds color and body to them **(Figure 5-60)**. Taken to extremes, the sliders will look like clown makeup, so don't overdo them.

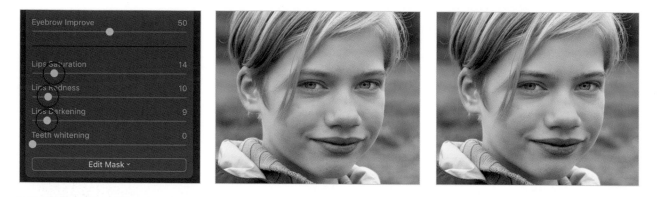

FIGURE 5-60: The controls for editing lip color work best at small increments, but are perfect for high-concept fashion looks.

Teeth Whitening

As someone who consumes quite a lot of coffee, I can appreciate this control. Increasing the value brightens teeth and removes the common yellow color cast of most teeth.

If you haven't done much portrait editing, you may not fully appreciate how much time the Portrait Enhancer and AI Skin Enhancer tools can save you **(Figure 5-61)**. These edits required less than 10 minutes of my time.

FIGURE 5-61: Comparing the original (left) to the final edit (right), I haven't done a lot of drastic work, but the photo is more flattering to the subject.

High Key

The term "high key" refers to a photo shot with an abundance of light, often against white or extremely bright backdrops. It's an effective portrait style, because all of the focus is on the subject, not the background.

Drag the Amount slider to apply the effect, and use the following controls to adjust the appearance.

Standard High Key, Dynamic High Key

The Standard High Key control pushes the high key effect throughout the image. Dynamic High Key, by comparison, tends to take skin tones into account **(Figure 5-62)**.

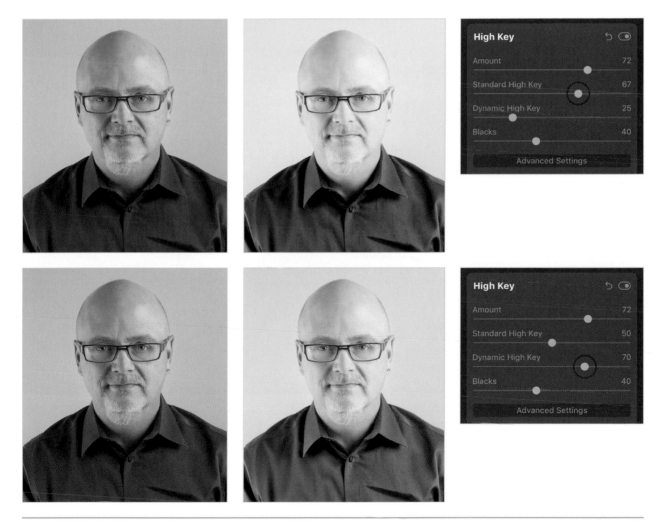

FIGURE 5-62: The Standard High Key control affects all of the tones (top), whereas Dynamic High Key creates a more targeted result (bottom).

Blacks

The Blacks control lightens or darkens the darkest areas of the image, which affects contrast.

Glow (Advanced Settings)

The brightest areas of the photo gain a soft glow using this control.

Contrast (Advanced Settings)

Although the High Key tool naturally makes the photo more contrasty, you can drag the Contrast slider to have more control over the setting.

Saturation (Advanced Settings)

Use the Saturation control to boost or remove the already adjusted color levels in the image.

Setting Saturation to zero, and Amount to 100, is a quick way to achieve a high-contrast, bright black and white high key look **(Figure 5-63)**.

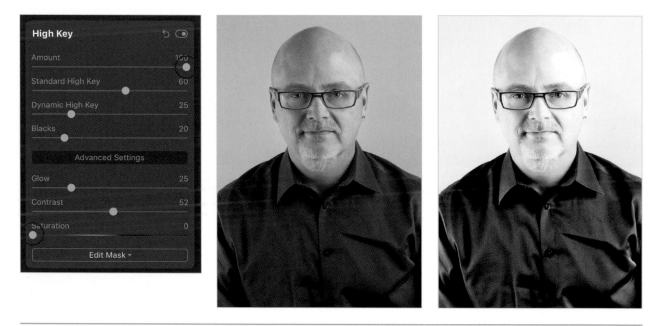

FIGURE 5-63: Reducing the Saturation slider gives you the classic high key, black and white look.

Orton Effect

The Orton Effect tool applies a rich, soft, stylized look. Originally the effect (named for photographer Michael Orton, who created it for his landscape imagery) involved overlaying two versions of the same shot, one in focus and the other slightly blurry. In Luminar, the effect is accomplished using a few controls **(Figure 5-64)**. Drag the Amount slider to apply the tool.

Type

The tool offers two Orton Effect types: choose Type 1 or Type 2 from the Type menu. You're probably thinking, "Say no more! I can tell just by the names what the differences are between the two!" But just to be thorough, Type 1 tends to be moodier and more saturated, while Type 2 produces a lighter, softer glow.

Softness (Advanced Settings)

Drag the Softness slider to change the glow appearance. As you increase the value, the soft areas lose definition (though in-focus details remain sharp).

Brightness, Contrast, Saturation (Advanced Settings)

Use these standard controls to affect the luminance and color of the photo.

Type 1 *Type 2*

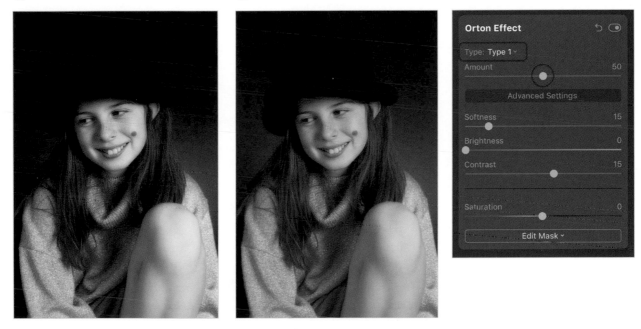

FIGURE 5-64: With the Amount slider set to 50, you can see the Type 1 Orton Effect is softer and more saturated (left), while the Type 2 variation is visible, but more subtle (right).

Professional Tools

Although I understand the reasoning behind labeling this set "professional," don't let the name scare you away. I think of the Professional tools as those that you're likely to reach for later, when you want to do more refined editing, or when you have a specific need in mind.

Advanced Contrast

The Smart Contrast control in the Light tool applies a uniform amount of contrast across the entire image. That can sometimes be too much.

The Advanced Contrast tool takes the same function and targets highlights, midtones, and shadows to give you more control over how contrast is distributed. For instance, if you want more contrast in a cloudy sky but not a darker foreground object, you'd adjust the Highlights Contrast settings.

Highlights Contrast, Midtones Contrast, and Shadows Contrast
Each slider controls how much contrast to apply in the respective tones (Figure 5-65).

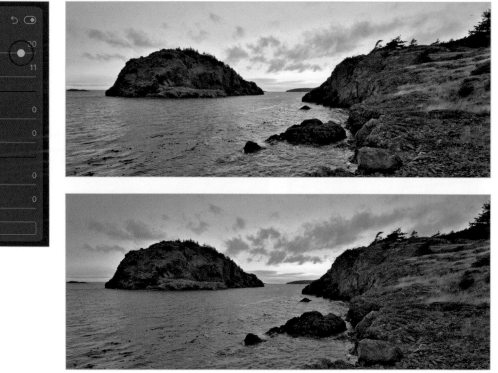

FIGURE 5-65: Increasing the Highlights Contrast value makes the sky more interesting and dramatic in this photo—without masking or using several other tools.

Highlights Balance, Midtones Balance, and Shadows Balance

The Balance sliders set the contrast level: left for less contrast (and generally a lighter effect), right for more contrast (usually a darker effect). If the value of the contrast slider is zero, you'll see no effect when you adjust the balance.

Adjustable Gradient

Some Luminar tools are great hacks that exist for convenience. Adjustable Gradient is one of these, and I love it.

With landscape photos in particular, there's often a drastic difference between the top and bottom of the image—a dark foreground with a bright sky, for instance, where you exposed the shot to get detail in front of you, but didn't want to blow the sky into pure white. So you end up with a photo that's a little lacking in both areas, but with a lot of potential.

One way to compensate would be to increase the exposure of the image by creating a new adjustment layer, increasing the Exposure control in the Light tool, and then creating a gradient mask for the layer so the effect is visible only on the top half of the scene. Then, repeat the process and do the same to adjust the appearance of the bottom half.

In the time it took me to type that, you would be finished by using the Adjustable Gradient tool.

Tones, Warmth, and Vibrance

It's simple, really: In the Top tab, and adjust the tones, warmth, and vibrance for the top half of the image **(Figure 5-66)**.

FIGURE 5-66: Edit just the top half of the photo using an adjustable gradient—no masking required.

To adjust the lower half, click the Bottom tab and make your adjustments **(Figure 5-67)**. Luminar blends the two halves together in the middle.

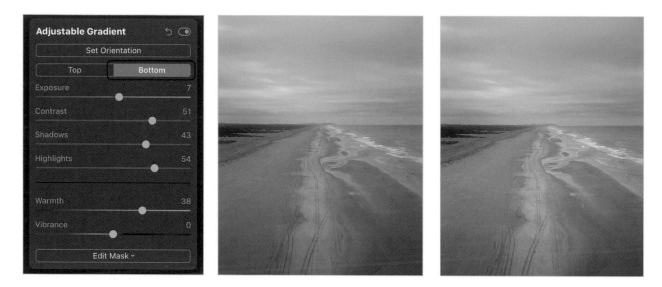

FIGURE 5-67: I wanted a cool blue sky, set in the previous step, but a warmer beach. With Adjustable Gradient, I'm able to edit it separately within the same tool.

Set Orientation

Your image may not be so evenly split, so click the Set Orientation button and drag the handle in the center to position where the top and bottom areas should merge **(Figure 5-68)**. Dragging the horizontal lines above and below the main line changes how gradual or dramatic the areas are blended.

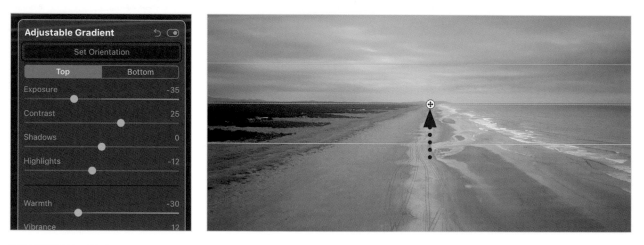

FIGURE 5-68: Drag to repositon the line separating the top and bottom of the gradient.

Of course, "top" and "bottom" are relative terms when applied to different compositions. Drag the center line—not the center point—to rotate the effect away from straight horizontal **(Figure 5-69)**. Click the Set Orientation button again to hide that control.

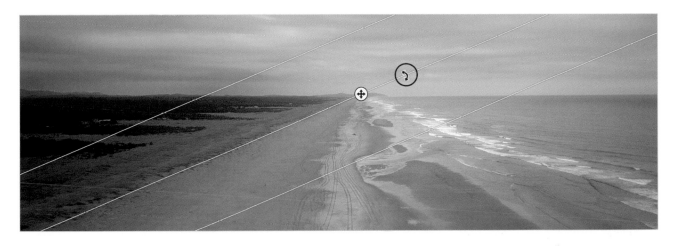

FIGURE 5-69: The gradient doesn't need to follow the horizon. Rotate it around the midpoint by dragging the center line.

Dodge & Burn

"Dodge" and "burn" sound like odd terms for making adjustments until you realize they refer to physical actions film developers took to lighten or darken areas of a photo print.

In Luminar, the Dodge & Burn tool is used to selectively make areas lighter (dodge) or darker (burn) by painting within the image. It's a great technique for drawing attention to some areas of a photo while minimizing other areas. Here's how to use it:

1. Click the Start Painting button; the mouse pointer becomes a circular brush **(Figure 5-70)**.

2. Select Lighten (the default) to dodge areas, or select Darken to burn areas.

3. At the top of the editing area, click the Size control to make the brush larger or smaller. You can also press the bracket keys ([and]) to resize the brush.

FIGURE 5-70: The Dodge & Burn tool uses its own painting interface.

4. Use the Strength slider to set the intensity of the edit. A Strength of 100 will quickly blow pixels to white or black, while a Strength of 10 makes a subtle adjustment that needs repeated applications to become visible.

127

5. Click and drag on the image to paint the effect **(Figure 5-71)**. You may need to work over an area more than once, depending on the amount of tonal shift you're looking for.

 If you overdo a section, you can switch to the opposite setting, or click the Erase button to remove the strokes you've made as you paint.

 On the other hand, if you think a squirrel could have done a better job of dodging and burning than you just did, click the Reset button to remove all the strokes. And don't be so hard on yourself! You're doing great.

6. When finished, click the Done button.

Remember that edits are non-destructive, so you can go back to the tool, click the Start Painting button again, and pick up where you left off, or reset the tool's edits entirely, without affecting the underlying image.

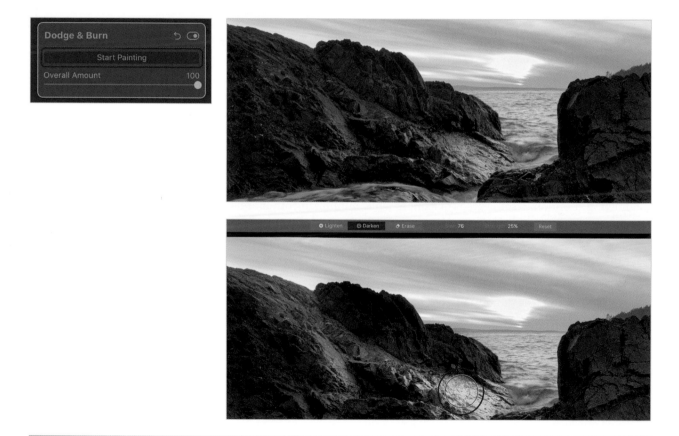

FIGURE 5-71: The tones in the edited version (top) aren't bad, but dodging and burning has accentuated some of the highlight areas on the rocks and darkened others (bottom).

Color Enhancer

I've expressed my appreciation for the Color tool and how it lets me manipulate individual color channels. The Color Enhancer tool gives you even more refined controls for refining the color in your image.

Brilliance/Warmth

Someone may look at an image and think, "I want that to better reflect the early morning sunlight I remember," but they might not immediately know that adjusting the white balance is one way to do it. The Brilliance/Warmth controls are straightforward: Drag the Brilliance slider to increase color saturation in the image. Drag Warmth to add a golden glaze (**Figure 5-72**).

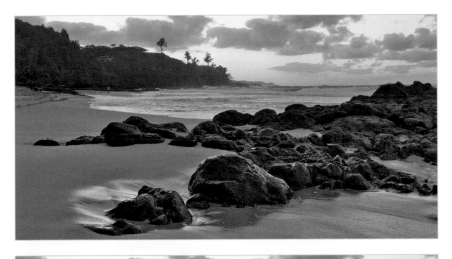

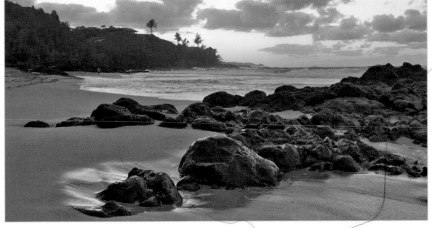

FIGURE 5-72: On an already colorful photo, the Brilliance slider can be quite powerful, which is why I've increased it only slightly (bottom).

Color Contrast

Contrast, as we noted earlier, refers to the difference between tones—the greater the contrast, the greater the separation between dark and light. That technique can be applied specifically to color, too, using the Color Contrast controls.

This is another tool that doesn't do anything until you increase the Amount slider, so push that to about 50 to see the effect. Next, drag the Hue slider to the color whose contrast you want to increase **(Figure 5-73)**. When the hue is set, adjust the Amount slider to intensify the effect or to make it more subtle.

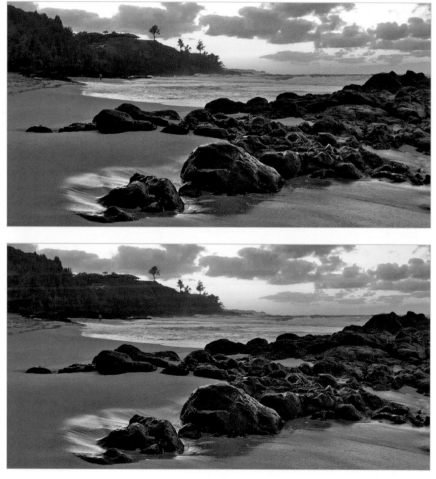

FIGURE 5-73: The color in the top image is ridiculous with Color Contrast set to 50, but that makes it easier to see how changing the Hue slider affects the photo. I brought the contrast amount back down to 13 in the bottom image.

Split Color Warmth

The Split Color Warmth controls perform a neat, useful trick: they adjust the hues of warm and cool areas separately. Want to warm up a beach but leave the sky blue? Drag the Warm slider. Then, optionally drag the Cool slider to adjust the sky area.

Because the controls look for tones that are already warm and cool, they skip past having to warm up the entire image and then mask the parts you want to keep cool.

Color Balance (Advanced Settings)

Another way to adjust an image for color cast is to use the Color Balance controls. This collection of sliders applies color adjustments within shadows, midtones, and highlights. So, if the issue is a predominant green cast just in the shadow areas, for instance, you can correct that without affecting the midtones or highlights.

To manipulate the color balance, choose the Shadows, Midtones, or Highlights tab and drag the slider that corresponds to the color you're trying to remove or enhance (**Figure 5-74**).

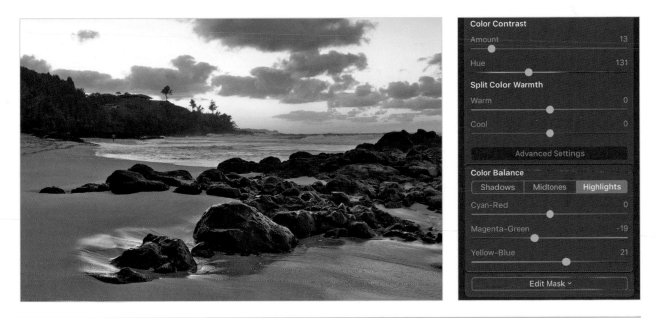

FIGURE 5-74: I wanted to exaggerate the purple and blue tones, so I pushed the sliders toward magenta and blue in the Highlights.

Photo Filter

Before digital editing, the way to affect the color of a photo was to put a tinted glass filter in front of the lens. In Luminar, the Photo Filter tool approximates the same effect.

Drag the Amount slider to apply the effect. Choose the color of the filter using the Hue slider **(Figure 5-75)**. Saturation is set to 100 by default, but I typically reduce that for a more realistic look.

One consequence of using Photo Filter, just as if you were adding glass to a lens, is that the overall image gets darker. To counteract this effect, click the Preserve Luminosity check box.

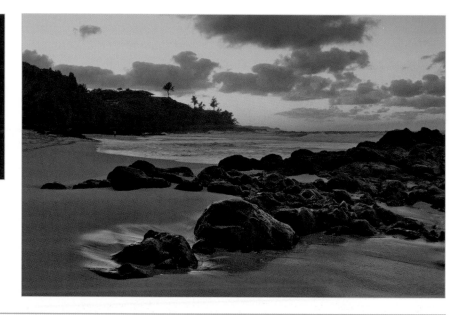

FIGURE 5-75: To make this image seem as if it were shot at the edge of blue hour, I've applied a blue photo filter.

Split Toning

Split toning may seem at first like a creative gimmick: it assigns colors to highlights and shadows. Why would you want color there? Well, although we may think highlights are white and shadows are black, they're full of color. Use split toning to accentuate tones in a scene, or subtly (or not-so-subtly) create a mood beyond what was captured in the original photo. To apply the Split Toning tool, do the following:

1. The saturation level of both highlights and shadows is initially set to zero, so no effect is active. Drag the Saturation slider under Highlights until you see a noticeable change in the image, typically at about 20.

2. Drag the Hue slider to adjust the color being applied to the highlights **(Figure 5-76)**. Notice that the Saturation slider takes on the current color along with the color box above the Hue slider.

3. When you've found the hue you want, adjust the Saturation value to set the intensity of the color.

4. Repeat the same process for the Hue and Saturation sliders under Shadows **(Figure 5-77)**.

FIGURE 5-76: The green hues have been intensified in the highlights (right), which will balance nicely with the shadows in the next step.

FIGURE 5-77: The shadows now have a purple hue to them, giving the image a unique look.

5. Optionally, adjust the Balance slider to give more weight to shadows or highlights.

6. Lastly, if needed, use the Amount slider at the top of the tool to dial back the effect. Sometimes it's good to exaggerate the look using the Highlights and Shadows controls to set the hues, and then lower the Amount value to bring back some realism to the photo.

You can also use just one setting instead of both. I may apply only a hue to shadows when I want the highlights to remain unchanged, for example.

Deprecated Tools

In the switch from Luminar 3 to Luminar 4, Skylum consolidated a lot of filters that were redundant or outdated.

For example, you wouldn't need a separate Highlights/Shadows filter now that those controls are included in the Light tool. In a scheme where filters were organized by workspaces, however, someone might have choosen to include that Highlights/Shadows filter because they didn't need everything else in the Develop filter, which housed the Highlights and Shadows controls.

When you open a photo edited by previous versions of Luminar, any of the old filters that were used now show up in the Deprecated tools category in Luminar 4, so you can still edit those adjustments **(Figure 5-78)**.

Because so many of the deprecated tools echo edits I've already discussed, I'm not including everything under this category. However, a few are worth mentioning in case you run across them.

Bi-Color Toning

The Bi-Color Toning filter simulates using a glass filter in front of a lens that is tinted two separate colors that blend in the middle. It's another way of applying color to a sky and foreground, for example, within a single filter without the need to create masks. Here's how it works:

1. Increase the Amount slider to see the results of the color shifts; I start at a value of 50 to make it clear what's happening.

2. To use one of the existing color combinations, choose an option from the Toning Preset pop-up menu **(Figure 5-79)**.

3. To manually change the colors, click the color wells to the right of Top Color and Bottom Color, and choose a hue from the color picker that appears. Under Windows, choose a color and click OK.

FIGURE 5-78: The Deprecated group icon appears only when old tools were used in an earlier version of Luminar.

FIGURE 5-79: Choose from the Bi-Color presets.

4. Initially the colors are split horizontally in the middle of the image. Click the Set Orientation button to reveal the following controls in the image **(Figure 5-80)**:

- Drag the center handle to reposition the midpoint between the two colors.

- Drag the lines above and below the center point to adjust the gradient between colors. Or, adjust the Blend value at the top of the screen by clicking the word and dragging left or right.

- Drag the middle line to rotate the effect around the center handle, or adjust the Rotation value at the top of the screen.

- Adjust the Horizontal Shift value at the top of the screen to reposition the center handle just on the horizontal axis.

5. Click Done. Or, click Reset to go back to the original settings.

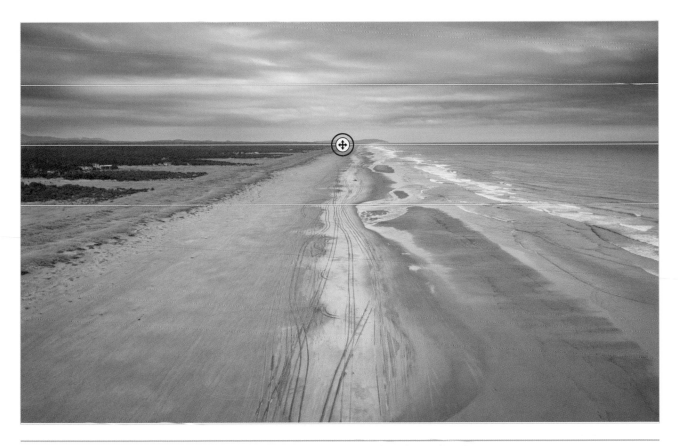

FIGURE 5-80: I feel a sudden urge to rewatch *Mad Max: Fury Road* after selecting this color combination.

Channel Mixer

The colors captured by a camera and viewed onscreen are made up of combinations of red, green, and blue pixels. When a photo exhibits a color cast, such as too much green, we can correct that by reducing the amount of overall green hues in the green channel.

The Channel Mixer filter takes a more granular approach, with controls for manipulating hues within each color channel. The tabs at the top of the filter switch between the red, green, and blue channels; you'll notice that for each one, its color slider is set to 100, while the other sliders are set to zero **(Figure 5-81)**.

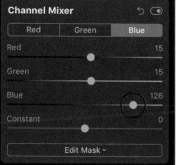

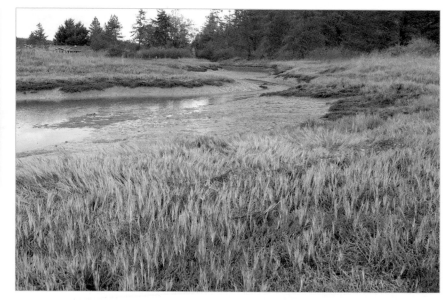

FIGURE 5-81: The Channel Mixer provides a fine control over how colors are rendered.

Choose a channel's tab and drag its primary slider to adjust the hue. For instance, in the Red tab, increasing the Red slider enhances the red tones in the image, while decreasing its value pulls red out of the image.

To fine-tune the channel's setting, drag the other two color sliders, which affect that channel's appearance, not the values in the other channels. It takes some trial and error, and it's easy to go overboard. The results can be creatively worth it, though.

There's one more slider, Constant, that appears in each channel. When you drag it, that color is applied evenly throughout the image **(Figure 5-82)**.

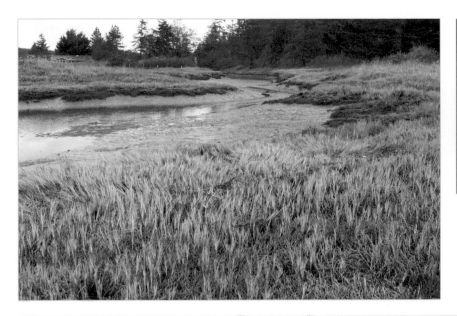
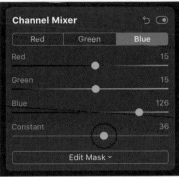

FIGURE 5-82: The Constant control forces the channel's color on the entire image.

Cross Processing

In the film photo days, cross processing referred to using chemicals from one type of film to develop film of another type. The result was sometimes unpredictable, leading to creative applications of color and contrast. In Luminar, the Cross Processing filter replicates those effects using preset formulations. From the Type pop-up menu, choose one of the effects—they're all named after cities. Then, drag the Amount slider to apply the cross-processed look **(Figure 5-83)**.

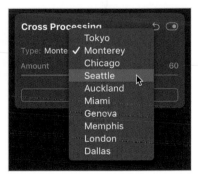

FIGURE 5-83: The Cross Processing tool was an easy way to apply a specific appearance.

The limitation of this tool is that you have no control over the appearance, other than choosing from a short list of pre-made effects **(Figure 5-84)**.

Miami

Chicago

Aukland

Geneva

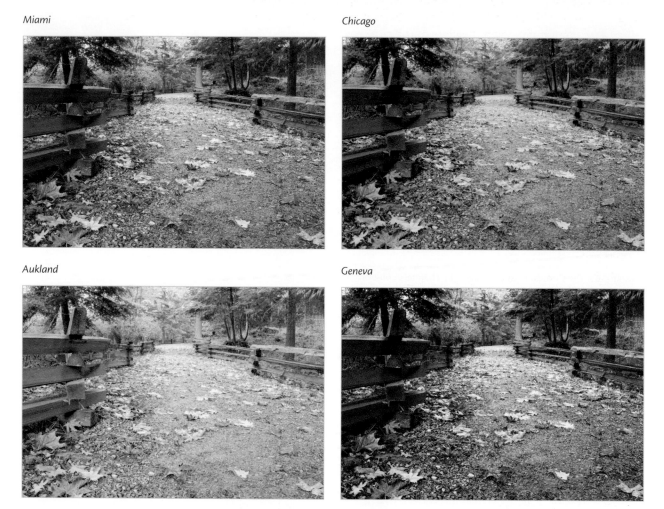

FIGURE 5-84: Since Cross Processing is now a deprecated tool, your best option in the current version is to create Luminar Looks that match the presets' appearances.

Polarizing Filter

A polarizing filter—the physical piece of glass you put at the end of a camera lens—can be invaluable when you're photographing water or other times when you want to cut down the glare of the sun.

If you didn't have one while shooting, the Polarizing Filter tool can simulate the effect of a glass filter. Drag the Amount slider to adjust the intensity of the effect **(Figure 5-85)**.

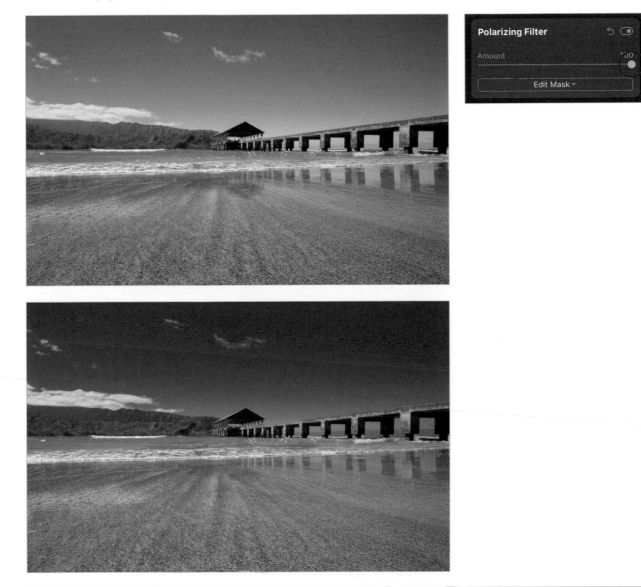

FIGURE 5-85: Did you forget your glass polarizing filter at home? Although the software version doesn't block light as well as the physical filter would, the results are still pretty good. In the original (top), there's a lot of glare on the water. The tool cuts it down (bottom).

Canvas Tools

All the editing tools in the previous chapter work with tone, color, or other effects. The Canvas tools, though, are more about structure: straightening or reframing the entire image; fixing or removing blemishes and objects; and dealing with lens distortion or other geometry. They also differ from most other tools in that, with the exception of Lens & Geometry, they each open in a separate editing environment.

Click the Canvas button in the sidebar to reveal these tools. Or, my preference, press the keyboard shortcut that activates each one: Crop & Rotate (C), Erase (Command/Ctrl-E), and Clone & Stamp (Command/Ctrl-J). You can also choose the tools under Edit > Canvas. The Lens & Geometry tool is in the sidebar, but doesn't have its own keyboard shortcut.

Not included in the Canvas sidebar is the Layer Transform (Command/Ctrl-T) command, which is in the same spirit as the others (and, in fact, appears in the Edit > Canvas menu). However, since it's layer-specific, you'll find coverage about it in Chapter 8.

Crop & Rotate

Did you know that modern cameras include a built-in electronic level feature? Based on the occasional skewed horizon in my images, you might think that my camera doesn't have a level, or that I just forget about it. When I'm editing those shots, the Crop & Rotate tool makes me look like a more deliberate photographer.

More often, you'll reach for this tool when you want to recompose a shot or change its aspect ratio. Yes, I know, it's best to compose each photo entirely in the camera, but sometimes that's not possible. You may also find a better composition while editing the shot that you simply didn't see while you were shooting.

Click the Crop & Rotate button in the Canvas tools group in the Edit sidebar or in the toolbar (⌐⌐) to open the Crop & Rotate interface (**Figure 6-1**); the sidebar disappears and a new tool-specific toolbar appears above the image.

When you're finished cropping and rotating, click the Done button to apply the change. When you crop in Luminar, remember that you're not actually discarding any pixels. You can return to the Crop & Rotate tool to adjust the edit later, if necessary.

Crop & Rotate button

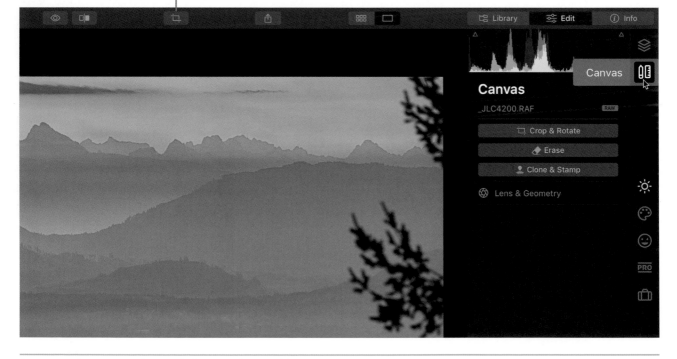

FIGURE 6-1: The Canvas tools are tucked up near the Layers button.

Rotate

Position the mouse pointer outside the bounds of the image and drag to rotate the photo around its center axis **(Figure 6-2)**. A grid appears to help line up horizontal or vertical lines. You can also click the Angle value on the toolbar and drag the slider that appears. Or, simply click and drag left or right on the word "Angle" as a shortcut.

When you rotate the entire photo, it's automatically cropped to ensure that areas outside the canvas don't appear in the visible area. So, as you drag, a badge near the pointer indicates the adjusted dimensions of the image. That's interesting from a data perspective, and can be helpful if you need to adhere to image size requirements.

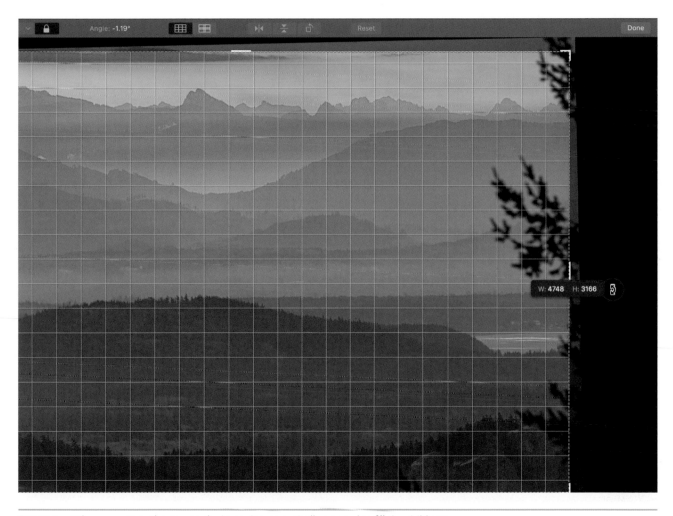

FIGURE 6-2: When you rotate the canvas, the image is automatically cropped to fill the visible area.

FIGURE 6-3: So, yes, I screwed up the orientation of this photo to make a point, which is that you can rotate the canvas in 90-degree increments in Luminar for macOS.

Rotate Left (macOS Only)

If the camera's sensor didn't properly interpret the orientation of the body as you took a shot, you could end up with horizontal photos in portrait orientation and vice-versa. Click the Rotate Left (Counter-clockwise) (▭) button in the Crop Image toolbar to turn the entire image 90-degrees **(Figure 6-3)**; you may need to click it twice more if doing it once results in an upside-down image.

When this book went to press, the Rotate Left button appeared only in the macOS version of Luminar. I assume it will arrive in Luminar for Windows in an update.

Crop

Drag the crop handles that appear at the corners and edges of the photo to adjust the visible area **(Figure 6-4)**. You can also reposition the area by dragging within the crop boundaries.

For assistance, a Rule of Thirds grid is visible to help you align objects in the scene. You can also choose to display a Phi Grid, which some photographers prefer. Click either the Rule of Thirds (▦) button or the Phi Grid (▦) button in the toolbar.

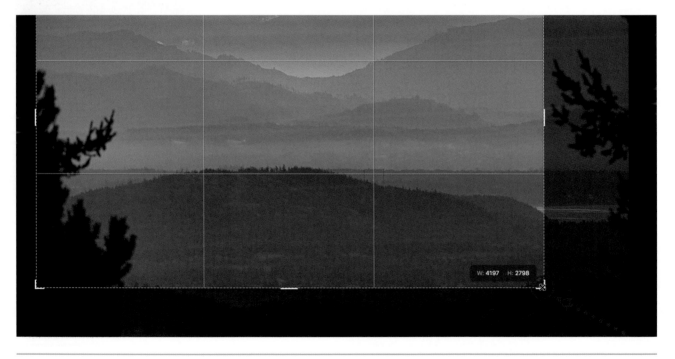

W: 4197 H: 2798

FIGURE 6-4: Drag the handles to resize the visible portion of the photo and hide unwanted objects like the branches at right.

Normally, the aspect ratio is locked, so no matter which handle you drag, the image stays in its original ratio. Click the Lock (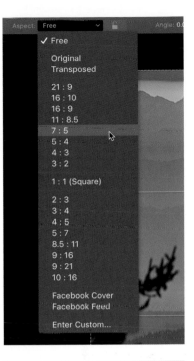) button to remove that constraint. Or, click the Aspect menu to choose one of several options **(Figure 6-5)**.

Most of the Aspect options are common sizes, such as 7:5 (the same dimensions as a 5 x 7-inch photo). If you're preparing images to be printed at specific sizes like that, use this menu to guarantee that the edges won't be cut off or extended with black bars. The grouping at the top represents sizes cropped to a horizontal orientation; the bottom group are the same ratios, only in portrait orientation. A few other items in the menu are for special cases:

- **Free:** When you unlock the Aspect menu, the aspect ratio changes to Free. The handles aren't bound to any ratio, so you can drag them any which way you like.

- **Original:** Choosing this option reverts the boundaries to the original capture ratio. Note that Original doesn't reset the handles to the outermost edges: it keeps your current crop, but enforces the original aspect ratio.

- **Transposed:** Switch between horizontal and portrait orientations quickly by choosing this option. The aspect ratio remains the same. You can also transpose the orientation by dragging.

- **Facebook Cover and Facebook Feed:** These two ratios match the sizes Facebook uses for its interface elements.

- **Enter Custom:** Specify a width and height that isn't listed in the menu.

FIGURE 6-5: Use the Aspect pop-up menu when you know which ratio you want to use. I find 2:3 often too tall for portraits, while 5:7 looks better to me.

Flip Horizontal and Flip Vertical (macOS Only)

The Flip Horizontal () and Flip Vertical () buttons reverse the image on the center axes.

Have you ever seen a magazine photo where some written text in the background is backwards? Editors will often flip an image horizontally so the subject is facing toward the inside of the magazine, not at the outside edges. That's what these controls do.

Just like the Rotate Left control, these two are currently available only in the macOS version of Luminar.

Reset

If you don't like your changes as you experiment with cropping and leveling, click the Reset button to revert back to the original aspect ratio with the handles around the outside of the image.

Erase

The Erase and the Clone & Stamp tools achieve similar results using two different methods. When you need to remove blemishes, dust spots, or other small imperfections, Erase is an easy one-click way to do it. It's also great for eliminating power lines. Luminar evaluates the affected area and fills in the gap with pixels based on what's around it. (Think of it as more of an "Erase and Fill" tool, since it's not simply erasing the pixels to white.) Clone & Stamp is more of a manual process.

Like the Crop & Rotate tool, the Erase tool hides the sidebar and adds a tool-specific Eraser toolbar above the image. To fix troublesome spots, do the following:

1. Adjust the size of the brush you'll use to define the areas to be erased by changing the Size value or by pressing the bracket ([and]) keys.

2. Click or drag the area you want to repair, which appears in red **(Figure 6-6)**. Luminar doesn't apply the fix right away. Instead, paint over all the sections you want to fix. Alternately, select Lasso in the toolbar and define an area by clicking points around it.

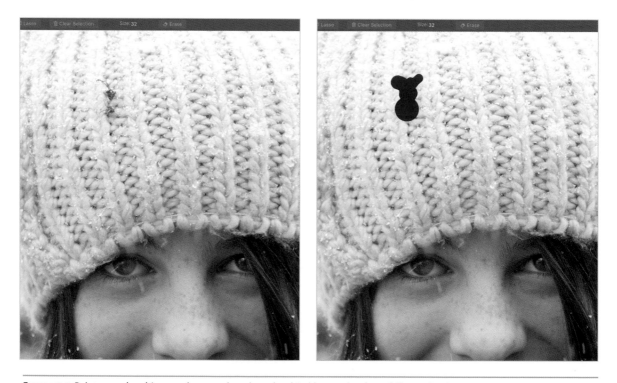

FIGURE 6-6: Paint over the objects to be erased, such as the dried leaves that have fallen on her hat.

If you make a mistake, switch to the Subtract brush in the toolbar, or hold Option/Alt as you paint to remove a spot or section; the center of the pointer target displays a minus sign instead of a plus sign. Or click the Clear Selection button to start over.

3. To process the erased areas, click the Erase button in the toolbar. Luminar erases the selected areas and replaces them with pixels that ideally match the surrounding areas **(Figure 6-8)**.

4. When you're finished, click Done. If you didn't click Erase in the previous step, the erasures are processed before the Erase interface closes.

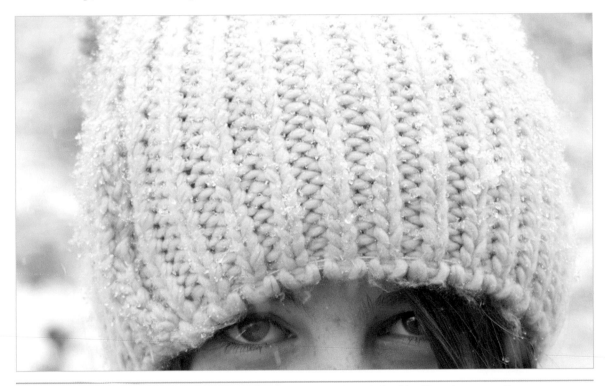

FIGURE 6-8: Luminar has removed the dried leaves and replaced them with pixels that blend into the surrounding scene.

This may sound obvious, but work at 100% zoom as you erase. This makes it easier to find spots that need fixing. Also, especially when you're addressing dust spots in skies, use the scrolling features of your mouse or trackpad, or hold the spacebar while dragging, to move the image while you search for blemishes. Why? So many times I've tried and tried to fix a spot, only to realize that it was physical dust on my display! When you scroll the image, the spots scroll with it. (Also, remember to clean your screen before editing.)

I find the Erase tool helpful in some situations, but it's not as powerful as Photoshop's healing tools. Erasing large areas tends to show artifacts, so I stick to using Erase for fixing dust spots and minor blemishes. In general, I tend to try Erase first, and then turn to Clone & Stamp if Erase doesn't work. And if that still doesn't do the trick, I'll send the image to Photoshop.

FIGURE 6-9: Using the Erase tool creates a new Erased image layer.

> ### Erase and Clone & Stamp Create New Image Layers
>
> Before I get to the mechanics of using the Erase and Clone & Stamp tools, I need to cover something important that will hopefully save you some frustration.
>
> Selecting either tool automatically creates a new image layer, so any adjustments you've made so far are baked into that layer **(Figure 6-9)**. That limits your editing flexibility, because if you decide you need to make a correction based on an existing edit, such as decreasing the exposure, you end up applying a new edit on just that new layer.
>
> Also, note that if you missed a spot and go back into the Erase tool, Luminar creates yet another layer; you can't selectively delete edit patches the way you can in Lightroom.
>
> Ultimately this is a good thing, because the edits remain non-destructive, and you can simply delete that layer if you don't like the results. That said, I recommend holding off on any erasure or cloning until the end of your edit, after you've adjusted tone and color.

Clone & Stamp

Before our smartypants computers started analyzing nearby pixels to intelligently fill in erased areas, we had to laboriously copy those pixels by hand. Kids and their AI these days…

However, even with the Erase tool's algorithms, you might get better results with the Clone & Stamp tool—even if it's at the risk of spraining a finger.

The idea behind the technique is that you copy pixels from one area (clone) and then paste them over the area you want to fix (stamp). Click the Clone & Stamp button in the Canvas tools to get started, which creates a new image layer (see the sidebar above), and then do the following:

1. In the Clone & Stamp toolbar above the image, click the Brush Settings pop-up menu (which displays a preview of the current brush) and set the size, softness, and opacity of the brush **(Figure 6-10)**. You can also click the Size, Softness, and Opacity sliders in the toolbar to adjust them independently. Don't forget that the bracket ([and]) keys are a quick way to change the size.

FIGURE 6-10: Set brush characteristics for cloning and stamping.

2. Click once on an area near the spot you want to fix to establish that as the source; the copied pixels will come from there.

3. Click on the area you want to fix, which stamps pixels from the source over that area **(Figure 6-11)**. You can click or drag to apply the correction, though I find I get better results when I spot-click several times.

4. To sample a new area, Option/Alt click to set a new source. If you make a mistake, choose Edit > Undo.

 Because you're lifting pixels directly, you risk repeating identical patterns. Lower the Opacity or adjust the Softness controls to help blend the stamped areas.

5. Click Done when you're finished.

Cloning and stamping definitely takes some practice, but it gives you more control over how and where to repair portions of the image.

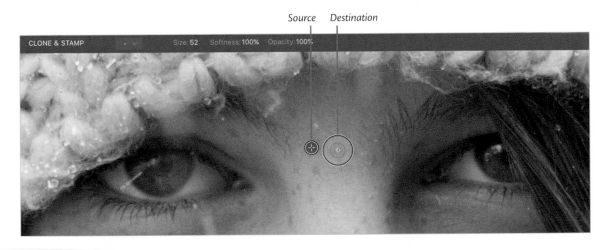

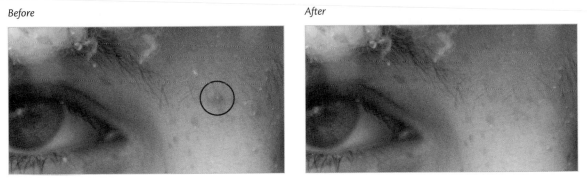

FIGURE 6-11: Small blemishes are easy to remove using the Clone & Stamp tool.

149

Lens & Geometry

Every camera lens model has its own quirks, such as slightly exaggerated barrel distortion or vignetting at the edges, even among lenses from the same manufacturer. Since the lens is identified in each image file's metadata, Luminar can automatically correct for those items in the Lens & Geometry tool.

Note that these controls apply to the active layer only. That's not an issue if you're editing the image without layers, but if you used the Erase or Clone & Stamp tools a moment ago, distorting the layer can make other layers visible at the edges.

Luminar addresses five issues with the Lens & Geometry controls:

- **Lens Distortion:** When you're editing a raw file, you'll see the Auto Distortion Corrections checkbox; click it to apply a fix based on what Luminar knows about the lens used to capture the image. Often this is all you need to do. If the image still looks distorted, drag the Lens Distortion slider to make manual adjustments **(Figure 6-12)**. For JPEG images, only the Lens Distortion slider is available.

- **Chromatic Aberration:** Some lenses exhibit purple fringing around contrasting areas, caused by the lens elements not accurately focusing the incoming waves of colored light (red, green, and blue). It's a common enough issue that clicking the Remove Chromatic Aberration checkbox usually does the trick. This control shows up only for raw files.

- **Defringe:** Similar to the above, Defringe looks for halos or edge noise not specifically characteristic of chromatic aberration. Click the Defringe checkbox to see if it fixes fringe issues in raw or JPEG images.

- **Devignette:** Vignetting is often used as a creative addition to images, but the look is based on lens limitations. When a lens exhibits darker tones around the edges, the Devignette controls can brighten those areas to match the exposure of the rest of the image. Drag the Devignette slider to set the strength of the effect. Use the Devignette Midpoint slider to adjust the size of the devignette area. Often, this control does a better job balancing the edges than entering a positive value in the Vignette tool.

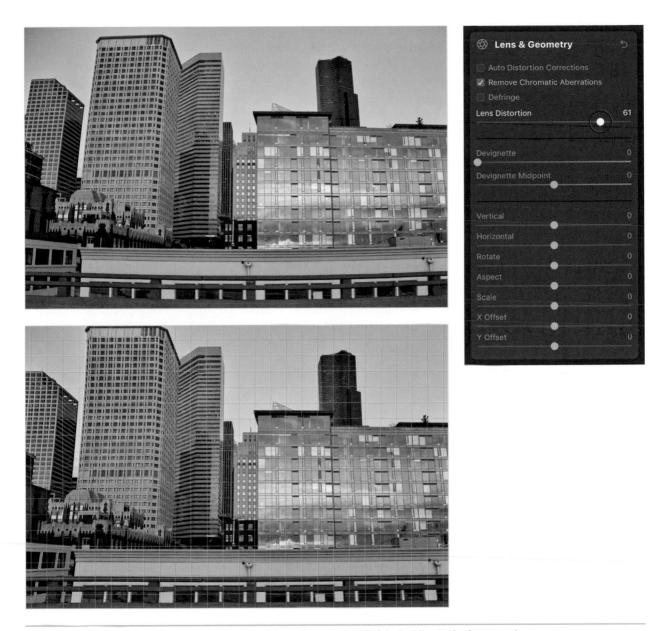

FIGURE 6-12: The Lens Distortion control can help straighten the curved roof of the building in the foreground.

Transform Controls

While the Lens Distortion controls will fix known optical issues, you may find yourself wanting more options, such as distorting the image to straighten vertical and horizontal lines. With most of these transformations, you'll need to also crop the image to remove empty space created by the effect. The Transform sliders affect the image in the following ways:

- **Vertical:** Turn the plane of the image around a center line from left to right—imagine a sheet of paper with a wire running through the middle. This faux 3D effect can compensate for photos with extreme angular distortion, such as looking up at a tall building **(Figure 6-13)**.

- **Horizontal:** Similar to vertical, only the plane turns around a center line running from top to bottom.

- **Rotate:** This control rotates the image around the center point, a task more often done using the Crop tool. If you're already needing another transformation control, you may as well rotate it here.

- **Aspect:** Sliding this control squeezes the image from top to bottom (drag left) or left to right (drag right).

- **Scale:** This slider zooms in or out of the image. Like the Rotate transformation control, it's more common to achieve this effect using the Crop tool, but the option is here, too.

- **X Offset:** Dragging this slider shifts the position of the image left to right.

- **Y Offset:** Shift the image top to bottom with this control.

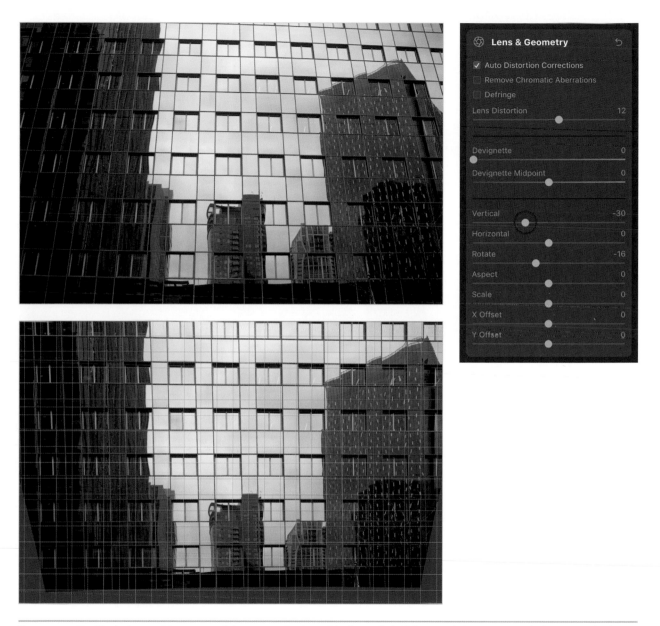

FIGURE 6-13: The Vertical control has removed the perspective from this photo of a building. Don't forget to crop the bottom and sides to remove the areas outside the original photo (which you can see at the bottom of the corrected version).

Luminar Looks

7

If you've read Chapter 5, you'll notice that I can't help revealing all of my editing biases. Well, here's another: I don't gravitate to presets, or in this application's parlance, Luminar Looks.

Luminar includes many pre-made Looks that apply specific appearances simply by clicking one button. Why would I want to make my photos look like someone else's? I've always been more comfortable editing each photo based on what the image needs. I'm not interested in what Well-Known Photographer X thinks is an awesome color treatment.

But then it clicked. I was looking at Looks the wrong way. Luminar Looks are *automation*, not gimmicks. (Well, some are definitely gimmicks, but stay with me here.) The power of Looks is to make a complex series of edits that you know you'll want to replicate on many other photos.

That's different from syncing adjustments between shots (see Chapter 9). Let's say you shoot night skies or portraits on a regular basis, two situations where you apply many of the same edits as a baseline (adjusting blacks, whites, and color temperature for the former, and face lighting, Smart Contrast, and skin smoothing for the latter). Syncing is great when you have 100 images from the same photo shoot, but Looks are better if you capture 100 photos every few weeks.

You can certainly apply the built-in Looks and install new ones, even from Well-Known Photographer X, but the real power lies in easily creating and applying your own Looks. Or, at the very least, you can use a Look as a starting point and then modify its adjustments to your liking.

I haven't suddenly become a hardcore Looks fan, but I can appreciate how they can be a useful tool in your editing arsenal.

Apply Looks

Open an image to edit. If Looks are not already visible at the bottom of the Luminar window, click the Looks button in the toolbar (or choose View > Hide/Show Looks Panel).

What's nice is that each Look displays a preview of the current image, so you can get a thumbnail idea of how those adjustments will appear. The downside is that it takes a little time and processing power to generate those previews; for that reason, I generally leave the Looks panel hidden until I want to use them.

Applying a Look involves three steps:

1. Unless the one you want is in the current set, click the Luminar Looks pop-up menu above the thumbnails and select a collection (such as Essentials, Landscape, or All Luminar Looks) **(Figure 7-1)**.

2. Click a Look in the panel to apply it to the image. When you do, notice that the editing tools are set to the values that deliver the Look's appearance.

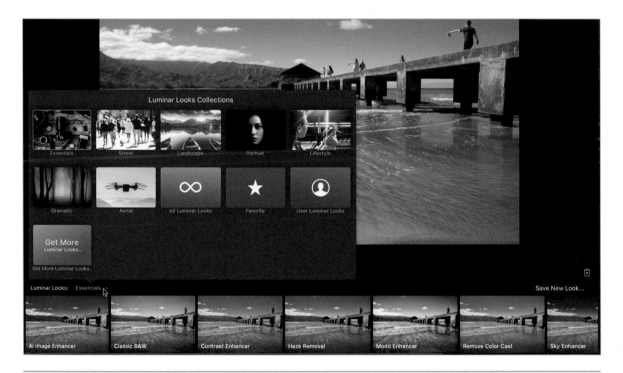

FIGURE 7-1: Luminar Looks are sorted into several collections.

If you want to try another Look, select it in the panel. Only one Look can be applied at a time, so the editing tool settings change when you pick a new Look.

3. Once a Look is active, you can adjust its opacity in the Looks panel by dragging the slider that appears **(Figure 7-2)**.

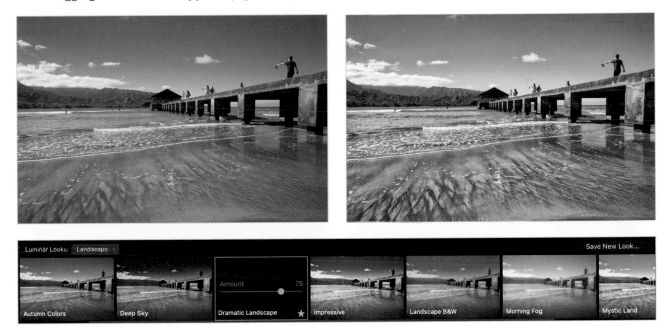

FIGURE 7-2: Applying the Dramatic Landscape Look was a bit too much drama for me (right), so I've reduced the opacity in the Looks panel.

If you decide a Look isn't the right approach for the photo, use Undo (Edit > Undo) or go to the History panel and step back to the point before you applied the Look.

Favorite Looks

It's likely you'll turn to a handful of Looks, which you can stash in one convenient place. Click the Favorite button (the star) in a selected Look's thumbnail to add it to the Favorite collection **(Figure 7-3)**. You can then select that collection and reveal only your favorite in the Looks panel.

Overlay Looks

Only one Look can be applied at a time, but who am I kidding? We're talking about Luminar here.

To combine multiple looks, put them on separate adjustment layers. In the Layers panel, click the Create Layer (+) button and choose Add New

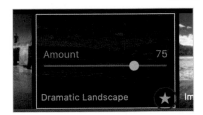

FIGURE 7-3: Mark favorite Looks to locate them easily.

Adjustment Layer. Then apply a Look to that layer **(Figure 7-4)**. (See Chapter 8 for more on layers.)

Remember that using a Look changes the settings in the editing tools, so if you want to add a distinct tone to your already-edited images (I see this a lot on social media), create a new adjustment layer and apply the Look there.

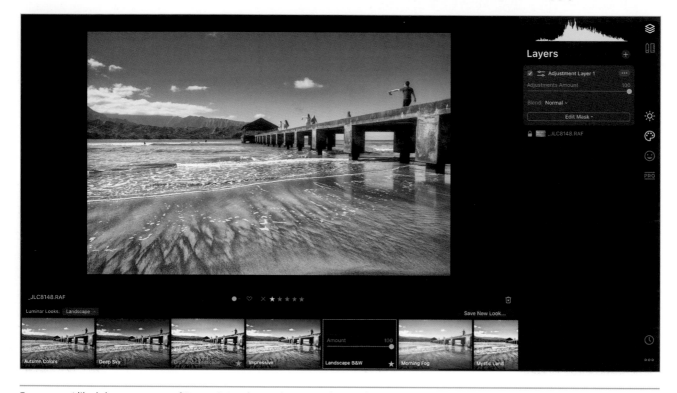

FIGURE 7-4: I liked the appearance of Dramatic Landscape, but wanted to see how it would look in black and white. By adding an adjustment layer, I can apply the Landscape B&W Look and get the best of both.

Create Your Own Looks

This is what convinced me that Looks can be more than just one-click presets. When you've made a lot of edits and want the same look for other photos captured at the same time, creating a new Luminar Look saves a lot of time.

Apply your edits and then click the Save New Look button in the Looks panel. Enter a name in the Luminar Look Name dialog and click OK. The new Look appears in the User Luminar Looks collection **(Figure 7-5)**.

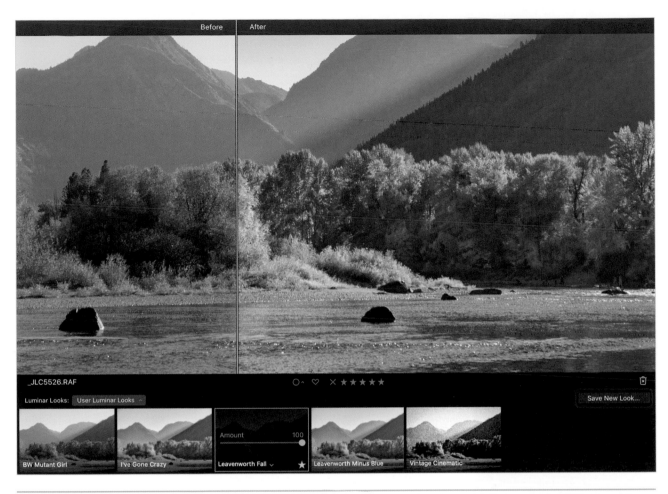

FIGURE 7-5: Based on the edits I made to a related photo in Chapter 1, I created a new Look and named it "Leavenworth Fall." For any of the images shot that day, or to apply edits that generally benefit from boosting yellows and oranges, I now have a Look that does it quickly.

A few important notes about Looks:

- The settings in a Look come only from the active layer, not all layers.

- If, after you apply a Look, you change some of the editing settings, you can update the Look to reflect the new appearance. In the Look's thumbnail, right-click it or click the name (which gains a small pop-up menu indicator when you move the mouse pointer over it) and choose Update with Current Settings **(Figure 7-6)**. Click OK to confirm the change.

FIGURE 7-6: Update a user Look.

- During the course of editing, you may have applied a mask to a tool (see Chapter 9) to limit the tool's effect to portions of the image. When you create a new Look, the settings are saved, but the mask is not.

If you added a B&W Conversion, for example, and used Edit Mask to make one area black and white, applying that saved Look on another image makes the entire photo black and white.

Now, you may want those B&W Conversion settings, even if you have to re-paint a new mask. In that case, before you save the Look, click the Visibility button () to hide the effect. You can activate it on the next image by turning Visibility back on and creating a new mask.

- Use the same pop-up menu in the thumbnail to rename or delete the Look.

Export and Import Looks

Behind the scenes, a Luminar Look is just a text file that specifies which tools are in use and what their settings are. If you use Luminar on another computer (a separate laptop while traveling, for instance), you can export your custom Looks and import them into another copy of the software.

Click the Look's name in its thumbnail and choose Export. In the dialog that appears, choose a location for the file and give it a name.

To import that Look on another computer, open Luminar and choose File > Show Luminar Looks Folder (**Figure 7-7**). In the Finder or in Windows Explorer, copy the .lmp file you created into that folder; it should show up immediately in the Looks panel.

Skylum and others also offer Luminar Looks Collections (free or for sale), which are wrapped in a special file package. Here's how to import those:

1. In the group of Looks collections accessible from the Looks panel, click the Get More Luminar Looks button, which opens the Luminar Marketplace on the web.

2. Download and decompress the .zip file that contains one or more .mplumpack files. (Older Looks marked for Luminar 3 work just fine in Luminar 4.)

3. In Luminar, choose File > Add Luminar Looks Collection, locate the file, and click Open.

The Looks appear in their own named collection in the Looks panel (**Figure 7-8**).

FIGURE 7-7: Reveal the location of user and third-party Looks files.

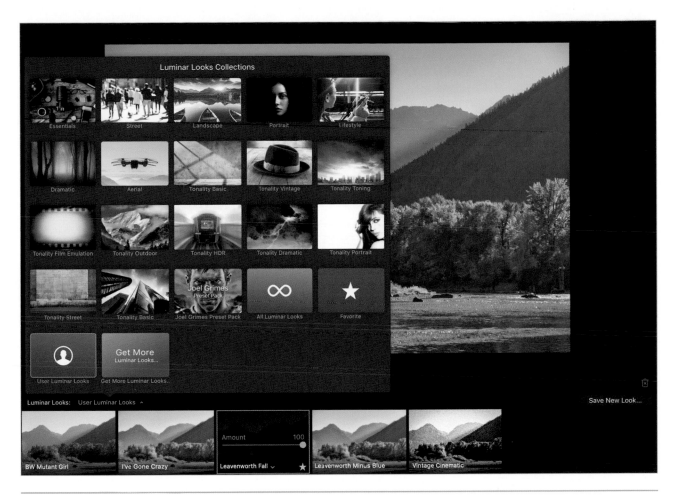

FIGURE 7-8: I've added more Looks packs to the Luminar Looks folder on the desktop, which appear in the Luminar Looks Collections window.

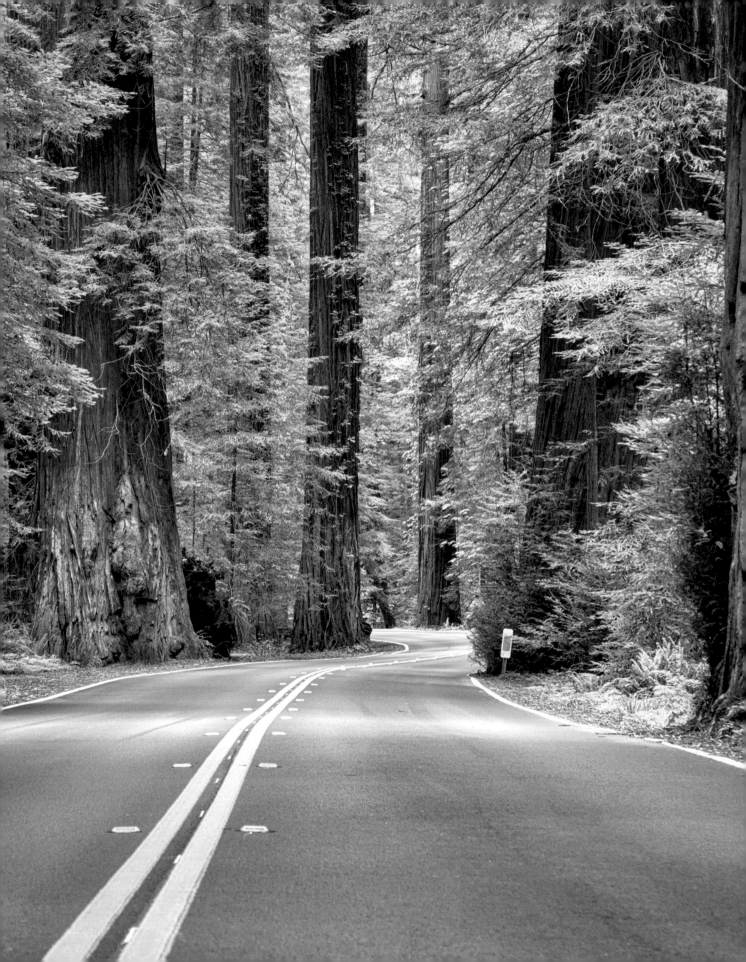

Layers

I keep referencing layers throughout this book, so let's get into them. You can absolutely make great edits in Luminar without using layers at all—that's the whole point of having so many editing tools at your disposal. However, Layers add another dimension to what you can do with Luminar.

Yes, that's a cliché, and it's also a small joke (the other dimension is Z, because you're stacking edits on top of each other). But layers open up possibilities. You can apply several instances of the same tool, for example, or try different editing experiments and then discard the versions you don't want.

Layers do introduce complexity, though, which is what this chapter is all about explaining.

Layers Fundamentals

If you've used layers in Photoshop or other image-editing apps, Luminar's implementation will be familiar, though not exactly the same. If you're coming from Lightroom or Apple's Photos, which don't use layers at all, this will be a new approach.

Imagine a physical photo, and then imagine a piece of tracing paper or a sheet of clear acetate on top of it. You can write on that top layer without affecting the original photo at the bottom, and you see both layers. You can also add more layers as needed.

Now take that idea to the digital image-editing realm. Each layer can include its own adjustments that change the appearance of the underlying photo. If you want to increase the exposure of the photo, for instance, you could create a new layer that applies that edit, which makes the photo below it brighter—but, crucially, the pixels in the photo itself don't change. As you stack layers, each one affects all the visible layers below it.

In Luminar, there's one additional thing to remember about layers: nearly all of the editing tools can be applied to each layer. For example, a layer can include settings from the Light tool, the Vignette tool, the AI Structure tool, the Dodge & Burn tool, and so on.

This structure gives you a couple of advantages. On a purely organizational level, you can separate adjustments onto their own layers, making it simple to turn those layers on or off as you work.

Practically, you can also apply multiple instances of a tool by putting each one on a separate layer. For example, perhaps you want to adjust the colors in one area of a photo differently from those in another area. Activating the Color tool on two layers lets you control them independently. (In that case you'd also use a mask to define the affected areas; we'll get into that in the next chapter.)

Let's look at a basic example to see how this works:

1. The original photo is underexposed, so I use the Light tool to brighten everything and work on the white balance **(Figure 8-1)**.

2. Specific areas could be darker, so I create a new adjustment layer, which sits on top of the original image layer. I use the Dodge & Burn tool to selectively darken those spots **(Figure 8-2)**. If I return to the Layers panel and select the bottom layer, the Dodge & Burn edits disappear, because I'm viewing only the original image layer.

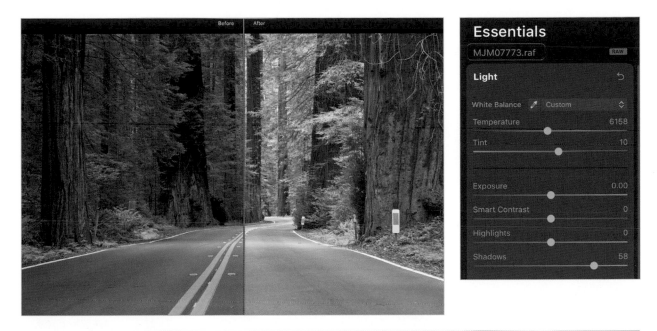

FIGURE 8-1: On the base image layer, I've applied some general tone edits using the Light tool. The layer name appears under the tool category (Essentials).

FIGURE 8-2: To draw attention away from the large tree at right, and to add more shading to the tree at left, I've used the Dodge & Burn tool on a new adjustment layer to darken those areas. I also burned the road in the foreground a little. To better keep track of things, I renamed the layer "Dodge & Burn."

3. I think this photo might look better in black and white, so I create another new adjustment layer, rename it "B&W," switch to the Essentials panel, and use the B&W Conversion tool to make the entire image grayscale. Note that the areas I burned are still dark because the Dodge & Burn layer is still visible under the B&W layer I just created **(Figure 8-3)**.

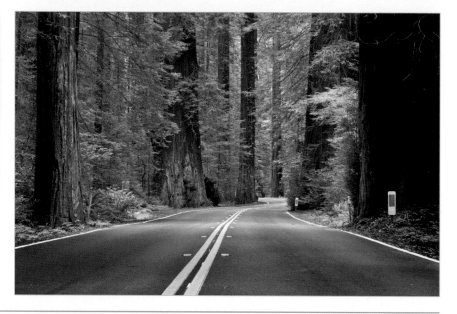

FIGURE 8-3: The new B&W adjustment layer contains only the edit to make the image black and white.

4. After some consideration, I realize that I do prefer the black-and-white version, but the burning is too much. I can preview the result by temporarily disabling that second layer **(Figure 8-4)**. Now, the black and white layer is interacting only with the image layer, so the burning isn't visible. If I want to, I can delete the burned layer.

I could have applied all of those edits on the original image layer and achieved the same results, since every layer can include adjustments from *all* the editing tools. But for my own sense of organization, making separate layers helps me organize edits into their own groups: in this case, tone (the original image layer), retouching (the Dodge & Burn layer), and black and white (the B&W layer).

In some situations, you'll be dealing with layers no matter what. Whenever you use the Erase or Clone & Stamp tools, Luminar creates a new layer (see Chapter 6).

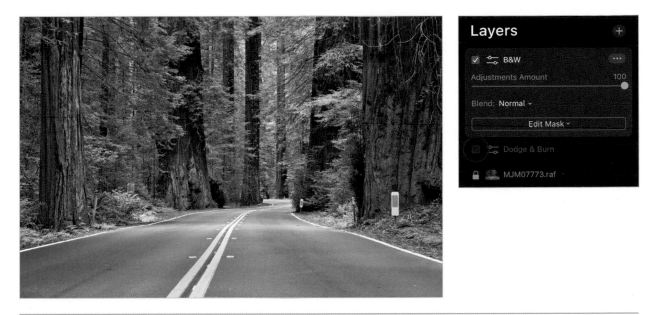

FIGURE 8-4: Removing the burn edits is as easy as disabling the Dodge & Burn layer. I have the flexibility to turn it back on or change that tool's edits (or any other tool on that adjustment layer) if I want.

Layer Types

Luminar offers three types of layers that each do separate things:

- **Adjustment Layer:** When you create a new adjustment layer, it starts only as a name (something thrilling, like "Adjustment Layer 1"). It contains no pixels, so it's not a copy of the base image, which is your photo. However, any editing you apply to this layer affects the appearance of the underlying image.

- **Image Layer:** An image layer contains a separate image you bring into Luminar, such as a texture, a watermark, or a closeup of your cat.

- **Stamped Layer:** In this context, "stamped" refers to creating a new merged layer that contains all of the edits on layers below it. Those layers are still there, but because the stamped layer is an image layer, it hides them (unless you change the layer's blend mode or opacity).

Work with Layers

All right, let's put this knowledge to the test. To create a new layer, do the following:

FIGURE 8-5: Create a new layer.

1. In the Layers panel, click the Create Layer (+) button and choose Add New Adjustment Layer, Add New Image Layer, or Create New Stamped Layer **(Figure 8-5)**.

 In the case of an image layer, navigate to the image file you want to bring in as that layer and click Open. One important thing to note is that image layer files are not stored within Luminar; they're referenced by their location on disk. If that file moves elsewhere or is deleted, Luminar can lose track of it.

2. Optionally, click the actions (●●●) button and choose Rename Layer, then type a descriptive title and press Return/Enter. This step helps you keep track of which edits are on the layers, preventing confusion when you're faced with Adjustment Layer 6 and you have no idea which editing tools were applied to it.

3. With that new layer selected in the Layers panel, switch to any of the editing panels. The name of the active layer appears at the top of the panel under the group name **(Figure 8-6)**.

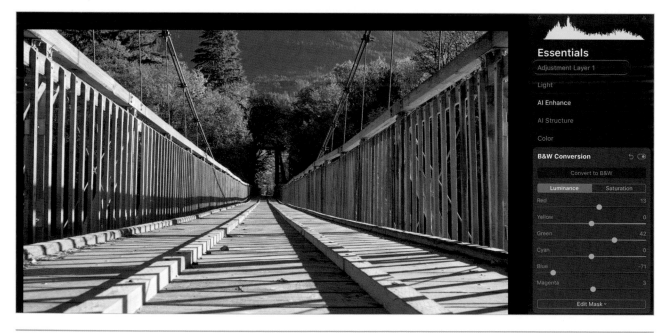

FIGURE 8-6: You can always see which layer you're on by looking for the name in the Edit panel.

Remember the example of the printed photo with the acetate overlay? Whichever layer is selected becomes the top layer, revealing its edits and the edits of the layers below it. Layers above are marked as hidden **(Figure 8-7)**.

In addition to applying edits, a number of layer-specific actions are available:

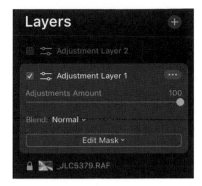

- **Adjustments Amount/Opacity:** In the Layers panel, use this slider to reveal how much of the edits are applied (for adjustment layers) or how much of the underlying layers show through (for image and stamped layers).

- **Visibility:** Click the checkbox to the left of the layer name to hide or show the layer. This is a great option when you're trying out different looks and layer combinations.

- **Blend Mode, Layer Transform, and Edit Mask:** We'll cover the first two shortly, and learn about masking in Chapter 9.

FIGURE 8-7: Although Adjustment Layer 2 is on top, it's hidden because Adjustment Layer 1 is currently selected.

The actions () button reveals still more options:

- **Image Mapping:** For image layers only, choose how the image fills the frame. Click the actions (•••) button and choose Image Mapping > Fill, Scale to Fit, or Fit **(Figure 8-8)**. If the new image doesn't match the underlying size—for instance, if you're working with a portrait-oriented photo and you add a landscape-oriented image—you can reposition the visible portion by choosing Scale to Fit and then using the Layer Transform feature to move the image (see "Layer Transform," later in this chapter).

- **Delete Layer:** Choose this option to remove the layer. Doing so doesn't affect the layers above or below it.

- **Duplicate Layer (macOS only):** If you want to quickly double the intensity of an edit, duplicate the layer. I also like this option when I'm experimenting with a look: duplicate a layer with its edits, then hide the layer you duplicated. Then, use the visibility checkbox to switch between the two to tell the differences.

- **Rasterize Layer (macOS only):** To *rasterize* is to burn any adjustments on that layer into an image, essentially converting it into a stamped layer. When you do that, all the adjustments are applied, but the controls are reset to zero.

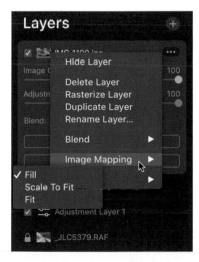

FIGURE 8-8: Choose how an image of a different size is displayed.

Since layer order is so important, you can also rearrange the stacking order in the Layers panel. Just drag a layer into a different position.

Blend Modes

There are two ways to approach blend modes: preview them all to see if one does something you like, or understand how they work and know which one to reach for at any given moment.

You can probably guess which approach applies to me. It ain't the second one.

Fortunately, both approaches are valid, and the more you use and understand how blend modes work, the more you drift into that second category where you can envision which mode will work the best for your photo.

How Blend Modes Work

The blend mode refers to the way the pixels in the active layer interact with the pixels on the layer below it. Depending on the mode, Luminar compares the values of each pixel that overlaps, and calculates a result based on tone or color.

With the default, Normal, selected in the Blend pop-up menu, the relationship is easy to understand: the top layer is entirely visible, obscuring the layer below (assuming the top is an image, which we're doing for the sake of explanation) **(Figure 8-9)**. The relationship here is that the active layer completely hides the layer below.

One simple way to blend the two layers would be to change the opacity of the top layer, so that some of the lower image shows through. At 50% opacity, the active layer's pixels are partially transparent.

The other blend modes use different calculations to achieve their effects.

Top layer 100% opacity *Top layer 50% opacity*

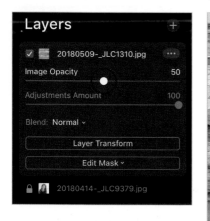
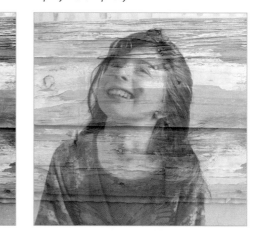

FIGURE 8-9: With a Normal blend mode and opacity set to 100%, the top image layer obscures the base image layer (left). At 50% opacity, the bottom layer shows through.

Choose a Blend Mode

Add a new layer above the base photo layer; an image layer will be most illustrative for our discussion here.

To change the blend mode, click the Blend pop-up menu in the Layers panel **(Figure 8-10)**. As you move the pointer over the menu items, the edited image displays how each mode will appear. Click a mode to select it.

Darken

Darker pixels from the base layer show through, while lighter pixels are replaced by pixels from the top image layer **(Figure 8-11)**.

Multiply

Each color on both layers is darkened, except for white, which is ignored.

Color Burn

The base color is darkened, as is the blend color where the two images overlap, and contrast is increased.

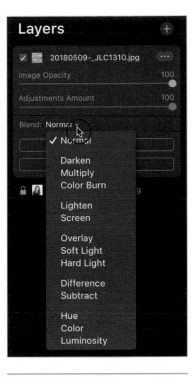

FIGURE 8-10: Choose a blend mode from the Layers panel.

Darken

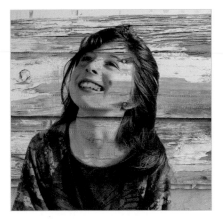

Multiply

Color Burn

FIGURE 8-11: The top three blend modes apply darkening effects between layers.

Lighten

The opposite of Darken, the Lighten mode displays whichever colors are lightest in the layers. Pixels that are darker than the blend color are replaced, while pixels that are lighter are left alone **(Figure 8-12)**.

Screen

Luminar examines pixels in each layer and inverses the blend color that results, leading to an even lighter result than the Lighten mode.

Overlay

When the colors of the blended layer are darker than the base, the two are multiplied. When the blended colors are lighter than the base, they're screened.

LIghten *Screen* *Overlay*

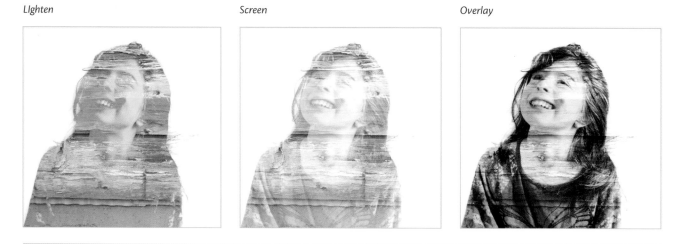

FIGURE 8-12: The Lighten and Screen modes work opposite of Darken and Multiply. The Overlay mode's effect depends on each layer's colors.

Soft Light

Soft Light performs the same actions as Overlay, but uses a Darken calculation instead of Multiply, and a Lighten calculation instead of Screen **(Figure 8-13)**.

Hard Light

Where the blended color is darker than 50% gray, the pixels are darkened; where it's lighter than 50% gray, the pixels are lightened.

Difference

Luminar looks at the layers' pixels and subtracts the values of each, based on which is the lightest.

Soft Light *Hard Light* *Difference*

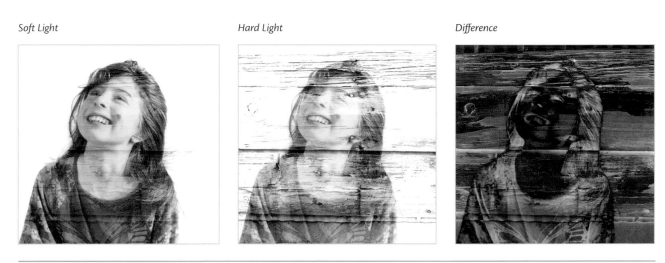

FIGURE 8-13: Soft Light and Hard Light create interesting textures. Difference, especially in this case, is cause for nightmares.

Subtract

This mode subtracts the value of the blended mode's pixels from the base layer **(Figure 8-14)**.

Hue

Luminar uses the overall hue of the blended layer and combines it with the saturation and luminance of the base layer.

Color

This mode applies the hue and saturation of the blended layer and the luminance of the base layer.

Subtract *Hue* *Color*

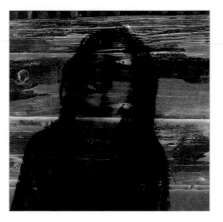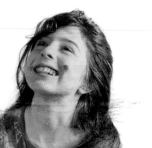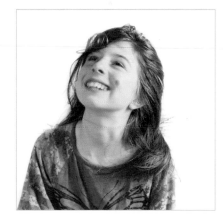

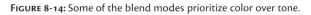

FIGURE 8-14: Some of the blend modes prioritize color over tone.

Luminosity

FIGURE 8-15: Make your own Banksy variation with the Luminosity mode.

Luminosity

This one is the inverse of the Color mode, applying the hue and saturation of the base layer and the luminance of the blended layer. You see the detail from the blended layer and the color of the base layer **(Figure 8-15)**.

Layer Transform

The last component of layers is the ability to transform them. Usually, a photo occupies the entire frame, but when it's on a layer, you can also scale, rotate, flip, and move it. When you're working with multiple images for a double exposure or collage, or adding a watermark or logo, the Layer Transform feature gives you the freedom to move elements around the image.

This is not the same as cropping the image, which removes the portions outside the visible area. The overall size of the canvas remains the same, but the image on the layer changes.

In the Layers panel, select the layer you want to work with and click the Layer Transform button to open its interface **(Figure 8-16)**. If an adjustment layer is selected, the transformation applies to the first image layer below it.

FIGURE 8-16: The Layer Transform interface resembles the Crop & Rotate interface, but in this case it applies only to the selected image layer.

From here, you can take several actions:

- **Resize:** Drag any of the edge or corner handles to resize the image. To keep its aspect ratio, click the Lock () button in the toolbar before you drag. You can also change the W (width) and H (height) values in the toolbar if you know the specific pixel dimensions you need.

- **Move:** Drag in the middle of the image to reposition it on the canvas **(Figure 8-17)**.

- **Rotate:** Drag outside the image edges to rotate the image on its center axis. Or, drag the Angle control in the toolbar or enter a degree of rotation.

- **Flip Horizontal and Flip Vertical:** Click the Flip Horizontal () and Flip Vertical () buttons to flip the image on the middle axes.

- **Rotate Left (CCW):** Click the Rotate Left (CCW) () button to rotate the entire image 90 degrees counter-clockwise.

- **Reset:** To return the image to its original state and remove the transformations, click the Reset button.

- **Done:** When you've finished transforming the layer, click Done.

FIGURE 8-17: The image layer has been resized and moved into position above the base image.

One thing the Layer Transform tool doesn't offer is the ability to crop an image on a layer, such as if you want just a portion of the image visible. However, since the image is on its own layer, the solution is to create a mask and paint the areas of the image you want to see **(Figure 8-18)**. It's not a perfect solution, but it's better than nothing.

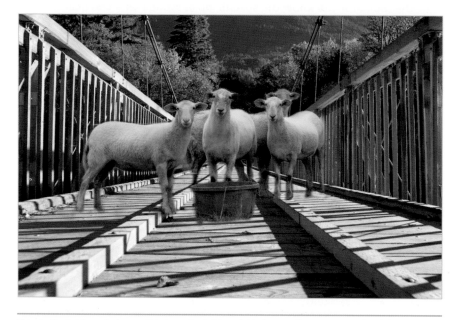

FIGURE 8-18: It's entirely possible I masked this quickly just to show an example of the technique. Ewe shouldn't judge the final result.

Blend Modes and Layer Transform: Add a Watermark

As a practical example of how to use all the layer features discussed so far in this chapter, let's add a watermark to a photo:

1. In the Layers panel, click the Create Layer (+) button and choose Add New Image Layer.

2. Locate an image file with a logo or text that can be used as a watermark and click Open.

3. If the image is scaled improperly (which is likely, unless it happens to be the same dimensions as your photo), click the actions (●●●) button for the layer and choose Image Mapping > Fit **(Figure 8-19)**.

4. The logo is still too large, so click the Layer Transform button.

FIGURE 8-19: Luminar automatically fills the image with an imported image, so the first step is to choose Fit and restore the logo to its proper dimensions.

5. Click the Lock () button in the toolbar and then drag the corner handles to resize the image to something manageable **(Figure 8-20)**.

FIGURE 8-20: Resizing the logo makes it much less attention-grabbing.

6. Reposition the image by dragging it into place, and then click Done.

7. Luminar can import common graphic file formats, but it doesn't recognize if transparency has been defined (such as in a .PNG file). That's okay, though, because we have blend modes at our disposal. In this case, with black text on a white background, click the Blend pop-up menu in the Layers panel and choose Multiply **(Figure 8-21)**. That knocks out the white and leaves the black.

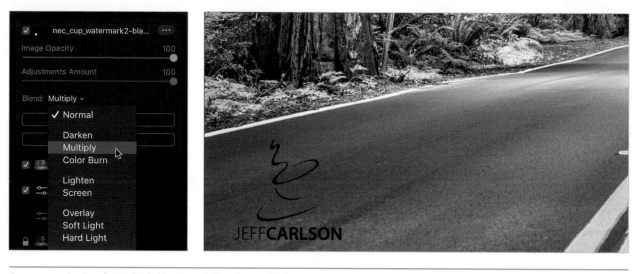

FIGURE 8-21: Setting the Multiply blend mode knocks out the logo image's white background.

What if the watermark would look better in white? Remember that every layer can take advantage of Luminar's editing tools. Click the Essentials group and open the Light tool. View the Advanced Settings to reveal the Curves control, and invert the image: drag the endpoints of the diagonal line so the line drops from the top-left corner to the bottom-right corner **(Figure 8-22)**. Back in the Layers panel, change the blend mode to Screen (which produces the opposite effect of Multiply).

8. To wrap it up, drag the layer's Image Opacity slider to about 40 **(Figure 8-23)**.

In a few steps, we've added a watermark to the image **(Figure 8-24)** and also hit every feature in this chapter.

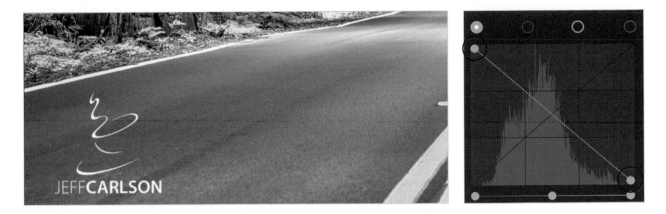

FIGURE 8-22: To invert the image, adjust the Curves control so the line runs opposite the default, pointed diagonally down instead of up.

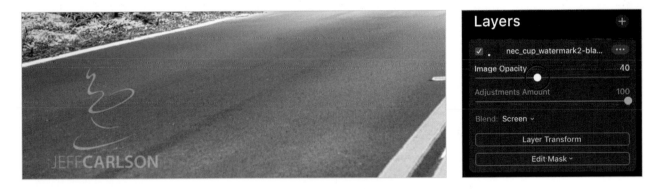

FIGURE 8-23: Reducing the opacity makes the watermark blend into the photo.

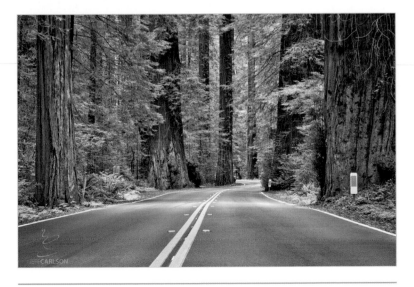

FIGURE 8-24: The finished watermarked photo.

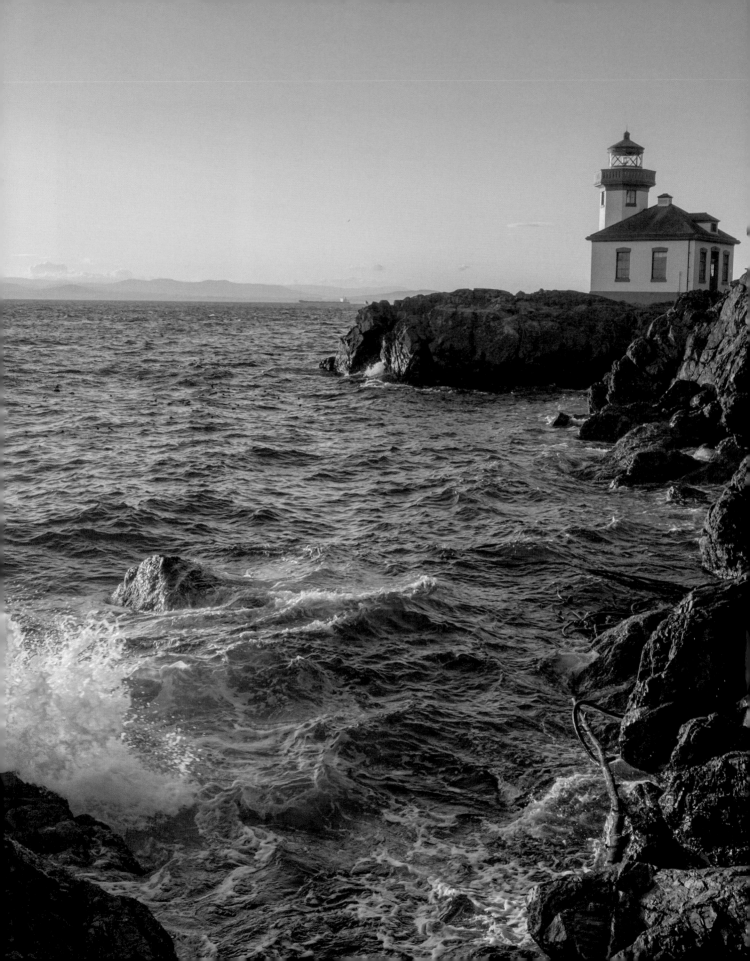

Advanced Editing

9

So far in this book, we've covered all the basics of editing photos, from importing photos to applying edits to working with layers.

Now it's time to introduce some of the more advanced tasks such as masking, which can be done for each layer or even for each tool, and assorted features such as batch processing, syncing adjustments, and working around a few specific situations like dealing with reflections using the AI Sky Replacement tool.

Masking

The concept of masking is pretty simple. Think of a literal mask, whether that's a superhero's cowl or a knitted balaclava to protect the face from the cold. A mask hides some areas and exposes others, and you have control over what is revealed.

In photography, a mask is used in the same way, hiding an edit's results from some areas of a photo so that the effect is visible in other areas. For example, you may want to isolate an object in color against a black-and-white background **(Figure 9-1)**. Using a mask, you can ensure that only the object receives the treatment.

Typically, masks are associated with layers (which I talked about at the end of Chapter 8). The mask affects all edits made to that layer. The exception is that you cannot apply a mask to the base image layer, since masking it would reveal nothing underneath; Luminar does not have the option for creating a transparent underlayer like Photoshop does. But any adjustment, image, or stamped layers above the base layer can be masked.

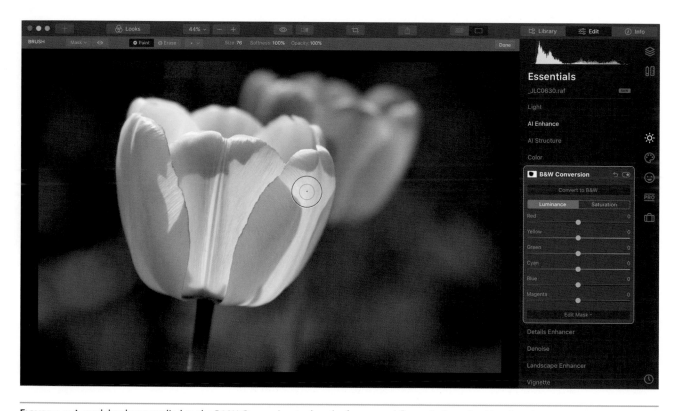

FIGURE 9-1: A mask has been applied to the B&W Conversion tool so the foreground flower is the only object in color.

In Luminar, each tool can have its own mask, too, which gives you a lot more control over how edits are applied to an image. Four styles of masks are available, depending on which types of areas you want to edit: Brush, Radial, Gradient, and Luminosity masks.

Masking Fundamentals

Before we get to those specific styles, however, let's cover some fundamentals that apply to all masks.

First, it's important to remember that a mask itself is just black and white. Black areas are always hidden; white areas are always revealed. And areas that fall in the range between black and white are partially transparent according to their grayscale value. When a mask is visible, Luminar shows it as a bright, can't-miss-it red overlay, but the mask itself is really grayscale.

Next, there are some commands you'll use on any kind of mask. Click the Mask button in the Mask toolbar to reveal the following options **(Figure 9-2)**:

FIGURE 9-2: The Mask menu appears in the toolbar in the masking interface.

- **Fill:** This option is the same as having no mask at all; the entire image mask is white (or red if the mask is visible), so edits apply to all areas.

- **Invert:** Choose Invert to flip all the masked pixels. In radial masks, this is the difference between revealing edits within the masked circle and outside it. You can also click the Invert button on the mask toolbar when it's available.

- **Clear:** Choose Clear to remove the mask entirely, effectively filling the mask entirely in black. No edits are revealed. When working with a radial or gradient mask under Windows, clicking the trash can (🗑) button in the Mask toolbar also clears the existing mask; on Mac or Windows you can also press the Delete key.

- **Copy:** The ability to copy and paste a mask is useful when you're editing several photos from the same session (such as a portrait shoot). Choose Copy from the Mask menu to copy the mask to the clipboard.

- **Paste:** To add the copied mask to another photo, switch to that image and create a new mask: click the Edit Mask button and choose Brush. Then choose Paste from the Mask button in the Mask toolbar.

Lastly, masks are additive: although each layer or tool can have only one mask, you can use the masking tools to define several masked areas. For instance, in a landscape photo you could apply a gradient mask to brighten the lower portion of a photo and then use the brush to make sure the mountains in the middle ground also get the same treatment. Or, you could add multiple radial masks to minimize the highlights cast by several lampposts.

Brush Mask

The Brush mask tool offers the most flexibility when creating a mask because you paint the areas that will be affected. You can also use it to augment other existing masks (such as painting areas that have already been affected by a luminosity mask).

To create a mask using the Brush mask tool, do the following:

1. If you're masking a layer, make sure you're on a layer that is not the base image (which cannot be masked). In the Layers panel, click the Create Layer (+) button and choose Add New Adjustment Layer (or one of the other options).

 If you're creating a mask for a tool, switch to that tool.

2. Make the edits on the layer or in the tool that you want to mask. At this point the effects apply to the entire image, but that's okay **(Figure 9-3)**.

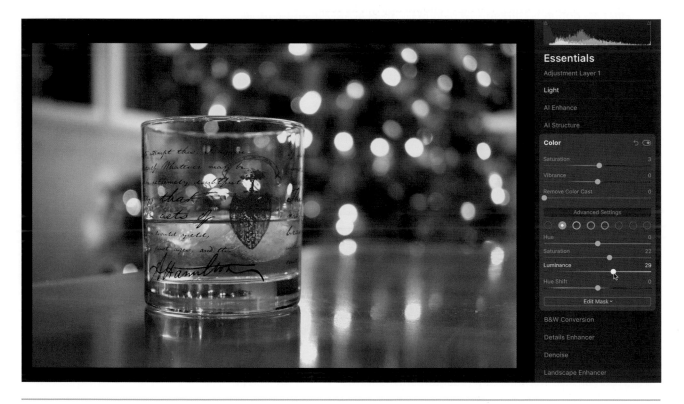

FIGURE 9-3: It looks like I've stepped into the 1970s, but actually I'm only making adjustments with the color of the whiskey in mind.

Alternatively, you could create a mask and then make the edits. I prefer to edit first when using the Brush mask tool because it gives me a better visual idea of the result once I start painting.

3. In the Layers panel or the edit tool, click the Edit Mask button, and choose Brush **(Figure 9-4)**.

4. In the Brush toolbar that appears at the top of the window, make sure the Paint option is selected. Use the Size control or the bracket keys on your keyboard to change the size of the brush.

 Use the Softness and Opacity settings to determine the intensity and falloff of the paint strokes. You can also hold Shift and press the bracket keys to adjust the softness from the keyboard.

 The Size, Softness, and Opacity sliders can also be found in the Brush Settings () button (which displays a preview of the brush size).

5. Paint the area on which the edits should apply. The rest of the image reverts back to the state before you made the most recent edits, and only the brushed area will reveal the new look **(Figure 9-5)**.

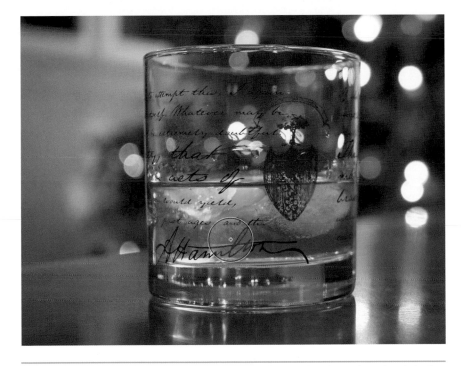

FIGURE 9-4: The mask I'm creating applies to the entire layer, which means I can use any tool I want to affect just the visible area.

FIGURE 9-5: As soon as you start painting with the brush, the effect shows through only in the painted area. By making the adjustments first, I can better see where I want to reveal them.

If you overpaint an area, switch to the Erase option. Press the X key to toggle between the Paint and Erase options. You can also hold Option/Alt as you drag to activate the opposite option.

6. Click the Show Mask () button in the toolbar to display your brush strokes in red **(Figure 9-6)**.

FIGURE 9-6: Showing the mask makes it easy to see which areas are painted.

FIGURE 9-7: The mask thumbnail indicates a mask is applied to the layer.

7. Click Done to finish editing the mask. You'll see a mask thumbnail next to the name of the layer or the editing tool to indicate that a mask is in use **(Figure 9-7)**.

Once the mask is created, of course, you can adjust the settings of the edits you made on that layer or in that tool.

The Brush mask tool includes a few more options than the other mask tools:

- **Density:** Click the Mask pop-up menu in the Brush toolbar to reveal general masking options. Density is almost like a reverse opacity: at its highest value (the default), only the area you brushed reveals the adjustments. When you lower the Density amount, some of the effects bleed through to the rest of the image.

- **Feather:** Think of Feather as a way to blur the edges of the painted area. This is especially helpful when blending the masked area into the rest of the image.

- **Pen Pressure:** Click the Brush Settings () button. On computers with an attached stylus or that accept touchscreen input, go to the Pen Pressure setting and choose whether variable pressure changes the brush size (Radius), opacity (Opacity), or both.

Radial Mask

Let's apply what we've learned about the Brush mask tool and masks in general toward creating a radial mask, which creates a circular area that feathers into the rest of the image. To create a radial mask, do the following:

1. On a new layer or using a tool, make the adjustments you want to appear within the radial area.

2. In the Layers panel or with a tool active, click the Edit Mask button and choose Radial Mask.

3. Position the pointer at the center of the area you wish to mask, and then click and drag outward to create the radial mask **(Figure 9-8)**.

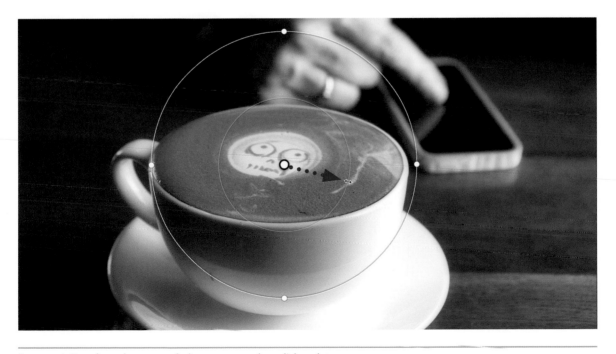

FIGURE 9-8: Drag from the center of where you want the radial mask to appear.

187

The default behavior is to fill the radial mask with black, which means the edits you made apply *outside* the radial area. This approach is counterintuitive to me for some reason, but it's easily remedied: click the Invert button on the Radial Mask toolbar **(Figure 9-9)**. Or, leave it as-is if you really are protecting the area inside the circle.

4. Click the Show Mask (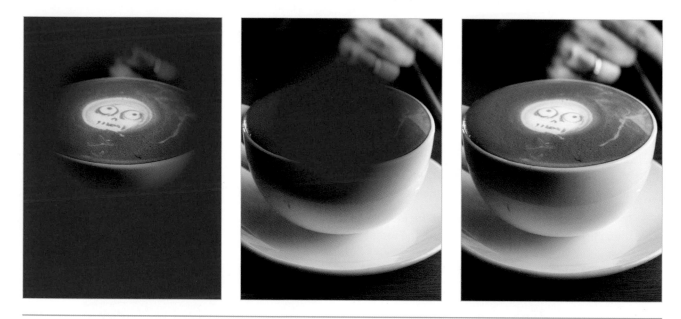) button in the toolbar to display the mask in red if you want help visualizing the masked area.

FIGURE 9-9: A radial mask's effect applies outside the circle (left). Invert the selection (middle) to make it appear inside the circle (right).

5. Adjust the size, shape, and position of the radial mask using the following controls:

 • Drag the center point or anywhere within the circle to reposition the mask; the pointer becomes a hand cursor.

 • Drag the edge of the inner circle to resize the entire mask proportionally.

 • Drag any of the outside control points to pull the circle into an elliptical shape **(Figure 9-10)**.

 • Drag the edge of the outer circle to adjust the amount of feathering between it and the inner circle. The further the outer circle appears, the more gradually the mask fades into the rest of the image.

- Drag outside the outer circle to rotate the mask. You can also drag just outside the center point to rotate the mask.

6. Click Done when you're finished creating the mask.

FIGURE 9-10: Resize the radial mask area using the control points and edges of the circle.

Gradient Mask

A gradient mask creates a linear gradient—a straight line that crosses the entire image and blends from black to white. For example, a gradient mask is great for illuminating the foreground in a landscape photo (although you may get the results you want using the Adjustable Gradient tool, covered in Chapter 5).

Here's how to create a gradient mask:

1. On a new layer or using a tool, make the adjustments you want to appear within the radial area.

2. In the Layers panel or with a tool active, click the Edit Mask button and choose Gradient Mask.

FIGURE 9-11: Gradient masks are great for photos with a distinct horizon or other line bisecting the image. Here, I want to make the foreground darker and more distinct.

3. Position the pointer at the middle of the area you wish to mask, and then drag to create the mask **(Figure 9-11)**.

4. Click the Show Mask () button in the toolbar to display the mask in red if you want help visualizing the masked area.

5. Adjust the position and the size of the gradient of the mask using the following controls:

 • Drag the center point to reposition the mask; the pointer becomes a hand cursor.

 • Drag either outer bar to adjust the size of the gradient. Each bar represents the pure black or white end of the spectrum **(Figure 9-12)**.

 • Drag the middle line to rotate the mask around the center point.

6. Click Done when you're finished creating the mask.

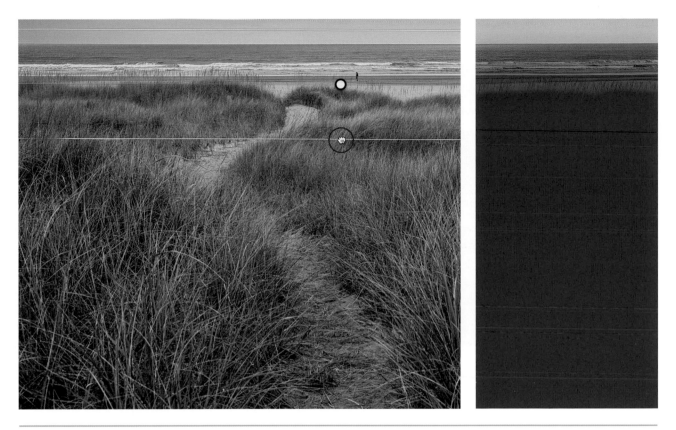

FIGURE 9-12: I've adjusted the gradient so the effect is at full strength up to the bottom line, and then blends vertically to 0% at the top line. You can view the effect with Show Mask turned on (at right).

Luminosity Mask

In each of the preceding mask types, the range between black and white is under your control, whether you're painting with a brush or creating gradients. A luminosity mask, on the other hand, has no manual controls other than just applying it. And yet, in some situations the luminosity mask will allow you to make more targeted adjustments than the other masks.

With a luminosity mask, Luminar looks at the brightness of all the pixels in the image and creates a mask based on those values. The lighter an area is, the more the edits show through. That enables you to edit brighter sections of a photo and not worry about whether you're adversely affecting the darker areas, or vice-versa.

Adding a luminosity mask is just one menu item, so let's walk through a photo to see how it works. In this example, I want to bring up the exposure and shadows in the rocks and accentuate the golden afternoon sunlight **(Figure 9-13)**. What I do *not* want to do is blow out the sky or the water.

FIGURE 9-13: Our starting point.

1. If I simply increase the Exposure and Shadows values in the Light tool, I end up exactly where I don't want to be **(Figure 9-14)**.

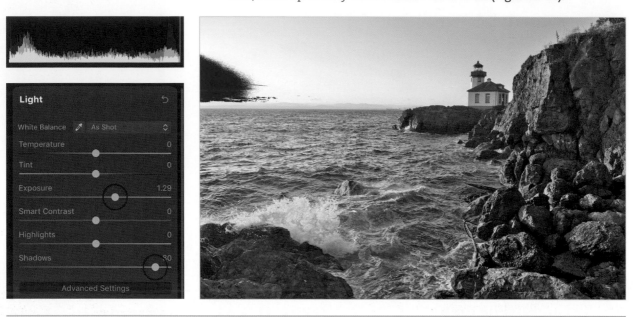

FIGURE 9-14: Increasing the exposure without a mask fixes the dark rocks, but blows out the left side of the sky (shown with clipping visible).

Instead, I create a new adjustment layer in the Layers panel, click Edit Mask, and choose Luminosity. When you see the mask thumbnail appear in the layer name, you know the mask has been created.

2. To view the mask, I'll click Edit Mask and choose Brush to enter the mask interface, then click the Show Mask button or press the slash (/) key **(Figure 9-15)**.

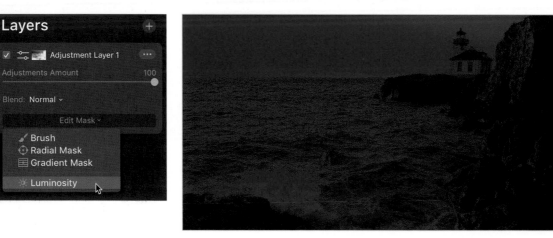

FIGURE 9-15: I've applied a luminosity mask to this adjustment layer and chosen to show the mask.

The areas with the most red represent the brightest parts of the image; on the mask itself, those are the lightest pixels.

3. Since I want to work on the darkest areas of the photo, the rocks, I'll go to the Mask pop-up menu in the Brush toolbar and choose Invert **(Figure 9-16)**.

4. Click Done to exit the mask editor.

5. Switch to the Essentials group, and in the Light tool, increase the Exposure and Shadows values. The sky and water are affected, but minimally, while the rocks become brighter **(Figure 9-17)**. When you look at the histogram, you'll see that the right edge of the graph is still pretty sparse, which is good.

FIGURE 9-16: Inverting the luminosity mask lets me edit the dark areas.

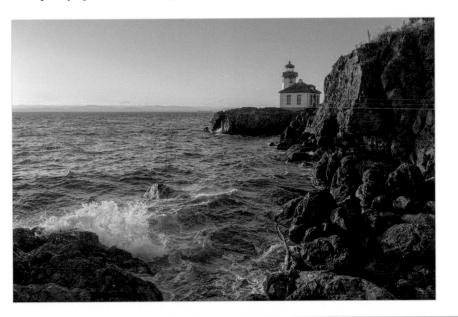

FIGURE 9-17: I've applied almost the same adjustments, but the highlighted areas are protected. The rocks are brighter, but the sky and wave are still manageable.

6. Activate the Landscape Enhancer tool and increase the Golden Hour control to warm up the rocks **(Figure 9-18)**.

When I return to the Layers panel, I can toggle the adjustment layer's visibility to see the before and after. The change in the sky in the top-left corner is subtle, because that area was mostly protected by the luminosity mask.

FIGURE 9-18: The rocks are warmer, but the sky isn't affected.

Another advantage of luminosity masks is that, because they're based on tonal values, they can mask areas that you might otherwise have to create masks for by hand. If you're editing a sky, applying a luminosity mask can protect the darker foreground elements, including any that stick up into the area you're editing, such as trees or buildings **(Figure 9-19)**.

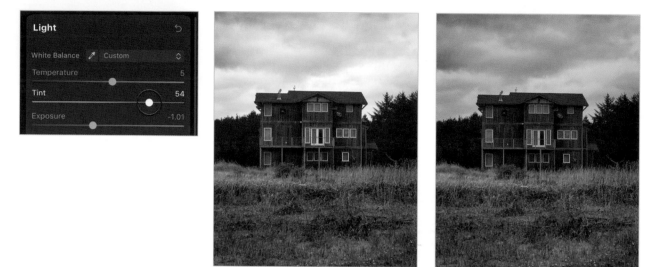

FIGURE 9-19: The luminosity mask applied here (left) makes it possible to tint the sky without affecting the darker roof.

That makes it easier when using the Dodge & Burn tool, for instance, because you can paint directly over the intruding element and not affect its tone **(Figure 9-20)**.

FIGURE 9-20: Normally, burning this section would blacken the corner of the roof, but here it's protected.

Editing a Portrait Using a Luminosity Mask

Luminosity masks are used often when editing landscape photos, but remember the mask's purpose: to protect dark areas and work on the light areas. That applies to all sorts of photos, including portraits, where lighting is critical to capturing the moment.

In this example, I have a photo that's intentionally dark. If I simply increase the Shadows or Exposure values, I improve the subject's skin, but also over-light the background and shirt **(Figure 9-21)**. I want to preserve that darkness and mood. Even using the AI Enhance tool reveals too much detail because it's trying to balance the entire image.

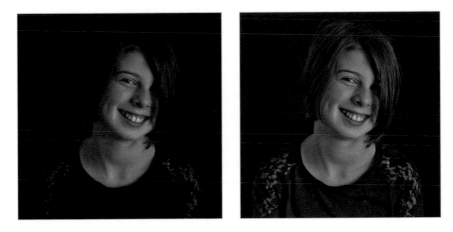

FIGURE 9-21: Increasing the exposure with no mask (right) reveals too much detail.

Instead, I create a new adjustment layer and apply a luminosity mask. Increasing the Shadows and Exposure sliders brightens the skin on her face, neck, and arms, but she's still enveloped in darkness **(Figure 9-22)**.

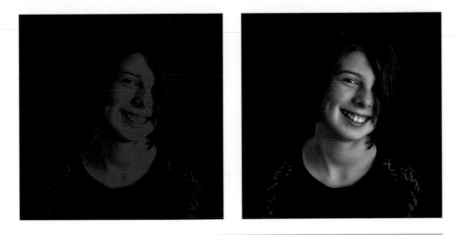

FIGURE 9-22: The luminosity mask (visible at left) allows me to increase the exposure of just the skin tones (right).

Layer Compositing

You can use your knowledge of layers and masks to blend multiple images into creative compositions **(Figure 9-23)**.

1. Open an image in the Edit mode.

2. In the Layers panel, click the Add Layer (+) button and choose Add New Image Layer.

3. Locate the image you want to add to the composition. When you add a new image layer, the photo you add must come from the hard disk, not the Luminar Library. Click Open.

4. If necessary, use the Layer Transform tool in the Layers panel to resize and reposition the new image. Make sure you do this before any masking, because the mask does not transform along with the layer.

5. Click Edit Mask and choose Brush.

6. Use the Brush mask tool to reveal the areas of the new image. It's often helpful to set the layer's Image Opacity slider to 50 so you can better see what you're working with.

7. Click Done when you're finished with the mask **(Figure 9-24)**.

FIGURE 9-23: Using image layers, we can composite these two photos together.

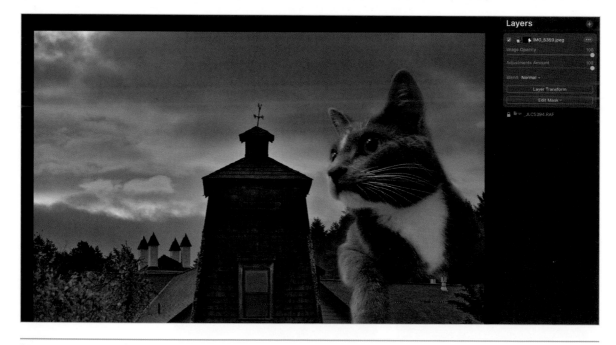

FIGURE 9-24: You never know where a cat will decide to hang out in the morning.

I've used a fanciful example here, but you can also use these techniques for exposure blending, such as when you have extreme differences in lighting between photos. Make sure each image was shot on a tripod so they align perfectly, put them onto image layers, and then use the Brush mask tool to paint elements from one image while hiding others.

Sync Adjustments

When you have several images from the same photo shoot, you can edit one and then easily synchronize all of the adjustments to the others, saving a lot of time.

To sync adjustments, do the following:

1. Edit one of the photos to your liking, and then switch to the Gallery mode (click the Gallery Images mode (▦) button or press the G key).

2. Make sure the image you edited is selected first, and then select the other images to which you want to apply the same adjustments **(Figure 9-25)**. The first image appears with an orange outline to note that it's the master, while the others are outlined in white.

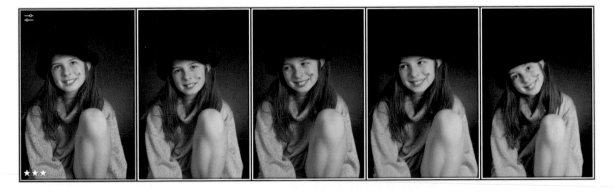

FIGURE 9-25: The adjustments from the first image selected (with the orange border) will be synced to the other images.

3. Choose Image > Adjustments > Sync Adjustments, or press Command/Ctrl-Shift-S. After a few moments, the thumbnails of the selected images change to indicate the edits are now applied to each.

When you edit any of the images, you'll see that they incorporate the same edits. If you've used any adjustment layers, those layers are also copied to the synced images.

197

In fact, any AI-based adjustments are smartly applied. The Portrait Enhancer tool, for example, determines where a person's face is in each shot before adding its settings, such as Face Light or Teeth Whitening; the tool is applied even if the model may have moved between shots.

However, there's a caveat: if you sync adjustments from an image with image layers other than the base photo (such as one made by using the Erase or Clone & Stamp tools, or by adding a new image layer), that layer is not copied to the synchronized images. You'll need to re-do any touch-up work, such as removing blemishes or dust spots, for each image.

Both layer and tool masks, however, do transfer between synced images. You may need to manually adjust the masks in the other images you sync.

Deal with Sky Reflections in AI Sky Replacement

The AI Sky Replacement feature is certainly one of the standout tools of Luminar, and it's quite remarkable how the software identifies the sky and intelligently works around objects that project into it.

What the AI does not comprehend is when the sky is reflected, such as in a body of water. That leads to a mismatch that ruins the illusion—a cloudy sky and a clear pool do not match. However, you can work around this with just a little more work with layers. Here's how:

1. In a photo with a prominent reflection of the sky, use the AI Sky Replacement tool to insert a new sky. Very important: load one of your own sky images, not one from the collection built into Luminar.

2. Edit the AI Sky Replacement settings to position the sky where you want it in the frame **(Figure 9-26)**.

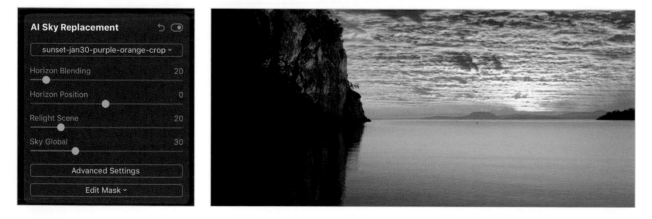

FIGURE 9-26: I've replaced the sky in this photo with an image of a cloudy one, but the water reflection still shows the clear sky.

3. In the Layers panel, click the Create Layer (+) button and choose Add New Image Layer. Select the same image file you used for the sky. It will overlay your original image.

4. Reduce the layer opacity to 70 or so to view the underlying image **(Figure 9-27)**.

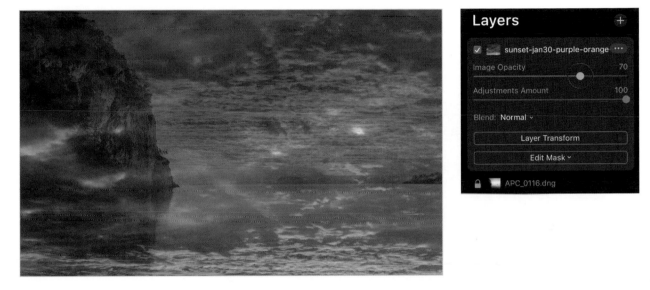

FIGURE 9-27: The imported image covers the entire photo, so it helps to reduce the opacity to see both layers.

5. Click the Layer Transform button.

6. Click the Flip Vertical (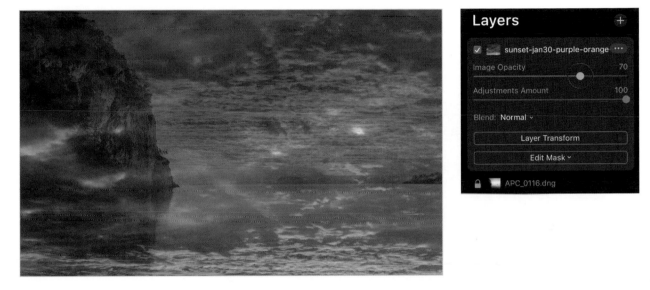) button, and then drag to reposition the sky so that it appears in the reflected area **(Figure 9-28)**. You may also need to resize the image if, in the AI Sky Replacement tool, you adjusted the Horizon Position control, because that scales the imported image to fit the frame.

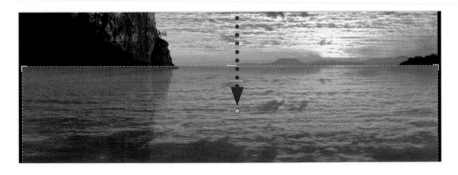

FIGURE 9-28: Flipping the image creates the reflected version, which is then moved into place.

7. When you're happy with the position of the reflection, click Done to exit the Layer Transform interface.

8. Still in the Layers panel, click Edit Mask and choose Brush. With the Brush mask opacity set to 100%, paint the reflected area to reveal the flipped image layer **(Figure 9-29)**.

 You may also want to try switching to a blend mode, such as Multiply, or adjust the image layer's opacity to see if that gives you a more realistic looking reflection.

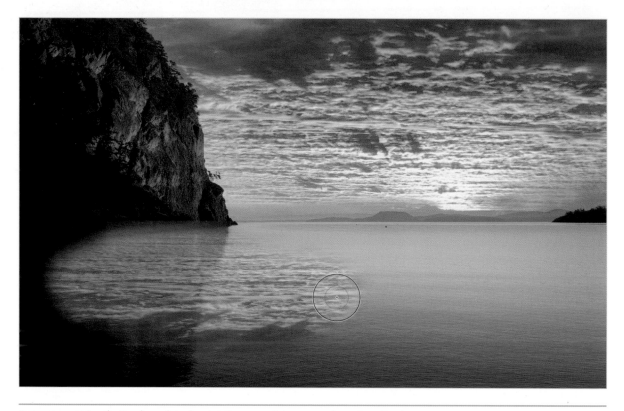

FIGURE 9-29: Using the Brush mask tool, paint the areas of the water where the reflection appears.

9. Set the Brush mask opacity to about 40%, switch to the Erase mode (or just hold Option/Alt), and paint any areas where objects other than the sky are reflected. Since those objects are closer to the water than the sky, their reflections need to be clearer.

10. Click Done to exit the Brush mask tool and view the finished result **(Figure 9-30)**.

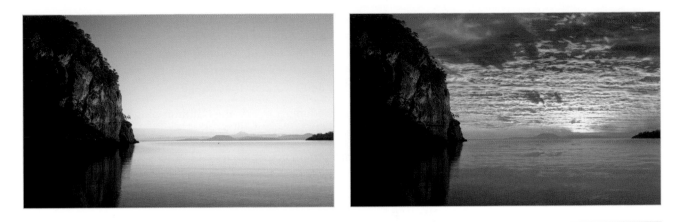

FIGURE 9-30: The original photo (left) now includes a dramatic sky reflected in the water (right).

It can take some practice and fiddling to get the reflection to match up correctly, but that's part of the challenge: you're working to convince the viewer that the replaced sky was there all along.

Automating with Photoshop Actions

Since Luminar can be used as a plug-in for Photoshop, that opens up the possibility of putting Luminar into automated Photoshop Actions.

For example, you may have created a Luminar Look that you want to apply to a set of photos, or you want to take advantage of Luminar's portrait tools to smooth skin, whiten teeth, and enhance eyes across a set of shots. When you hand the image from Photoshop to Luminar in an action, those edits get applied and then returned to Photoshop.

Here's how to record such an action:

1. In Photoshop with a representative image open, make the Actions panel visible (choose Window > Actions).

2. Click the Create New Action (□) button, give the action a name, and click Record **(Figure 9-31)**.

3. Choose Filter > Skylum Software > Luminar 4 to open the Luminar plug-in.

4. Make the edits in Luminar that you wish to apply to any future photo that uses this action. That can include edits on adjustment layers, which are also created for each processed image.

FIGURE 9-31: Create a new Photoshop action that sends a photo to Luminar.

Here's where making edits on adjustment layers becomes an advantage. Suppose your action not only applies effects using the Portrait tools, but also the Glow and AI Structure tools. If they're each on separate adjustment layers, it's simple and quick to turn any of them off if you decide they don't work for that image.

5. Click Apply in the toolbar to exit the Luminar plug-in and return an edited version of the image to Photoshop.

6. If there are any other Photoshop-specific edits you wish to include in the action, do those now.

7. Click the Stop Recording (■) button in the Actions panel to save the action.

To take advantage of the action you just created, open a different image that will benefit from its edits. Then, with the action selected in the Actions panel, click the Play Selection (▶) button. The Luminar plug-in runs and applies the edits you made. If you need to tweak any of the settings in Luminar, go ahead, and then click Apply.

You can also use the action as the basis for batch-editing a bunch of photos. Choose File > Automate > Batch, specify the Luminar action, choose which files are to be processed, and where the edited files will be saved. Note that for each one, you'll still need to click Apply in the Luminar plug-in.

Strategies for Speeding Up Luminar

Although publicly we say that what matters most is the finished photo, I don't know anyone who wouldn't want to reach that point faster. Some methods of speeding up Luminar are obvious: a newer, faster computer will tend to give the program more pep just because the hardware can process instructions more efficiently. But there are a few things you can do to speed up your interaction with Luminar that don't involve shelling out money for new hardware.

- **Hide the Looks panel.** I can make arguments in favor of Luminar Looks, but one thing that annoys me is actually a feature: the thumbnails in the Looks panel update to show the current photo with their effects applied. That's good, but it takes them a while to populate.

 What you may not realize is that you can start editing while the thumbnails are updating. Luminar doesn't make you wait until the panel is ready. However, even the perception that the thumbnails are

taking time to draw still feels like a slow-down to me. So, if you're not currently using the Looks panel, click the Looks button in the toolbar or choose View > Hide/Show Looks Panel to hide it until they're needed. That also gives you more screen real estate to work with.

- **Increase the Cache Size (macOS):** As you edit, Luminar creates cache files, temporary working files that it can reference to speed things along. On the Mac, you can increase the maximum amount of disk space allocated for caching. Choose Luminar 4 > Preferences and increase the Max Size for Caching slider **(Figure 9-32)**.

- **Use Graphics Processor (macOS):** If your computer has a decent graphics processor (GPU), Luminar can tap its power to speed up rendering edits and other tasks, and free up the main processor to calculate other edits. Choose Luminar 4 > Preferences and, under Graphics, set Use Graphic Processor to On.

 The Windows version of Luminar relies more on the central processor (CPU) and RAM than on a GPU, which is why there's currently no similar setting under Windows. I'm hoping that a future update starts to take better advantage of the processing power of GPUs.

FIGURE 9-32: The macOS version includes a setting for assigning more cache memory for Luminar to work with.

- **Use Stamped Layers:** File this one under "Your Mileage May Vary," but it's worth a try in some situations. When you stack lots of adjustment layers, Luminar works harder to calculate the effects they all apply to the underlying image. If editing is starting to get sluggish, create a new stamped layer that incorporates all of the adjustment layers below it: in the Layers panel, click the Create Layer (●) button and choose Create New Stamped Layer. Then turn off the adjustment layers below it by clicking the checkbox next to each layer's name.

 You can then continue to edit by adding more adjustment layers above the stamped layer. If you decide you need to change an edit on one of the hidden adjustment layers, no worries: hide the stamped layer, make the change, and create a new stamped layer that reflects the new appearance.

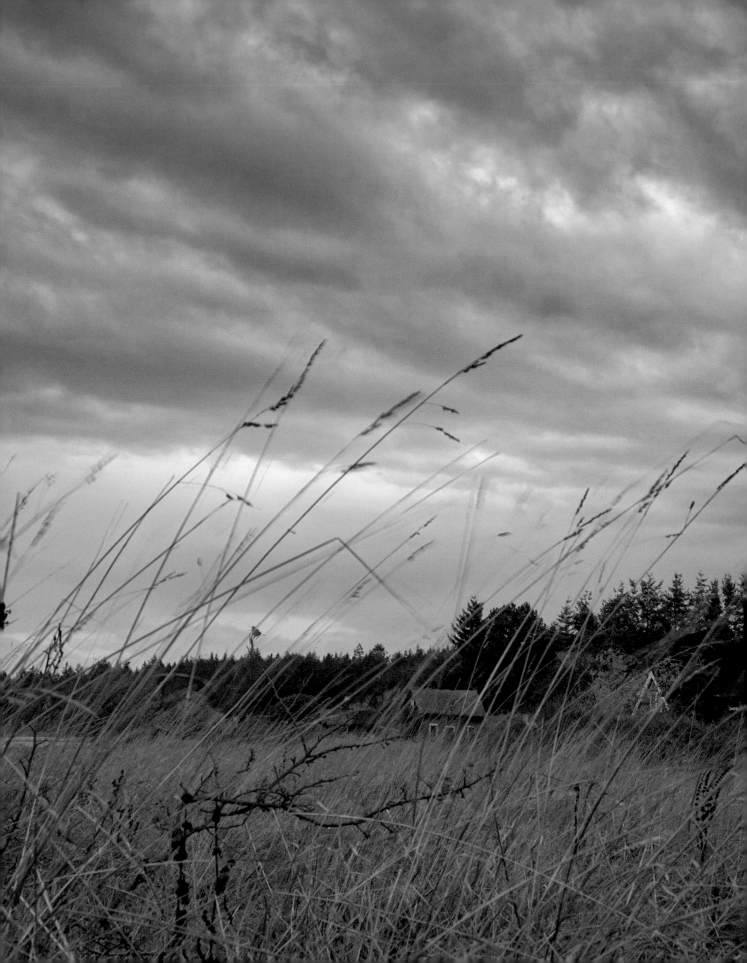

Luminar Library

Until recently, Luminar was strictly an image editor, which meant you had to wrangle your photo library separately. Perhaps you stored the image files in folders, or leaned on the organizing features of an application such as Apple's Photos, Adobe Bridge, or Photo Mechanic.

I know many photographers make it work, but I can't stress enough how much better the workflow is when management and editing features are melded together in the same application. You can browse all your photos visually in one place, regardless of where the files are stored on disk—or on network volumes. And when you edit a shot, you don't need to worry about where the edited version exists, or what format it is. You can keep your mind on the creative task of editing instead of feeling like an office drone shuffling files around.

In Luminar, your photos are handled by the Luminar Library, a long-awaited component that I believe makes Luminar much more intuitive. The Luminar Library isn't yet a full-fledged digital asset manager (DAM), but it's a solid first step that proves to be immediately useful.

I covered how to add photos to the Library in Chapter 2. Here, I'm focusing on the other features of the Library, such as navigating your image collection, rating photos, and sorting and filtering them. I also address backing up and restoring the catalog.

Use Library Shortcuts

FIGURE 10-1: Any photos shot on today's date in the past appear in a special On This Day shortcut.

Shortcuts quickly reveal photos based on several criteria, so you can jump to the ones you want right away. In the Library panel, click the Show button that appears to the right of the Shortcuts entry if you don't see any of the shortcuts.

Select a shortcut depending on what you want to view. For example, All Photos displays the entire library, while Favorites shows only images you've marked as favorites. As you work, additional shortcuts automatically appear, such as Recently Added, Recently Edited, or On This Day (which shows up only when photos exist in the library with today's date in previous years) (**Figure 10-1**).

If you know when a photo was made, expand the All Photos entry to reveal listings for years, months, and days (**Figure 10-2**). Selecting any of those displays only the photos from that date range.

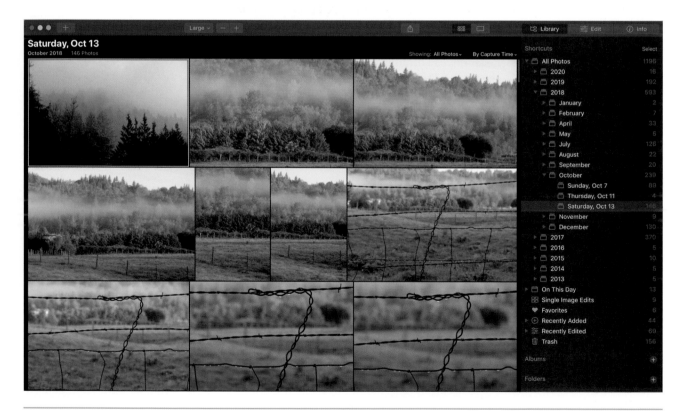

FIGURE 10-2: Expand the All Photos shortcut to drill down to specific dates.

Rate and Flag Photos

Part of the motivation for keeping your photo collection in a library is to have fast, visual access to all your images, but it's also important to be able to easily determine which ones are good and which ones can be ignored or tossed.

After I import a batch of photos, I quickly scan through them and assign ratings and flags to find the ones that stand out. This task is made easier by keyboard shortcuts that speed up the process (so I can get to editing faster).

Luminar offers three ways of flagging images: star ratings, Flagged/Rejected labels, and color labels. Depending on your preference, use any or all of them. I rely mostly on star ratings along with the Rejected flag for images I know I want to delete; it's faster to mark bad images as rejects and then delete them as a group later instead of deleting them one by one. Secondarily, I use color labels to group images for specific tasks, such as marking ones I intend to share on social media.

The goal is to be able to filter your library and surface only the shots you want without the distraction of misfires or mediocre images getting in the way. Here's how to apply each type:

Star Ratings

With a photo selected in the Library, do one of the following:

- Press a number key between 1 and 5 to assign the corresponding number of stars.

- Press the bracket keys ([and]) to raise or lower a given rating.

- In the grid view, position the mouse pointer over the lower-left corner of the thumbnail to reveal the ratings in gray, and click the number you want. Or, in the detail view, click a rating at the bottom of the screen (Figure 10-3).

- Choose Image > Set Rating and pick a number from the menu. Or, right-click and choose among the same options from the contextual menu.

FIGURE 10-3: As you scan through your photos, you can rate each one by clicking the stars at the bottom of the screen.

Flagged/Rejected

A five-star scale may seem needlessly complex—for some people, a simple toggle between good and bad is enough of a rating system. I like to use Reject to get rid of obvious flubs and Favorite to elevate better shots. Here's how to flag images **(Figure 10-4)**:

- Press the P key (for "pick") to flag and image or the X key to reject it. Press U to set it as unmarked.

- Click the heart icon in the thumbnail or detail view to set the image as Flagged. The Rejected option, the X icon, appears only in the detail view.

- Choose Image > Set Flag and choose either Flagged, Rejected, or Unmarked. Flagged images appear with a white heart icon on the thumbnail or detail view; Rejected images include a white No symbol on the thumbnail, or an X icon in the detail view. Unmarked images, the default, show neither icon. Or, right-click and choose among the same options from the contextual menu.

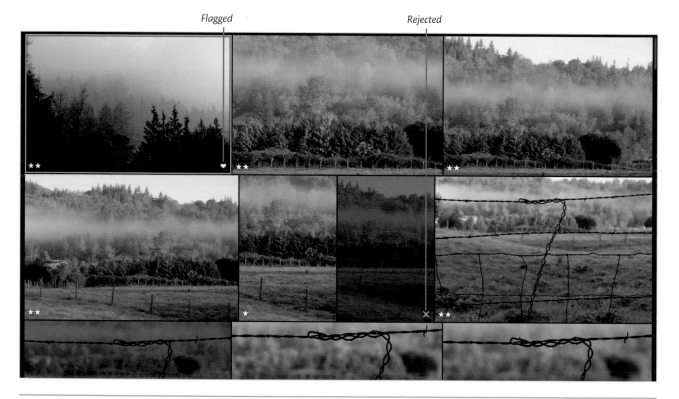

FIGURE 10-4: Rejected photos are a little easier to spot, because Luminar dims them in addition to applying the X icon.

Color Labels

To assign a color label, do one of the following **(Figure 10-5)**:

- Press a number key between 6 and 9 to assign, in order: Red, Yellow, Green, or Blue. (Sorry, Purple, you get left out.) Or, press the hyphen (–) key to reset the color label to none.

- In the detail view, click the Color Label pop-up menu at the bottom of the screen and choose a color.

- Choose Image > Set Color Label and choose from Red, Yellow, Green, Blue, or Purple. The same options are available from the contextual menu.

FIGURE 10-5: Color labels add one more method of categorizing photos.

The Case for Rating before Editing

Over the years I've developed a system of organizing my photos that picks out the most promising images without taking much time. It requires some discipline, however.

As soon as you import a batch of images, start rating them: Double-click the first one to switch to the detail view (where you can see a larger version than just a thumbnail), and use the keyboard to assign a star rating (or set a flag or color label). Press an arrow key to advance to the next image, rate it, and repeat until you've scanned through the entire set. The rating system is up to you, but be consistent about it so you can see at a glance which photos stand out from the others.

In my case, I assign two stars to any photo that's at all promising: I like the composition, or it's interesting and in focus, or it just catches my eye for some reason. If a photo is especially appealing, I give it three stars. If something is particularly bad, I press X and mark it as Rejected. The idea is to set these apart so I can devote editing attention to them later.

You'll be tempted to start editing one or two images—a little crop here, maybe an exposure adjustment there—but try to resist that impulse. Don't spend a lot of time evaluating each shot; this pass is just to set a baseline and make sure you've seen everything.

Next, I'll filter the library to reveal only images rated 2-stars and higher, and then start my editing pass. Anything I edit gets three stars. If I need to pause while editing, it's easy to sort the promising photos, so I don't have to re-scan the entire set to find the ones I want to work on. As I edit, I'll assign 4 or 5 stars to finished photos. At the end, I'm able to immediately pull up my best shots.

Before I'm done, I also filter the group so only the Rejected images are visible. With a quick Edit > Select All command, I then choose Image > Move to Trash to remove them from the library.

Sort Photos

The order in which photos appear in the library depends on two factors: which criteria to sort them, and whether to view those in ascending or descending order.

In the grid view, the sort menu appears at the top-right corner, under the toolbar **(Figure 10-6)**. Click it to choose to sort by Capture Time, Edit Time, Rating, Pick, Color Label, File Name, File Type (such as JPEG, DNG, or your camera's raw format), or File Size.

Next, choose Ascending to list the items from first to last—such as earliest captured to latest captured—or Descending for the reverse. For instance, I prefer to see my most recent photos at the top of the library, so I choose By Capture Time and Descending.

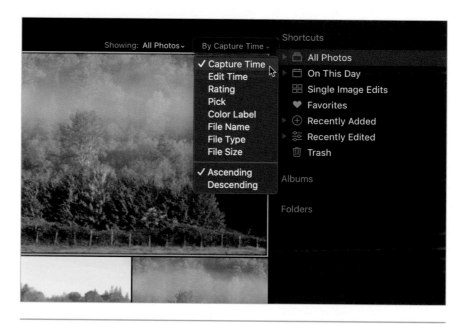

FIGURE 10-6: Arrange photos in the grid view based on the sort criteria.

Filter Photos

The Showing menu at the top of the grid filters which images are visible. This allows you to, for example, view all photos marked two stars or higher.

Click the menu and choose a criterion: whether photos are marked as favorites, rejected, or unmarked; by star rating; by color label; or whether the images have been edited **(Figure 10-7)**.

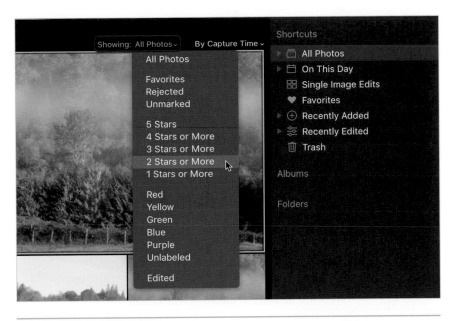

FIGURE 10-7: Filter the visible photos according to the ratings or other criteria.

Although you can't select multiple criteria from the Showing menu, you can narrow the scope of a filter by also choosing a shortcut, album, or folder in the Library panel. Since there's already a Favorites shortcut, you can then choose, say, a star rating to locate all 4-star photos marked as favorites **(Figure 10-8)**.

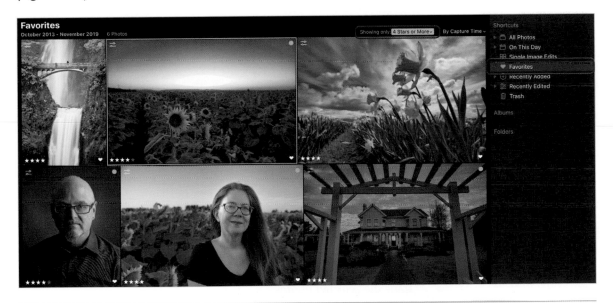

FIGURE 10-8: It's clunky, I know, but this approach does let you view your top-rated favorite photos.

Let's say you've identified some of your top-rated photos, but you think there might be one from that photo shoot that's also worth revisiting. Instead of navigating the folder hierarchy, choose Image > Go To > Images from the Same Date (or choose it from the contextual menu when you right-click the photo) **(Figure 10-9)**. Luminar takes you to that day's images in the library.

And if you need to locate the original image file on disk easily, choose Image > Show in Finder/Explorer.

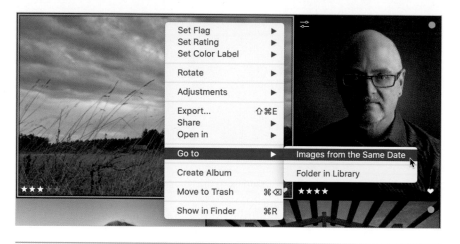

FIGURE 10-9: Jump to related photos without crawling through the folder hierarchy.

Work with Albums

Most of the built-in shortcuts give me enough structure to narrow what's visible in the library to what I'm looking for, from viewing specific dates to seeing which images I've recently edited. Sometimes, though, I want more deliberate groupings, and that's where albums come in.

An album contains whichever photos you manually add to it. To create an album, do the following:

FIGURE 10-10: Right-click in Windows to create an album that includes the photos you selected.

1. Select one or more photos in the grid view or in the Filmstrip running alongside the detail view. At least one image is selected at all times in the library, so make sure it's one you want to include.

2. In the Library panel, choose Image > Create Album or right-click and choose Create Album from the contextual menu **(Figure 10-10)**. You can also click the + button next to Albums, but in the Windows version of Luminar, the album will be empty. The album is created and contains the selected photos.

3. Type a name for the album and press Return. The album is selected in the Library panel and only its contents are visible **(Figure 10-11)**.

4. To add images to an album, drag them from the library grid or the Filmstrip in the detail view to that album in the Library panel. Photos can appear in multiple albums (the files aren't duplicated on disk).

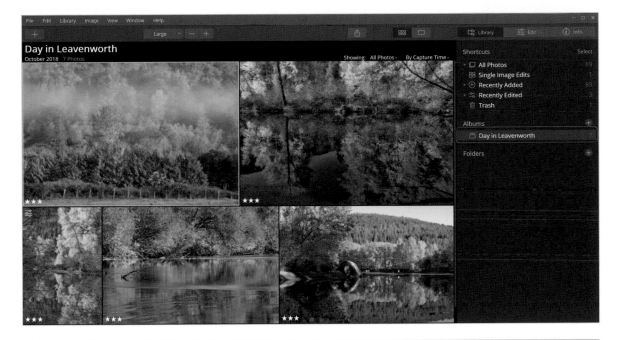

FIGURE 10-11: The new album contains only the photos I selected, not every image from that day's shooting.

Remove Photos from Albums

To remove photos from an album, do this:

1. Select the album in the panel.

2. Select the photos and press the Delete key. You can also choose Image > Remove from Album or right-click and choose Remove from Album. The images remain in your library, but no longer appear in that album.

Similarly, you can delete an album from the library by selecting it and choosing Library > Delete or right-clicking it and choosing Delete. In the Windows version of Luminar, the only option is to right-click the album and choose Delete. Again, nothing happens to the images within the album; only the album itself is removed.

Add an Album to Shortcuts

You can end up with so many albums that it's difficult to keep track of them in the Albums list. When that happens, change your strategy slightly by moving albums you're actively working with into the Shortcuts list:

1. Select the album in the Library panel.

2. Choose Library > Add to Shortcuts (macOS), or right-click and choose Add to Shortcuts (macOS and Windows). You can also just drag the album to the Shortcuts list under Windows **(Figure 10-12)**.

When you're done with the album, select it in the Shortcuts list and choose Library > Remove from Shortcuts, or right-click and choose Remove from Shortcuts.

> ### Metadata in the Future
>
> One feature that's noticeably missing from the Luminar Library is the ability to edit text metadata, such as a photo's name or description, and search the library based on that criteria.
>
> According to Skylum, an update in 2020 will bring basic IPTC metadata editing and a search tool (IPTC is an acronym for the International Press Telecommunications Council, a group that established standards for embedding text data in image files to make it easier to identify a photographer's contact information, important keywords, location data, and more).
>
> These features will make their way to both Luminar 4 and Luminar 3.

Remove Photos from the Library

In Chapter 2, I covered removing a source folder from the library, but what if you want to get rid of individual photos? To remove images from the library, do the following:

1. In the Library, select one or more shots you want to remove.

2. Choose Image > Move to Trash, or right-click and choose Move to Trash. On the Mac, you can also press Command-Delete.

The photos get sent to the Trash shortcut, listed under Shortcuts in the Library panel; the files themselves are still in place on disk **(Figure 10-13)**. If you change your mind, select the Trash, pick the photos you want to rescue,

FIGURE 10-13: The Trash in Luminar is a temporary holding place within the application; trashed files stay put on disk.

and choose Image > Put Back or right-click and choose Put Back. In the Mac version, there's also a Put Back button.

However, if those shots really are destined for the bin, you have two options:

- Choose Library > Empty Trash, or select the Trash shortcut in the Library panel and click the Empty Trash button.

- Select one or more images in the Trash and choose Image > Delete Forever, or right-click and choose Delete Forever. On the Mac, you can also click the Delete button, or press Command-Delete.

Emptying the Trash isn't as final as it sounds—the files are moved to the system trash, where you can still grab them and put them back into a source folder manually.

215

Locate Missing Folders and Edits

Luminar is good about dealing with image files it can't locate, such as when part of your library is on an external drive at home. The name appears in gray with a warning badge next to it **(Figure 10-14)**, and Luminar displays thumbnails and low-resolution versions of the photos, though you can't edit them.

FIGURE 10-14: The network drive on which this folder lives is not connected, but Luminar still displays thumbnails for its contents.

Usually, all you need to do is reconnect the drive or network volume. The application sees that it's back online, removes the warning, and lets you edit the images as normal.

But what happens when a folder is renamed or moved when Luminar isn't running? Thankfully, the software doesn't freak out (I've seen others do that). To reconnect it, though, requires some hand-holding from you:

1. In the Library panel, right-click the folder Luminar can't find and choose Locate Folder.

2. Navigate to the folder on disk and click Choose Folder.

3. In the warning dialog that appears, click Locate Folder.

If an individual file is moved or renamed when Luminar is closed (and therefore unable to track it automatically), Luminar creates a Lost Edits shortcut **(Figure 10-15)**. It's so named because, as a non-destructive editor, the software stores all of the edits in its catalog, not in the image file itself.

FIGURE 10-15: These three photos were edited, but then inadvertently moved to another location on disk.

This feature is fairly smart, too. It can recognize other image files with lost edits in the same folder and reunite them. It also looks for criteria such as the file name, image dimensions, and creation date and time to identify the correct lost image.

However, there's a potential trap here: Luminar adds the new location to the Folders list, so in addition to reuniting the missing image with its edits, *all images in that folder are added to the library.* That's not an issue if the folder is already in your library, or if only the images you want are in the folder. But if, say, your lost image ended up at the top level of your hard disk, you could be in for a surprise because Luminar adds *every image on disk* to the library (don't ask me how I discovered this; it wasn't pretty).

So with that warning, go into these steps with eyes open:

1. Select the Lost Edits shortcut.

2. Right-click the photo you want to find, and choose Locate Image.

3. Navigate to the folder in which the lost edit appears and click Choose Folder.

Any lost edits are applied to their images, and any other photos in the folder are added to the library.

Alternately, if you know those files are permanently lost to the bit-demons in the sky, click the Delete Lost Edits button and confirm that you want them eradicated from the library. Or, right-click one or more selected Lost Edits and choose Delete.

Back Up and Restore the Catalog

Have I badgered you about backups yet? I haven't? Well!

If you currently have just one copy of your images on a hard disk, stop reading now, buy an inexpensive external hard disk, and make a copy of your images. Seriously, do it right now! I know from experience that technology can fail spectacularly, and with digital photos, once they're gone, they're never coming back.

Even if your images are stored with an online service such as Dropbox or Google Photos, you should have at least one local copy that's under your control. Better yet, make two copies and keep one at another location, such as work, a trusted friend's house, or a safe deposit box, just in case your home is carried off by a tornado or UFO.

As it relates to Luminar, there's another important backup consideration. As we discussed early in this chapter, Luminar creates a catalog that stores the location and editing information about your photo library. If you lose the catalog, you also lose your edits, because they're all non-destructive, leaving the original image files untouched.

So in addition to making sure you have good backups of your photo files, also make a point to regularly create a backup of the Luminar catalog. The macOS version includes a way to do it within the application:

1. Choose File > Catalog > Backup.

2. In the dialog that appears, set a destination for the backup catalog file, preferably in a place other than your hard disk.

3. Click Save.

Luminar creates a file, called "Luminar Catalog.luminarBackup," that includes the catalog and the stored edit history of your images.

If something goes awry with your regular catalog, do the following:

1. Choose File > Catalog > Restore from Backup.

2. Locate the backup you created and click Open.

3. In the next dialog, name the new catalog and choose a destination for it (such as the Pictures folder).

4. Click Save.

In Windows (as of this writing), you'll need to make the backup manually. In the Explorer, locate the Luminar Catalog folder within the Pictures folder and copy it to another location.

Work with Multiple Catalogs

I tend to use just one catalog and one library, because I prefer to have all my photos in one place. In some situations, you might use multiple catalogs, such as to house a side project or work for a client where the photos need to remain in their own library.

To create a new catalog, choose File > Catalog > New. In the dialog that appears, give the catalog a name and choose where to store it on disk. Click Save. The new catalog opens with an empty library.

To access existing catalogs, choose File > Catalog > Open and locate the catalog file, or choose File > Catalog > Open Recent and pick one from the list.

Sharing Photos

Luminar is a non-destructive editor, as I've mentioned before, which means the original photos are not actually touched when you work with them. The image files on disk are the same as when you imported them from your camera, while the edits you make exist as saved commands in Luminar's catalog.

To use any edited photo outside of Luminar, you need to export it in order to create a new version that incorporates all the adjustments. Luminar offers two routes to do this: export it as a file to your hard disk, or share it directly to a few online services.

It can also batch process groups of photos on disk to create edited versions, even if the originals have not been edited yet.

Export to Image

Luminar handles all of its exporting options in the one place. Select one or more images in the Library and choose File > Export or click the Share (▣) button and choose Export to Image **(Figure 11-1)**.

In the dialog that appears, adjust the following export options (on macOS you may need to click the Options button to reveal the settings), and then click Save/Export. The options that appear depend on the file format you choose **(Figure 11-2)**.

FIGURE 11-1: The Share button in the toolbar is a fast way to export a photo.

Location

Navigate to the folder in which you want the edited versions saved. Under Windows, click the Browse button and specify a location. Don't choose the location where the originals are stored; you want to create new edited copies, not replace the originals.

File Name

If you want to rename the exported file, enter it in the Save As (macOS) or File Name (Windows) field. If you've selected more than one photo, the images' original file names are used, with no option to rename them.

FIGURE 11-2: The export options are mostly the same, but look different, in macOS (left) and Windows (right).

Format

Luminar supports six formats that are useful in different situations:

- **JPEG:** In most cases, you'll want to save your photo as a JPEG (Joint Photographic Experts Group) file, which offers high image quality, near-universal compatibility, and compression to create a file size that's much smaller than the original. JPEG achieves its file reduction through *lossy* compression, which means image data is discarded; normally this isn't an issue, but if you were to edit a JPEG, export a JPEG copy, edit that copy, and so on for a few generations, you'd notice image degradation.

- **PNG:** The PNG (Portable Network Graphics) format was largely designed as a higher-quality alternative to the GIF format. Although PNG is supported by nearly everything at this point, if you're exporting photos, JPEG is still a better alternative for both image fidelity and size.

- **TIFF:** The TIFF (Tagged Image File Format) option includes the largest number of export settings. TIFF images are used most often when outputting images for print or when transferring images between applications, where image size isn't as important as having a lot of data to work with. (When you edit an image in Luminar from Lightroom or Photoshop, Luminar receives a TIFF file.) As such, TIFF images tend to be quite large. Note that TIFF images are exported in RGB color spaces; Luminar does not support converting photos to print standard CMYK images.

- **JPEG-2000:** JPEG-2000, which sounds like a cool retro sci-fi movie, is an updated JPEG format that uses a more efficient compression algorithm. That sounds great, but in practice, plain-old, non–sci-fi JPEG is used more often.

- **Photoshop:** When you choose Photoshop as a format, Luminar creates a PSD file that is saved in Photoshop's native file format, which is widely supported among many apps. However, Luminar is unable to save *layered* Photoshop files, so any layers you created during editing are flattened to a single layer in the exported file.

- **PDF:** Adobe's PDF (Portable Document Format) is included here for compatibility, since it's a format that can be opened by nearly anything. That said, unless you have a specific reason to use PDF, it's not common to export images as PDF files.

Sharpen

If you spent a lot of effort sharpening your photo using the Details Enhancer tool, you may be wondering why this option even exists.

When you export an image to a compressed format, such as JPEG, some of that detail can be softened as the algorithm chooses which data to throw away. That's particularly true when resizing an image, because all of the pixels are being affected.

The options here aren't specific: None, Low, Medium, and High. So the best option is to export a few versions to see which one looks best **(Figure 11-3)**.

None Low Medium High

FIGURE 11-3: I've zoomed in at 300% to see the difference between the four sharpening levels (the detail area is marked in red, above). Make a point of also looking at the entire image at 100% zoom.

Resize

Depending on how you're going to use the exported image, you may want to save it in dimensions other than the original measurements. For example, photos look best on Facebook when the long edge is 2048 pixels, while Instagram prefers 1024 pixels. Since you don't want to resize your original, it's easiest to export a copy in the size you need.

If you want to resize, choose from the following options:

- **Original/Actual Size:** The dimensions are unchanged.

- **Long Edge:** Enter a pixel value for the longest side, and the short side is set to a proportional value. For example, to share it to a Facebook-friendly 2048 pixels, a landscape-oriented photo that's originally 4619 by 3080 pixels becomes 2048 by 1365 pixels.

- **Short Edge:** If you're targeting the short edge, enter the value here and the long edge is proportionally adjusted.

- **Dimensions:** If you need to target specific dimensions, select this option and enter them in the fields provided. That said, Luminar really only honors the long side; it keeps the photo's aspect ratio, and does not artificially stretch or compress the image to fit both values.

Color Space

The term *color space* refers to the range of colors that appear in a photo. When a device—whether that's a tablet, phone, or desktop computer—knows which color space an image uses, it can render the colors in the file correctly.

Luminar supports three color spaces:

- **sRGB:** This color space is the standard for viewing images on the web and on many devices. For the greatest compatibility, export a photo as sRGB.

- **Adobe RGB:** The Adobe RGB color space is capable of displaying a greater gamut of colors than sRGB. It's a good choice if you're exporting an image that will be edited in another application.

- **ProPhoto RGB:** For the largest gamut of colors, such as capturing every hue recorded in a raw file, export the image in ProPhoto RGB.

Since a large color gamut equals the most colors, you'd think ProPhoto RGB would be the natural choice to use, right? Ahh, welcome to the wonderful world of color management. To properly view all of those colors, you need

to make sure your computer's display is capable of showing them, and that it has been accurately calibrated. The same is true for every device in the chain between your computer and the final output.

If that's not the case, you could find yourself with a beautiful image on your laptop screen that exhibits color shifts or muted hues when viewed online or as a print. So, keep the end result in mind. Stick to sRGB for most web or app destinations, and use the others only in situations where you know the color gamut will retain its accuracy.

Quality

Sorry, this setting won't turn a mediocre photo into a masterpiece just by cranking the slider to 100.

What it will do is determine how much compression to apply to the image. With a JPEG image, for example, a higher Quality value translates to less compression, a larger file size, and a better-looking photo. When you drag Quality down to 50 or lower, the image exhibits noticeable artifacts **(Figure 11-4)**. The Quality setting appears when saving in JPEG and JPEG-2000 formats.

Quality: 85 *Quality: 40* *Quality: 20*

FIGURE 11-4: There's really no good reason to save a JPEG with a Quality level of 20, but this example reveals how much data is thrown out.

Compression

When you save a photo as a TIFF image, you can choose the type of compression employed to reduce the file size. Unlike the Quality setting for JPEG and JPEG-2000 images, which uses visually lossy compression to reduce the file size, the compression type for TIFF images determines how much lossless compression is applied, as follows:

- **None:** The image is not compressed, producing a large file size.

- **LZW:** The LZW (Lempel-Ziv-Welch) option is a lossless algorithm that reduces the file size without throwing away any data. It looks for blocks of the same data and creates smaller references to describe them. For instance, in a photo with a line of blue pixels, the computer reads that as "blue pixel, blue pixel, blue pixel, blue pixel." LZW compression shortens that to "4 blue pixels," and the software reading the TIFF knows how to render those pixels. (I'm oversimplifying, of course.)

- **Packbits:** Packbits is also a lossy compression format, but doesn't do as good a job as LZW. However, Packbits is more widely supported, because LZW requires a license to encode and decode it. That said, unless you're using the TIFF image on something out of the ordinary, or a printer tells you otherwise, stick with LZW or None.

Depth

This option, available when TIFF is selected as the format, determines whether the photo is saved as an 8-bit or 16-bit file. Bit depth dictates how many colors can be included.

JPEG images are 8-bit, and in some situations can exhibit artifacts such as banding in skies or other gradations. A 16-bit TIFF version of the same image creates a smoother sky, because there's more color data to blend the colors. The downside to 16-bit images is that their file sizes are larger.

If you're working with a raw file, which contains more data, choose 16 bits from the Depth pop-up menu to ensure you include as many colors as possible. If you're editing a JPEG file, which started out in 8 bits, saving it as a 16-bit TIFF doesn't offer an advantage, because it can't add colors that weren't in the file already. However, unless you're aiming for a smaller file size, it won't hurt.

Resolution

When exporting a TIFF file, you can specify a resolution for the photo. Typically this value refers to the number of dots per inch (DPI) a printer is capable of reproducing on paper. Luminar uses the measurement of pixels per inch (or pixels per centimeter) to convey the same idea.

Enter a resolution value here if you've been instructed to do so by whichever outlet is going to process the file. Otherwise, leave it set at the existing number, which will be the maximum setting.

Share to Services

Exporting an image requires you to do something with the file, but in a few cases, you can jump right to a destination. Currently, Luminar offers three options: creating and attaching a photo to an email message, sending it as a text message (macOS only), or publishing directly to a SmugMug account.

Click the Share (⊞) button and choose one of the following options:

- **Mail:** Luminar exports a JPEG image, opens the application you use for email, and attaches the photo to the body of a new outgoing message **(Figure 11-5)**.

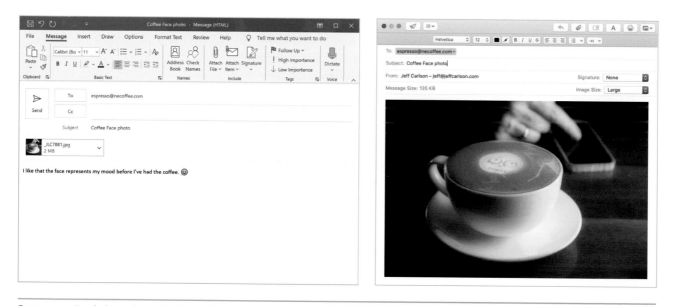

FIGURE 11-5: Send photos by email directly from Luminar. At left is Outlook under Windows; at right is Mail under macOS.

- **Messages:** On the Mac, choosing this option also exports an image that is attached to an outgoing text message. For some reason, though, Luminar exports an *uncompressed TIFF file*, which is…insane. You could easily send a file larger than 100 MB to someone's phone, using a service that's designed to handle small, fast bits of data. If you want the convenience, enter a recipient and an optional message and then click Send. Otherwise, I recommend exporting a JPEG and dragging that to an outgoing text message. (Skylum's online manual says a JPEG is created, so perhaps this is a bug in Luminar 4.2, the latest version used as I wrote this.)

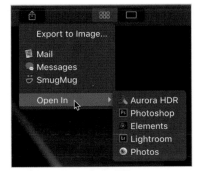

FIGURE 11-6: Upload to your SmugMug account and include a title, caption, and keywords.

- **SmugMug:** If you have a paid SmugMug account, you can upload one image at a time directly from Luminar to your online galleries. Enter an image title, caption, keywords, and select one of your albums, and then click Upload **(Figure 11-6)**. Since this feature is limited to sharing just one photo at a time, you may find it preferable to export multiple images and use SmugMug's own tools to add them to your galleries.

Open in Other Applications (macOS)

In Chapter 2, I talked about how to use Luminar as a plug-in, enabling you to start working with a photo in Lightroom, for example, and send a photo to Luminar for editing. Ever eager to play fair, the macOS version of Luminar can also hand off an image to other photo-editing applications when you want to take advantage of some of their features.

Select one or more photos in the Library, or with a photo in Single Image mode, click the Share button and choose Open In and the name of a compatible app installed on your computer **(Figure 11-7)**.

In most cases, Luminar creates a TIFF file, which is opened in the chosen app. If you own Aurora HDR, it opens the original images.

The action is a one-way trip: Luminar doesn't automatically re-import the version you edited in the other application, unless you save it in a folder that Luminar is already tracking in the Library.

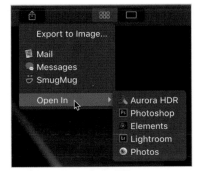

FIGURE 11-7: Send an image from Luminar to another application.

Batch Process Multiple Photos

I tend to overshoot everything. Why stick with a handful of shots when I can mash the shutter button on the camera's drive mode and end up with dozens or hundreds? (I'm exaggerating. A little.)

Sure, a lot of those will be tossed, but I may want to edit several of them. The Batch Processing feature makes short work of applying adjustments to many, or even all, of those images in a series.

As another example, batch processing is great for converting images to sizes that are social media friendly.

Keep in mind at the outset that this feature works *outside* the Luminar Library. If your photos are already in the library, you want to sync the adjustments you make in one photo to the others in the set (see Chapter 9). With batch processing, by contrast, you load images from disk and specify a Luminar Look to be applied to them all.

Here's how to do it:

1. Edit one of the images and create a new Look to save the adjustments that will be applied to the other shots. Remember that a Look includes only the settings on the current layer. (See Chapter 7 for creating new Looks.)

2. Choose File > Batch Processing, or press Command/Ctrl-B.

3. In the window that appears, click the Browse button to choose the folder where the other images reside. Or, drag image files or folders from the Finder or Windows Explorer to the window **(Figure 11-8)**.

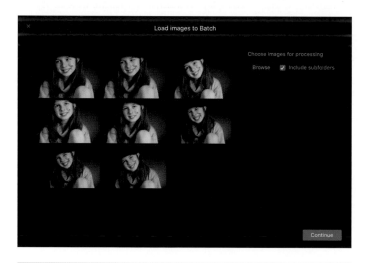

FIGURE 11-8: I'm starting with several images from the same photo shoot.

4. Click Continue.

5. In the Batch Settings dialog, optionally choose one of the Default Settings presets **(Figure 11-9)**. Or, choose from the following settings:

- **Luminar Look:** Select the Look you created in step 1.

- **Save to:** Specify where the processed files are saved. I recommend choosing a folder separate from the originals. If you like to live dangerously and don't plan to rename the new files, you can set the same location as the source, and mark the Overwrite without warning checkbox. But that would be crazy, so don't do that.

FIGURE 11-9: Choose the Look to be used and how the files will be saved.

- **Naming:** The pop-up menus affect separate parts of the output file name, and they can all contribute. Options include the original file name, timestamp (with options for how to display days, months, and years), custom text, or an incremental counter. For instance, you could rename each file with a timestamp prefix, a custom base name, and a counter suffix, leading to something like: *05302020_coolphoto_1.jpeg*. The underscores between blocks are automatically added.

FIGURE 11-10: If you're going to use that combination again, click Save Settings to create a new User Setting.

- **Format:** Choose from one of the supported file formats, described earlier in this chapter. A Quality slider appears when needed, such as with JPEG images.

- **Color Profile:** Pick a profile, also described earlier.

- **Resize:** Specify how to resize the image, if needed. The Don't Enlarge checkbox guards against smaller images being upsampled and losing definition.

6. To use the same parameters later, click the Save Settings button and give the new user setting a name **(Figure 11-10)**.

7. Click the Process button. The Look is applied to all of the specified files, and new versions are saved in the folder you chose in the Save to section. When the processing completes, you're given the option to view the exported files on disk or return to Luminar.

Index

Luminar 4

Curiosity Leads to Creativity

Exclusive offers for Rocky Nook readers!

Rethink your definition of photo editing and use tools like AI Sky Replacement to transform your images in ways you never imagined! Start by downloading your exclusive Rocky Nook sampler pack today!

www.skylum.com/rockynook

BONUS

Use **ROCKY20** to receive a 20% discount on any add-on packs in the Skylum Marketplace.

© Cuma Cevik